magCulture

new
magazine
design

magCulture

new magazine design

Edited and designed
by Jeremy Leslie

LAURENCE KING PUBLISHING

Published in 2003 by Laurence King Publishing Ltd
71 Great Russell Street
London WC1B 3BP
United Kingdom
Tel: +44 20 7430 8850
Fax: +44 20 7430 8880
e-mail: enquiries@laurenceking.co.uk
www.laurenceking.co.uk

Copyright © text and design 2003 Jeremy Leslie

A catalogue record for this book is available from the British Library

ISBN 1 85669 336 8

Designed by Jeremy Leslie

Typeface FF Atma

Printed in China

Contents

Introduction

The magazines

Foreword

By Jeremy Leslie

Magazines have always played a central role in our visual culture. A unique format, they represent a medium that combines a number of essential elements – portability, tactility, repetitiveness and a combination of text and images – that have enabled them to be continually renewable and relevant. These factors, combined with recent developments in production methods and the influence of new media, have enabled magazines to retain their position at the forefront of modern communication and continue to be a source of inspiration to graphic designers everywhere.

Magazines remain, at a most basic level, a combination of text and image created in a process of collaboration between editors and designers. The chemistry between these two disciplines is a central part of the process – a good magazine designer will always have a good grasp of journalism, a good editor will understand the importance of design. And within this broader issue, are the specific design elements: the page size, grid, typefaces and details, all of which contribute to the magazine's identity and visual impact.

Into this designed environment are added the other key elements that define a magazine. For example, it is the contrasting way in which two magazines will cover the same story that defines each magazine's philosophy and outlook – every component of the magazine, however small, has to be seen as part of the larger, ever-changing mass of magazines. The best, sharpest content will often spark the most interesting design in response.

Another key aspect of what makes a magazine's magazine-ness is that there will be another issue. For the magazine designer this means that he may be working on several issues at the same time, and that a new issue is often only half completed before the previous one comes back from the printer. A magazine is therefore an organic project that exists continually rather than in weekly/monthly/bi-monthly bites. This makes it easier to make gradual design changes rather than execute complete redesigns. This ability to continually develop and change without losing the central nature of the magazine is an essential part of good magazine design.

However, whereas once the use of the grid, a set of typefaces and other self-defined rules offered a one-off decision to aid the production process, the Apple Macintosh, now on every magazine designer's desk means that these basic rules can be set, reset, broken and adapted far more freely today. The designer now has more time to fulfil that desire for a unique identity, to question what does and doesn't work on the page. It is this positioning of the

traditional elements within this new cultural context that has created a surge, in recent years, in design-led and design-aware magazines.

And the repetitive nature of the magazine itself plays into the hands of the designer. Each new issue offers the chance to try something new, in reaction to the previous issues and to what other magazines (and other media) have been doing. It is this continuity that lends magazines the ability to both reflect and start graphic trends, as the examples selected for this book will demonstrate.

Today, there are more magazines than ever available, and more continue to be launched. But not all of them are relevant to *magCulture* – there are plenty of magazines being successfully published that are of little interest design-wise. Were an objective measure of quality magazine design possible, I believe the overall mean average would currently be higher than ever before. But here my concern is only with the magazines that are significantly above average in their design outlook.

It is no coincidence that Canadian magazine *Adbusters* features so prominently in this book. Published as a critique of consumerism, globalism and the state of the environment – some of the most challenging subjects of our time – the designers at *Adbusters* have responded with some of the strongest design statements currently being published. Designs such as the cover of the Design

Anarchy Issue *(see page 84)* revel in the irony of using such a commercially orientated medium to criticize the very world in which these market forces dominate.

One of the themes of my earlier book, *Issues*, was that the computerization of magazine design had become the subject of magazine design. Magazines such as *Raygun* (US) had pushed the boundaries of early versions of layout software to create pages where design overtook content. Many magazine designers had responded to these experiments with completely neutral designs, almost 'non' designs. However, this has now changed. The shock of the computer is now over and technology is no big deal. The Apple Macintosh, QuarkXpress and Adobe Photoshop are taken for granted. Instead designers today see the technology simply as tools to achieve what they want.

magCulture looks at what magazine designers from around the world are trying to achieve today. One coherent theme that has surfaced is the reintroduction of 'handmade' techniques. Designers are eschewing the hi-tech and looking back to simple grids and blocks of text that recall pre-Macintosh typesetting; needlecraft is being used for illustration (*Dazed & Confused*, *Tank* [UK]); collage and handwriting have left the domain of secondary illustration and are being used to display the central content (*Adbusters*) and graffiti-style handwriting and marks are used to

loosen otherwise tight layouts (*Nylon* [US], *Tank*, *Re-* [The Netherlands], *M-real* [International]). At first glance, these hand-drawn designs share *Raygun* art director David Carson's earlier disregard for content, but in fact the marks and doodles are more often used to enhance it, ironically through using technology.

Several magazines go further and adopt handmade styling for their physical format. *Mined* (UK) has made a virtue of roughly bound pages that rely on the reader tearing them to open them. *SexyMachinery* (UK) contains instructions on how to assemble loose elements into a bound magazine. In the process of reading, one becomes involved in its construction.

At the opposite end of the scale designers are using technology to experiment with new mixes of text, colour and image. A new flamboyance can be seen in magazines like *Frame* (The Netherlands), *Pop* (UK) and *Surface* (US). These designs mix text and image, applying Illustrator and Photoshop filters as necessary, to create integrated designs that owe as much to the influence of Japanese magazines as to websites.

Alongside the mechanics and creative processes of magazine design there are also wider issues at play, and *magCulture* explores these through a series of essays by prominent figures in this field. Such themes include a consideration of the commercial pressures surrounding a magazine's

concept, as well as the processes involved in its actual construct and physical form, whether printed or available on the internet.

But above all, this book celebrates not just how the design of magazines has increased their influence on modern graphic design, but how the magazine format has increased its influence on other media too: newspapers are hiring magazine designers to help retain their relevance to readers who have access to real-time news on the internet; websites are looking to magazines for help in successfully combining words and images; advertisers are hiring magazine publishers to produce magazines that help communicate their brand messages, and, a new type of independent publisher is using modern production and distribution methods to create small-scale but influential 'microzines' that are unafraid to look to such famous US publications as *The New Yorker* and *National Geographic* for influence.

Today, magazines have fought off the challenge presented by other media and are now striding ahead of those same media, adapting new technology to further hone their ability to present content and design as one. Their visual influence is significant across newspapers, websites, marketing pieces and catalogues. Magazines have not only become a medium in their own right, they have also come to be defined by the way in which they define themselves. This is *magCulture*.

Buy me...

DESIGNING MAGAZINES THAT SELL: AN INTERVIEW WITH ANDY COWLES

How did you first become involved in magazines?

I was involved through my school magazine, which, back in 1975 in the UK, we produced as a spoof of *The Sun* newspaper. We thought it was pretty funny, but when the headmaster saw it finally printed he ordered all copies to be burned, as he considered it to be nothing but sexist, puerile, sixth-form humour, which, frankly, it was. But a few copies were saved and entered into *The Sunday Times* school magazine competition, which it duly won, causing the biggest stink. The front page of the local paper screamed 'Blue Book Wins Prize'.

Our headmaster had to send back the prize money, and we were all nearly expelled.

I really enjoyed the whole thing – the power and subversive nature of magazines, how people get really upset or excited about them and how they can provoke strong debate. So when I left art school, I got a job as a magazine designer with Emap in the UK on *Horse & Pony* magazine. Which then led to being art editor of *Melody Maker* in 1982, followed by the launch of *Q* in '86, *Empire* in '89 and *Mojo* in 1993.

What changes have you seen in the industry in the past 20 years?
The biggest change has been, without question, the technology. The advent of the Apple Mac has allowed designers to have control over content and editors to have control over presentation. Design is no longer seen as some sort of repro function, a black art involving ancient language, a strange rubric and a lot of red film. The Mac has increased the level of magazine craft – the integration of words and pictures, box-outs, sidebars, captions, pull-quotes, subheads, lists and blobs – devices that attract a reader's attention.

The other huge change is that of celebrity and sex. This influences all magazines in every area, with the possible exception of specialist niche titles. You may not see a woman in a black brassiere on the front of a gardening title, but I bet publishers would do it if they thought it would sell more copies.

Have the commercial pressures changed since you started?
I don't think so. The need to sell has always been there. Circulation figures underscore everything you do on a consumer title. Advertising is more of a variable, depending on the nature of the readership. With *Wallpaper** (UK), for example, I would assume that, as long as the sales figures are adequate, they will sell a lot of space because of the very focused group of readers that they reach. Whereas a mass-market men's magazine like, say, *FHM* (UK), will need a big circulation to pull in the ads, as the readership is so broad-based.

Publishers are far more aware now that magazines can become

brands. A magazine is more than just paper and ink – it's a set of values, a belief system. For sure it exists on paper, but can also appear in the form of websites, exhibitions, events, books and so on. The world's biggest magazines can spawn dozens of foreign editions. *Cosmopolitan* and *FHM* have a global presence similar to MacDonald's or Pepsi.

The key to making a magazine brand is consistency. It has to always be the same, yet also changing. The reader has to know what to expect, yet when the page turns they must be surprised.

Obviously, the level of design has increased enormously over the past 20 years. But it's still rare that a new consumer magazine comes along and shouts 'Bang! Look at me! This is different.' To be revolutionary is difficult. When a consumer magazine makes those moves, often the market will punish it. In terms of format and presentation, the market can reject things they haven't seen before, things that make the reader uncomfortable or that challenge them. But magazines can always succeed in finding new ways of packaging a story.

In the UK, *Loaded* was revolutionary because the moment it was invented you could talk about 'the *Loaded* reader' as a concept. *Q* magazine was revolutionary. It said 'You may be a sad, thirtysomething that enjoys listening to Phil Collins, but, actually, you're a power in the market place. You're our reader

Maxim
(UK, November 2002)
220 x 285mm/8 ¾ x 11 ¼ inches
Art director Damian Wilkinson

(US, October 2002)
210 x 275mm/8 ¼ x 10 ⅞ inches
Art director David Hilton

This magazine shook up the UK men's market with its diet of schoolboy humour and sex, before being successfully exported to the US and doing the same there.

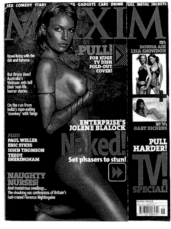

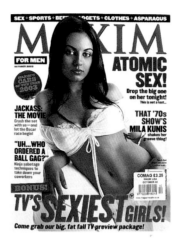

and we love you.' *LivingEtc* was revolutionary. It acknowledged that home magazines didn't have to be about paisley prints and how to repaint your kitchen. It just reflected a social trend, a distinct group of people, and packaged it perfectly. Likewise *Wallpaper**.

To make a mainstream magazine look revolutionary is next to impossible and probably not necessary. The really progressive, challenging work inevitably lies in magazines which people buy for that very fact. David Carson's *Raygun* (US) was a success because people bought it for the way it was presented.

However, taking those design values and merely applying them to another magazine does not work. For example, *Blah Blah Blah* (UK), a music magazine, attempted to use the *Raygun* look, but the magazine failed because readers need a certain functionality from a music magazine that is not required from a title that is understood to be an

experimental pop cultural phenomenon. The *Blah Blah Blah* design was no less good than *Raygun*, but it didn't serve its purpose. Certain subject matter demands that text is read and subsequently a design that allows this to happen.

Yet *Raygun* has influenced the look of modern magazines to a considerable degree. It acknowledged that you could make the magazine look as if it had been created on a computer, as opposed to a replication of hot-metal setting, even if it's just in the details – a column rule touching a column of type, an invisible item pushing text over or even a transparent box.

Not all the magazines you mention were revolutionary design-wise. *Loaded* and *Wallpaper had design statements to make, but *LivingEtc* didn't.**
The look of *LivingEtc* isn't revolutionary but its design is,

because in a consumer magazine, the design is all about the reader and making the link between content and presentation absolutely seamless. But *Loaded*, yeah, that was revolutionary because it looked like they were all off their heads when they were making up the pages. It was great because it reflected the editorial point of view and the needs of the readership. It would have been inappropriate for it to be slickly designed. Whereas *FHM* was a more conservative, black-white-and-red, safe, traditional style, which did not threaten or challenge a 20-year-old estate agent from the provinces.

Setting aside these successful magazines, can you identify any that were revolutionary, but which failed for their lack of commercial expertise?
Those magazines often tend to be great inside but have bad covers. *Neon* (UK), for example, was a wonderful, hip movie title, but with covers that didn't work because they didn't communicate the benefit of the magazine to the reader. So it never achieved the sales to keep it going.

Aside from that, most consumer magazines fail because they're not interesting enough to a big group of people. If they keep going in spite of that, then they are more of a vanity project, serving the needs of the owner or some other interested party, as opposed to the reader, such as Mohamed

Al Fayed's *Punch* or the *New Statesman* (UK).

On a pure design level, there are a lot of what you might call vanity publishing projects – *Raygun* was one of them – that inform other more commercial magazines and are important in that respect. This is true, though it's my suspicion that *Raygun* was profitable because there were enough design professionals who were interested in it, and enough brands like Levi's and Diesel that wanted to be associated with that kind of cutting-edge work to make it a viable proposition. It was clearly a very focused magazine.

I'm trying to think of magazines that were successful from an aesthetic point of view, yet commercially unsuccessful, and I find it hard to disengage the two. When I think of commercial I don't think of profit. I think of identity with the reader and their aspirations and desires. So if the design, the typography, the art direction, the page furniture, the colour and everything else communicates a certain feeling that I can clearly recognize – if I can see the reader – then it is successful. If I can't see who the reader is, the magazine confuses me.

What I'm thinking of here is design for designers. I'm thinking of magazines that ask questions about what a magazine is, what a magazine can be: magazines that are completely outside of the commercial world,

that add to a discussion about what good design is.
Those kind of magazines aren't consumer magazines in the strictest sense. They are niche titles for people with an interest beyond the content: like a fashion magazine, but where the fashion is the very nature of print and ink. And fashion magazines, like *Raygun*, do influence mainstream consumer magazines, as did *The Face* when Neville Brody was there. It had an impact beyond its target market.

It's interesting you pair those two magazines. In both cases, the designers became superstars on the basis of their magazine design work.
Absolutely. The magazines were very high-profile vehicles for their own particular aesthetic. Both were great designers, though neither can necessarily say that those titles were their best work. My favourite Carson works are the surfing and snowboarding magazines before *Raygun*, such as *Beach Culture* (US). Here, they had to serve a practical purpose. They were niche leisure magazines, but with a very cool aesthetic to them. Those readers are demanding. I suspect surfers like their type in straight columns – they want to be able to read it. And so these pages created the sensibility of *Raygun*, but in a more practical context.

It is possible to be radical within a commercial context. UK *Vogue*'s redrawing of Gill two years ago was excellent. That was

The Face
(UK, Volume 3, Issue 64, May 2002)
220 x 300mm/8 ¾ x 11 ⅞ inches
The 'original' style magazine is currently living up to its reputation for innovative design, which was earned during its '80s heyday under the art direction of Neville Brody.
Art director *Craig Tilford*

progressive – you don't mess with Eric Gill's work unless you're on sure ground. They did a wonderful job. They used all the type in black and white, and they had the production values to do it well.

It's interesting to see what *Harper's Bazaar* is doing in America now. They've gone back to the original logo and restored Fabien Baron's typography, the Bodoni, which seems the right thing to do. It's all very simple, black and white, following UK *Vogue*'s lead.

What are the differences between working in the UK and in the US?
There are so many! Two nations divided by a common language, and all that. The differences can be fundamental. Looking at their various magazines, the UK feels like a pagan country, and the US essentially a puritan country. Right now, Americans are conservative. Many publishers have trouble with sex on the covers of their magazines. They have difficulty

with irony – they don't understand this form of humour. And the way in which they make their magazines is very traditional, using lots of separate departments. It is like the difference between American football and soccer. In American football, you have many people with their own job to do, and everything is controlled by one person at the top. Soccer teams are smaller – people take far more individual responsibility and work in each other's areas with greater fluency.

Overall, UK magazines have the edge in packaging – concepts, angles, box-outs, caption styles – whilst the US leads in terms of pure content – photography, writing, accuracy and so on. UK magazines can read poorly, measured against American titles, but they are funnier and make more opportunity to surprise the reader. The culture of perfectionism in US magazines can boil a lot of the fun out of the process.

The Americans like their market research. They put every detail of every issue to focus-group research and expect the editorial and design teams to respond immediately to the data.
For sure. The way the cover lines are written, the pose of the cover girl, the fashion styling, the colour palettes, can all be very controlled. Americans have the resources to put far more science into the process. They believe you can get results – sales – that way.

Is that because of the scale of the US publishing industry? Because so much more rides on success or failure?

Possibly. The numbers are so much larger, the circulations are enormous and the advertising figures are huge. Also, magazines are far more elevated products in the US. To be on the masthead of a magazine means something there. Magazines are considered more important than newspapers, whereas in the UK I suspect it's the other way round.

When you do get a European magazine breakthrough in the US, the results can be devastating. The enormous success of the US edition of *Maxim* demonstrates that. By US standards, *Maxim* looks really 'cutting-edge' because it is produced out of a mindset and a culture that are not their own. It looks radically different to American magazines because of the way it is made, not because of its 'design'. The thought process, production methods and its context are so different.

Staff working on American magazines refer to photographs as 'the art'. If you want to do a cut-out round someone's head in a photograph, you are interfering with 'the art'. This can trouble people, as in the US this technique is often considered that of a lower-class title. US magazines can take themselves very seriously. They like to separate the text and the pictures. They're designed so that the text is over here and 'the art' is over there. In the UK, magazines are less squeamish about developing the closest possible relationship between the text and pictures.

Rolling Stone **is a good example of that tendency. Your predecessor, Fred Woodward, worked with some great photographers and designed some beautiful typographic layouts, but these two elements were always very separate.**

Fred's a brilliant typographer and a great art director. And his current work on American *GQ* continues to prove that. At *Rolling Stone* (US), the photography was always of the highest standard and likewise the typography. The two elements were always aesthetically balanced on the page, but there was not much integration of text and pictures. Caption-writing is not part of their culture, so, to this point, *Rolling Stone* has not developed these ways of communicating their points of view to their readership. There is a sense of expectation here that people will read. That's the American style. When you read a story in an US magazine, often the hook won't come until paragraph three. A feature may well start with two paragraphs of waffle. The English style is to start with a bang, straight in at the top, which is more of a newspaper style and approach. However, now that Ed Needham has been appointed as our new managing editor, all that could well change.

Do Americans read magazines in a different way?

I don't think so. We're all human. The success of a title like *Maxim* proves it. If there is a difference, it is that Americans have a little more reverence for magazines. They believe them to be important. The British perhaps consider them to be light entertainment.

You have an experience across a range of consumer magazines. Is there a particular area where your heart lies?

I enjoy magazines that are funny. I think that if you can make people laugh, then you make a relation with them that is stronger than almost any other. *Q* was, and still is, a funny magazine. Ironic, dry, well-informed, but funny. I love that. *Total Sport* (UK) was a funny magazine too, and I loved that as well. To do something where people are just entertained by the page is important.

What is the current state of consumer publishing?

Consumer publishing is always very dynamic. Magazines are such a spontaneous purchase. You're always living and dying by your next issue. Magazines can turn themselves around very quickly. They can go from being rubbish to brilliant in three issues. *The Face* still does that on a regular basis. New magazines launch all the time. Others are in slow and terminal decline, and will eventually disappear. It's always been so. The industry doesn't feel any different now to how it used to be, because it's always changing so fast.

On the one hand, it always seems to be more exciting, because you can do more with less, thanks to the technology. On the other, it's becoming more and more difficult to get access to celebrity. The power of the publicist is so big. And readers are also becoming so desensitized. Things that were considered shocking just five years ago are now the norm. Sex is no longer risqué, along with dozens of other things. Shocking people is a great function of a good consumer magazine. You should appal some people, yet truly delight the person who you really want – your reader.

Andy Cowles *is art director of Rolling Stone magazine*

'Looking at their various magazines, the UK feels like a pagan country and the US essentially a puritan country.'

Take me...

MAGAZINES AS BRAND MESSENGERS: BY JEREMY LESLIE

As I write this, the highest circulation magazines in the UK are *Sky* magazine, *O* magazine and the *AA magazine*. None of these titles are available on the newsstand, none are available by subscription. If you watch Sky television, use an Orange mobile phone or are a member of the AA car rescue service you will receive them. They will fall through your letter box delivering various degrees of brand- and sales-orientated messages mixed with lifestyle material. They are produced and distributed by publishers on behalf of commercial clients and are the clearest marker of the growth of customer publishing.

Magazines have always been vehicles for communicating with consumers – the income from advertising is a vital part of magazine economics (in the US it is *the* vital part). So it was perhaps inevitable that advertisers and marketers would eventually make the jump from buying advertising space in consumer magazines to publishing their own magazines.

The business model of the consumer magazine has become increasingly complex as publishers, advertisers and readers have become more sophisticated. What was once a simple financial exchange has become much more complicated. Today the advertiser is buying far more than just a page in a magazine. He is aligning the product or service he is selling with the rest of the content of the magazine – both the editorial and the other ads – and buying into a set of values and beliefs that the reader associates with the magazine. The advertiser is seeking

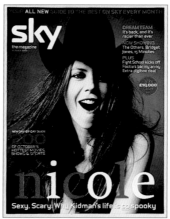

Sky Magazine
(UK, October 2002)
210 x 265mm/8 1/4 x 10 1/2 inches
The UK's highest circulation magazine promotes movies and sports coverage to satellite television viewers.
Art direction *Chris Parker and David Grenham*

to take advantage of the unique relationship between reader and magazine, a relationship unlike any created by other forms of media. As Kevin Roberts, CEO Worldwide of Saatchi and Saatchi has said, 'Great magazines are the ultimate interactive, tactile medium, they offer real emotional involvement.' The advertiser is hoping that some of the magic of that involvement will rub off on his product. The reverse happens too. A magazine will happily offer a discounted page to

an advertiser with the right 'fit'. You want your magazine to look hip? Do whatever you have to do to get Prada to buy a page.

And research has shown that readers expect advertising in their magazines – take away 'their' advertising and they complain.

Such research is endless. The sheer economic scale of the mainstream magazine industry today has led to extended research into every element of the publishing process. Major US publishers routinely focus group each page of every magazine and expect the creative teams to respond urgently to the opinions generated, while advertisers invest in tracking research to check the efficacy of their ads. Publishers and advertisers know increasing amounts about how the relationship between their respective interests is perceived by the reader.

Publishers have long been using the language now favoured by brand specialists to describe the character of their magazines. But it is only recently that magazines have come to be overtly regarded as brands. Visit the website of the National Magazine Company – the UK arm of publisher Hearst – and you'll find their magazines listed under the heading 'Our Brands'.

Front covers, content, and advertising all have to fit the brand. The celebrity on the cover has to be on-brand, to reflect the right values. Like advertising this is a two-way process. An editor might want Tom Cruise on his front cover,

Sony Style
(US, Autumn 2000)
228 x 275mm/9 x 10 ⅞ inches
Sony produce a wide range of consumer electronics and use this magazine, which is sold on the newsstand, to cross-sell their products by combining them with lifestyle content, presented using a clean modern design.
Creative director *Terry Koppel*

but will Tom Cruise's marketing team want him to appear on it? Does his brand fit your brand?

The cachet held by longstanding, successful brands such as *Vogue* and *Cosmopolitan* has been used to launch local editions across the world, and is now being used to create new titles – *Vogue Teen* and *Cosmo Girl* (US) – seeking to attract younger readers to the core brands and help ensure their future. Men's magazines spin off titles such as *Maxim Fashion* (US), and *Loaded Fashion* (UK), built around potentially lucrative ad sales. Such titles have a level of brand recognition that many owners of consumer products would kill for. Without realizing it, magazine designers have become brand experts, responsible for many of the strongest brands around today.

It is against this background that advertisers and their clients began to explore new relationships with publishers. Why pay a publisher to include a page of your

message in their magazine when you could publish your own magazine full of your message(s)? Why not produce a magazine actually about, rather than merely featuring, your brand? Thus customer publishing was born.

Over the past 20 years customer publishing has grown from being a rather murky world of cheaply produced give-away magazines that were little better than glorified catalogues (for which the miserable word magalogue was coined) to encompass not only the biggest magazines in the UK, but also some of the best-designed publications. Titles such as *Volvo* (International), *Army* (UK), and *M-real* (International) regularly win awards for their design, and an increasing number of high-profile magazine designers are being attracted to this field of design.

For the designer, customer publishing can be a refreshing alternative to the pressures of the consumer magazine world. All magazines designers have to work within a commercial environment, but for consumer magazines this means just one thing – they have to sell. To help them achieve this singular aim there is a single business model, based on the same distribution channels and sales outlets as your competitors. Consumer magazines are generally monthly, carry ads and have to conform to a page size that is easily distributed via the news trade.

When launching a new customer magazine, however, the

designer is more likely to start with a blank sheet of paper. How often will it be published? What format can it be? As Rami Lippa, creative director of Redwood, one of the major UK customer publishing agencies, says, 'The challenge for the customer magazine designer is striking the right balance between "pure" editorial values and the brand environment they need to express.' Gone are the deliberations over whether the magazine cover will stand out on the newsstand against its competitors. Instead, the concern is whether the cover fulfils the client's brief.

That brief is different for each project. The client may want to increase product sales or emphasize a brand message. They may want to improve or adjust their relationship with their customers,

'Magazine designers have become brand experts, responsible for some of the strongest brands around today.'

or perhaps even reach a new group of customers altogether.

One magazine that successfully combines these three functions is *Waitrose Food Illustrated (UK)*, published on behalf of Waitrose supermarkets. The magazine is Waitrose's chosen method of communicating to its customers that they are about quality food above cheaper prices. It uses commissioned photography and restrained, modern typography to create an upmarket, glossy magazine that reflects the clients' brand values and successfully communicates the quality message. The magazine also acts as a loyalty reward, being free to holders of a Waitrose account card. Finally, it also has a direct effect on sales; items highlighted on the cover and in major features regularly see increases in sales instore.

Other customer magazines are purely brand-orientated. Finnish paper company M-real publish a bi-annual magazine of the same name in the UK, targeting magazine creatives, a group to whom paper manufacturers would not normally address their marketing. The magazine is printed on the product it promotes, allowing the content to avoid the hard sell. Instead it concentrates on being a must-read/look publication, changing its design each issue in response to the issue's theme, building up a loyal readership, winning awards and generally garnering attention on behalf of the client.

Volvo Magazine
(International, Autumn/Winter 2002)
220 x 284mm/8 ¾ x 11 ¼ inches
Ten different language editions of this magazine are mailed to Volvo owners in 30 countries. It sets out to express the spirit of the Volvo brand while keeping customers up to date with the company's range of cars.
Art director *Lynn Watt*

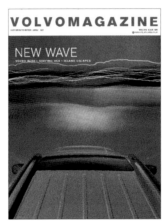

Customer magazines have to be thought of as part of the wider marketing effort by both client and publisher. Alongside the magazine, M-real also sponsor various magazine awards and run client workshops, the aim being to position their paper brands at the heart of the publishing industry.

But as the broader marketing imperatives change, the magazine must change too. This can present the designer with a challenge way beyond the normal redesign.

When *IKEA Room (UK)* was launched in 1997 the brief was to move customer perception of the furniture store away from 'cheap and cheerful' toward ' the source of good, modern design at low prices'. The magazine was launched as a large, square-format lifestyle magazine full of room sets featuring good-looking, young people enjoying life. In 2001 when the marketing direction changed the magazine was relaunched at a smaller page size giving a more pluralist vision of IKEA providing

solutions to the issues facing modern society: extended families, lack of living space, the degrading of the environment. It was a reinvention on a scale a consumer magazine could never risk for fear of alienating its paying readers.

Occupying the top three positions in the audited circulation figures is one sign of the scale of the UK customer publishing industry. Another is that after initial disdain for this new area of publishing, consumer publishers are now moving into customer publishing themselves. Both Condé Nast and National Magazines have recently set up such publishing divisions.

Meanwhile, most of the major UK customer publishers have been taken over by the global marketing conglomerates. Despite this international interest, the market for customer publishing outside the UK remains relatively small and creatively uninteresting. London and New York remain the twin centres of western magazine publishing, but the US industry has been slow to pick up on customer publishing, with the post 9/11 fallout slowing it down further. Examples that stand out include *A&F Quarterly* from fashion company Abercrombie & Fitch, which caught a lot of attention with its 'Back to School' issue featuring pictures of high-school-age models in sexually provocative poses, while Sony have created a lifestyle title around its electronics ranges with its well-designed but editorially unfocused *Sony Style*.

One exception to this UK/US axis is the German title *Statements*. Like *M-real*, this is essentially a niche title, published on behalf of bathroom equipment manufacturer Dornbracht on a smaller scale than many of the projects discussed here. Aimed at a very precise group of opinion formers, *Statements* publishes artists' interpretations of 'bathroom culture', and each issue comes in a different form, a recent example being a leather-bound book.

But whatever the scale of the project, it is the brand itself that defines the magazine: combine a strong brand, a strong creative team and a magazine-literate client and you will get a powerful magazine. But magazines are unapologetic messengers. Start with a brand weakened by lack of clarity and the magazine can only reflect that.

All the magazines discussed above are part of broader marketing strategies carried out on behalf of clients with well-defined messages to convey. They are strong brands that have engendered equally strong magazines. For the designer, translating such brands into the language of magazines is a highly satisfying creative challenge.

And as the design-led titles such as *M-real* and *Statements* reveal, no customer magazine can succeed without good design. In the world of the multi-million circulation magazine, *Sky*, *O* and *AA* magazines are highly sophisticated, design-conscious projects that belie their mass circulation status.

Love me, hate me...

THE NEW WORLD OF THE MICROZINE: BY MICHAEL JACOVIDES

Big, Wish You Were Here, Neo2, Viewpoint, Deliciae Vitae ('Do you have the first issue?'), *Carl's Cars, Tank, Mined, Nice Magazine* ('This is just a block of wood, man!'), *Street Fashion, Lab, Oyster* ('C'est nouveau!'), *10, Putt, Nest, Dutch, Self Service, Nylon* ('A bit mainstream. Try Borders.'), *Surface, 032c, Magazine, List* ('We're not sure if they're still going.'), *Coupe, Re-, AM7, Spector, Very, Catalogue, The Illustrated Ape, Another Magazine* ('Sorry, madam. It's a magazine. Once they've sold out, they don't print any more.'), *Intersection* ('I'd like it in hardback.'), *Archis, Adbusters, Visionaire* ('How much?!'), *Doing Bird, Exit, Shift!* ('But I sold my VCR.').

A bookshop somewhere in London (though it could easily be in Paris, New York, Milan, Barcelona or Stockholm). It's an early Tuesday evening, and the small retail space is crammed full of people jockeying for elbow room around the one wall of the shop that is dedicated to selling magazines.

The titles on the shelves are more than a little fashionable-looking, but Italian *Vogue*, *The Face* and *Wallpaper** (UK) are absent. In place of the familiar are scores of magazines that make up a newsstand from a parallel universe. Some look like huge steroid-injected versions of *Harper's Bazaar* (US), others like bohemian journals put together by Jean Cocteau. One of them comes with its own light box, another is just an A4-sized block of wood. One isn't printed at all, but comes on video tape. Some of the titles are indulgent, difficult, elitist and esoteric, others conservative. But whatever category they fall into, they're getting the customers excited, as they discuss them, and importantly, there is a queue at the till.

Something is happening in the world of magazines. For the past few years, a new strain of independent publishing has emerged and evolved into what is sometimes called the 'microzine'. Vibrant, iconoclastic, stylish and innovative, microzines are beginning to show the rest of the magazines on the rack just what you can do if you've got a little

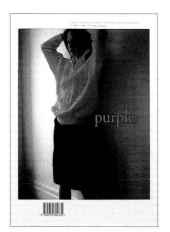

Purple
(France, Issue 13, Autumn 2002)
200 x 270mm / 7 7/8 x 10 5/8 inches
This is one of the original microzines.
Art director *Makoto Ohrui*

'There is an emerging trend within the microzine to question the very nature of what a magazine is.'

imagination and are prepared to challenge the status quo. Not since the post-Punk explosion of independent record labels in the late 1970s have different creative tycoons come together to provide alternatives to the mainstream.

Like those independent record labels, microzines are inspired by the 'do-it-yourself' ethic, and share a disillusionment with the prevalent commercial sector. Anti-commercial, cut-and-paste zines they are not, however. Talking to the art directors and editors of microzines for this piece the same influences are cited again and again: *The Face, The New Yorker, Harper's Bazaar, National Geographic*. Microzines are, on the whole, produced by individuals who have loved or been greatly influenced by, mainstream titles. Their defining characteristics are high production values, a lavish use

of photography, an emphasis on design – in a word, slickness.

It's surprising, actually, just how 'slick' or conservative in design microzines are. As they are published independently, you might expect rampant Carson-ogenics from art directors given free reign, but, on the whole, a new simplicity can be found. Many microzines like London-based *10* or *Self Service* in Paris, for instance, keep text and images well apart. Indeed, to all practical ends, words and pictures are given their own sections, as is the case with *Tank* (UK), again from London. Photography is almost always presented full-bleed. With these magazines, you're either reading text or reading images – they represent two distinct modes. It makes for a pleasurable pace, after the visual information overload frequently found in most mainstream titles.

It would be encouraging to think that the mainstream could adopt some of the rethinking

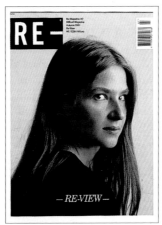

Re-
(The Netherlands, Issue 7, Autumn 2001)
218 x 297mm/8 ⅝ x 11 ¾ inches
Every issue of this magazine asks questions about what a magazine can or should be.
Designer *Jop van Bennekom*

microzines have brought to magazine design, and they can, to an extent. Yet one should bear in mind that the microzine's freedom to stray from accepted norms is down to the entirely different economic model by which it exists.

Microzines have micro-niches. They sell in small numbers to a relatively affluent, international and visually sophisticated readership. Outlets for microzines are restricted to design-oriented bookshops, designer clothes shops and the occasional switched-on newsagent (invariably located in the centre of large cosmopolitan cities). It's this market that defines the look of the microzine.

Cover lines are largely absent on the fronts of microzines because they don't have to compete on the newsstand. A microzine reader appreciates the absence – it is cleaner, so it will look better on their coffee table.

Also, the appearance of advertisements is minimal. Microzines usually survive through a combination of sponsorship and high cover prices. Perhaps the best example of this would be the New York-based *über*-fashion title *Visionaire*. Published quarterly, it distinguishes itself by its variation in format and presentation. No two issues look the same. Recent examples would be the issue that came with its own light box to view the images supplied, and another sponsored by Fendi, which came boxed with its own Fendi kid-leather neck-warmer. But *Visionaire*

carries no advertising. It receives sponsorship from luxury brands (eager to be associated with such a hip product) and has a luxury cover price too – a subscription for four issues costs $675 (about £480).

Perhaps, though, the major contributing factor to the design of the microzine is the determination and maverick nature of their creators. Magazines like the recently-arrived-on-the-scene *Deliciae Vitae* (France), or the more established, and very successful, New York-based *Nest* magazine, are distinguished by the singular visions of their founders.

Edited and designed by its creator Joseph Holtzman, *Nest* has a very distinct take on the world of interiors, one that eschews the dominant vogue for urban modernism in favour of an aesthetic that embraces the idea of using sculpted forms, colour and pattern. This philosophy directly informs the design of the magazine. Some issues are shaped or die-cut to produce a carved or sculptural effect. Others are fastened with ribbon. White space is noticeable by its absence. Instead, images are surrounded, decorated even, by blocks of colour pattern and textures that interact with the images. The more conservative magazine professional might say that *Nest* breaks every rule.

'I didn't learn the rules, so you can't say I set out to break them,' says Holtzman. 'When I started, I didn't know about magazine design and really didn't want to.

Established people in publishing were telling me you couldn't do this and you couldn't do that – but I've done all those things.'

Similarly, the editor and publisher of the luxuriantly sexy and decadent *Deliciae Vitae* manages any commercial considerations that might interfere with the design of his magazine. 'I say no to many lucrative advertising deals, because I don't want bad images – I pick and choose what I want,' says Kinder Aggugini. Of course, the producers of microzines are well able to take these risks. There are no large publishing houses watching the bottom line or throwing results from research surveys or focus groups at them.

Despite the discrete, privileged position of the microzine, their influence on the mainstream is beginning to surface. This is most notable in fashion magazines, an area of publishing that can't be seen to be standing still, whose raison d'être is responding to and setting trends. Andreas Laeufer, art director of Tank Publications explains: 'The larger fashion magazines have loads of little images and text boxes to draw readers in, but if you look at the layout of *Another Magazine* or *Pop* (UK), I think things are changing. It's all full-bleed images and lone pages of text. Which is all great, because it's changing the rhythm of magazines. It's not only about fashion photography either, but fine art photography... *Another Magazine* has photo journalism, still-life and

Shift!
(Germany, Issue 13, 2002)
214 x 260mm/8 ½ x 10 ¼ inches
This issue consists solely of advertisements created and contributed by artists and designers from across the world.
Art director Anja Lutz

city photography, giving photographers loads of space. I think all these changes to more commercial publications are down to magazines like *Tank*.'

It would be wrong to claim that microzines are trying to establish a new design language for the mass-market magazine, however. Microzines want to do things on their own terms. Yes, there's unexpected conservatism about their design, but that, in itself, presents an alternative. The alternative is not always the avant-garde. Having said that, there is an emerging trend within the microzine to question the very nature of what a magazine is, how it works, or how it could work. In short, microzines are developing self-reflective tendencies.

Two recent covers of the Canadian anti-brand microzine, *Adbusters,* express this development. One cover has a standard portrait of an attractive model, only she is obscured by thick, black marker scribble. The second simply has the word 'Magazine' printed on a blank background. Both covers show an awareness of the medium. Even mainstream independent titles, like *Dazed & Confused* (UK), have been deconstructing the magazine. Recent issues contained articles with sub marks and corrections.

Perhaps two of the most interesting microzines to have questioned the magazine format have both come from the creators of the fashion-centric title *Tank*. Published quarterly, *Mined* (UK) blurs the boundaries between magazines and books. Printed without a cover its bound sections are clearly visible. The paper is thick, its rough edges forcing you to cut the pages to open it. *Tank*'s art director, Andreas Laeufer, explains: '*Mined* is essentially an unfinished product. What we do with *Mined* is question everything we do with *Tank*, a high-gloss coffee-table magazine... *Mined* is really a book with the pace of a magazine. Reading a book is much slower than reading a magazine, and with *Mined*

the challenge was to introduce a magazine speed. It has features that run over 20 pages, but then speed is picked up with things like fashion spreads. But then you have to cut the pages, which makes the journey last longer than the ten minutes it takes to flick through *The Face*.'

Where this experimentation with the magazine will lead is perhaps a fruitless question to ask. Some of it may well be assimilated into the mainstream. What it does show is that the magazine is coming of age. It is finally moving beyond its function as vehicle for disseminating information about that which exists outside of itself – what we call journalism. Perhaps the most exciting realization for magazine creatives is that their titles could actually aspire to being art, existing for no other reason beyond their existence.

One new microzine certainly comes close to being an artwork. Or maybe its aim was to undercut such pretensions. *Nice Magazine* (UK) consists of an A4-sized block of wood. On the 'cover' is the title – *Nice Magazine*. On the 'back page' is an ad for Evisu jeans. That's it. And its price is £7.50. A situationist gag? A statement about the ecological resources magazines devour? A call to action to take the raw material and create your own microzine? Like true artists, the creators of *Nice Magazine* were unavailable for comment.

Michael Jacovides *is director of the Fifty One magazine consultancy*

Download me...

CAN PRINT MAGAZINES WORK ONLINE? BY PATRICK BURGOYNE

Remember the dot.com boom? Suddenly, everyone had to have a website. Why, they weren't entirely sure, but they knew they couldn't be left stalled on the on-ramp of the information superhighway. Magazine publishers were no different. Convinced of the Web's opportunities and scared to death that their competitors would exploit them first, publishers rushed to the Web, with very mixed results.

In spite of the well-publicized calamities that followed, as major publishing houses lost millions in ill-thought-out online adventures, the Web continues to offer tempting possibilities to anyone publishing or intending to publish a magazine.

By definition, the World Wide Web is a global medium, whereas it is very difficult to reach an international audience with a printed magazine. Organizing effective distribution overseas is a logistical headache; launching overseas requires large financial risk, while the compromise of a franchise model involves inevitable loss of control over your cherished brand. But with a website, a magazine can reach the world without ever having to leave home.

The marketing opportunities are massive, but the advantages of the Web go beyond revenue generation. For a start, a title can publish as often as it likes – a boon for monthlies frustrated by their rigid schedule. Content can be presented online in a manner that would be impossible in print – particularly valuable for magazines concerning film or audio.

Many publishers who took the online plunge early on, however, found the medium far less straightforward than they had thought. The Web is a different world, demanding different skills and different revenue models.

Many publishers failed to answer the most fundamental question – how do we make money from our website? But even today, magazine art directors who are translating a print magazine to the Web, still face a tricky set of problems.

Print magazines work. They never crash, their batteries don't run out and they don't need plug-ins. They are portable, light (well, light-ish) and everyone knows how to use them. Moreover, the mechanics of creating a magazine brand are tried and tested. Art directors know how to use paper stock, repro and print quality, the pacing of layouts, choices of typography and covers to embody the aspirations and values of their magazine. But how to translate those values online? For art directors of print magazines this has proved a major challenge, especially for upmarket titles.

Many have learned the hard way, that there is far more to producing a magazine online than putting up a slideshow of the printed version. You may have thought dealing with printers and repro houses was tough, now you've got programmers and hosting companies to wrestle with.

The limited resolution and image sizes available online will probably not do justice to your expensive fashion story. Neither will your spectacular typographic feature openers look so glorious

when rendered at 400x355 pixels on a dodgy monitor in a brightly lit room. But there are tools at the designer's disposal that can create a complementary look and feel for a magazine's website. The tactility of the printed product can be mirrored by the feel of a site's design elements – the way a button reacts when it is rolled over, the speed at which elements load or the way in which they behave on the screen. If a magazine has a youthful, fun appeal, this can be achieved through appropriate sound effects, animations, audio and colours, just as the same tools can be used to create a more serious, hi-style aesthetic.

Not all magazines have explored these possibilities. Some have opted for a simple treatment online, staying visually faithful to their paper-based parent. Swedish lifestyle title *Stockholm New* (www.stockholmnew.com) takes this approach, presenting spreads from the magazine in an elegant Flash-based slideshow. The only alteration to the printed version is a larger point size on headlines and captions to aid legibility.

UK style title, *SleazeNation* (www.sleazenation.co.uk), was more adventurous. With a reputation for powerful covers, strong typographical treatments and innovative photography, *SleazeNation* initially set up its website (in June 2000) to give the magazine an international presence and to experiment with content unsuitable for the printed version.

At first, articles placed on the site were replicas of the printed version, but, with the arrival of designers Alex Smith and Nemone Caldwell six months after the site launched, a more appropriate strategy was introduced. 'We were interested in creating something a little different, using the capabilities of the Web to make the whole experience more involving for the viewer,' Caldwell says. 'Whereas previously the articles stuck to a more or less rigid formula (title at the top, image to the side, text along the length, with a crooked line under the title), we have tried to experiment a bit more within the 400x355 pixel space that we have to work in.'

Reflecting its relative importance to the publishers, each issue of the printed magazine was completed first. Then, Smith and Caldwell would receive the Quark files for the issue and work out which articles would work best on the internet. 'Usually, we chose an article which a) was more likely to appeal to a web-using audience, b) we could play around with visually and c) one which we ourselves are interested in. We tried to avoid articles with large amounts of text, as these are memory-heavy and the site wasn't really designed for easily reading huge chunks (one of the main problems with adapting the magazine). We were also keen to put stuff on the website that wasn't in the magazine. For example, once we did a feature on a graphic novel and animated certain scenes from it. Generally, the magazine experiments with print and words a lot more, whereas we tended to be more visual.'

The core content of the site was driven by the printed magazine, but additional material appeared on the site only, such as a news section updated weekly, a gallery and competitions, as well as a selection of different music tracks each month. In Caldwell's view, however, the website was never likely to threaten the primacy

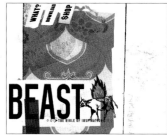

Beast This magazine is distributed as PDFs from its own website. Design *Thomas Schostok*

of the print magazine: 'The website will never take over the print version. The whole thing about a magazine is the actual physicality of it. Something you can hold in your hand, rip pages out of and doodle on, or whatever. A website is transient, it comes and it goes, it changes constantly. It's never something you can "have" in the same way as with a magazine. But, that's exactly why the website is important – because it provides the user with a different kind of experience.'

The alternative functionality of websites, therefore, offers added value to the reader of a print magazine and a means for the publisher to enhance the package to be sold to subscribers, but not the only means. Websites are still not great at displaying video or large amounts of detailed images. Magazines that rely on a great deal of this content, such as *Creative Review* (UK), turned to CD-Rom and then DVD to deliver a high-quality experience to a specialist readership. And where content is purely text-based, email provides an alternative publishing medium to the website: music industry gossip sheet *Popbitch* has created a

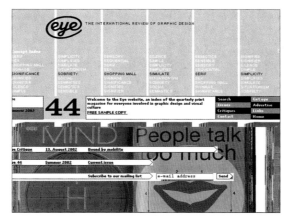

Eye This site acts as both search engine and online advertisement for the printed magazine *Eye*. Its design was conceived at the same time as the latest redesign of the printed magazine and the two media share many common elements. Design *Nick Bell and Artificial Environments*

major following for its scurrilous email service, which delivers salacious titbits to subscribers. *Beast*, on the other hand, is produced as a downloadable set of PDFs (www.ths.nu/beast).

One area in which the Web does offer leadership is in managing and retrieving data. Graphic design quarterly *Eye* (UK) is a visually led magazine, but its website does not feature pictorial content. The site 'was never intended to be a magazine itself – its role is to complement and to serve as an index to the printed quarterly,' wrote *Eye* editor John L Walters, when announcing the launch of the site in Issue 43, Spring 2002. It takes an innovative approach to archiving – a list of concept words on the homepage can be dragged to the active area and a list of issues that dealt with that concept is revealed.

Another innovation with *Eye* is that both website and magazine were designed together. With the print magazine undergoing a redesign at the same time as the development of the website, it was possible to work with both in mind, providing an unusually harmonious marriage of the two media. 'Some editorial elements of *Eye*'s new design were intended for both media, for example the key words and phrases at the start of each feature,' writes Walters. 'They're both a means with which to explore the website and a quick way to communicate some of the content of the article.'

Hint
Available solely online, this fashion magazine uses the immediacy and animation possibilities of the Web to create a different type of magazine in an overcrowded market.
Design *Deanne Cheuk @ Neomu*

SleazeNation and *Eye* represent two of the happier translations of a print magazine to the online environment, from an aesthetic point of view. However, they remain subordinate to their printed parent and their content reflects that. Stand-alone Web magazines must work harder online, but they can do so free of some of the restrictions faced by their print peers.

For anyone who has an idea for a new magazine, the Web offers a genuine alternative publishing medium. After all, a magazine is about conveying information, which is not dependent on putting ink to paper. *This is a Magazine* (www.thisisamagazine.com), a monthly online magazine based in Milan, is very much in the tradition of independent fashion/style magazines, but turns convention on its head by publishing primarily on the Web, with a printed spin-off produced every three months.

And when photographer Nick Knight and graphic designer Peter Saville decided to start *ShowStudio* (www.showstudio.com), a publishing vehicle for new fashion imagery, they rejected print in favour of a website. '*ShowStudio* can get away from corporate politics and broadcast to the world,' explained Knight in an interview with New York-based online fashion magazine *Hint* (www.hintmag.com). 'It's a global audience, global distribution. Even the big magazines can't do that.'

Going online allowed *ShowStudio* to look at fashion in a way that would not have been possible in print: 'There are things a magazine can't do,' Knight noted. 'I've always considered fashion, how it's represented in print, to be a little disadvantaged. There's been a compromise because photographers have to sum it up in one moment. I always felt motion imagery would benefit fashion. If the dress can move, it's better for the dress.'

Hint is an online fashion magazine that is providing an alternative to its glossy print counterparts. Founder and creative director Lee Carter recognized those same freedoms mentioned by Knight: '*Hint* began as a means of circumventing the politics, power-plays and petrified hierarchy of the cut-throat industry of fashion magazines,' he says. 'When I started *Hint* in 1998, I felt I didn't want to waste years of my life in that kind of thankless arena. With an indie like *Hint*, I could avoid the pitfalls of investor backing and parent-company paranoia, since the costs of a web server pale in comparison to the crippling expense of print publishing and distribution. And there was (and is) nothing like *Hint* on the Web, whereas there are many newsstand publications devoted to avant-garde fashion. That said, I have begun to think seriously about a *Hint*-to-print expansion, but it would probably mean a biannual magazine or a book of photos, not a monthly.'

Though broadly similar in content to printed fashion magazines, *Hint* exploits the Web to provide an experience that print cannot. 'The moving image is very important in *Hint*'s photo shoots,' says Carter. 'I always include Flash motion of some kind. Then I add snippets of music, usually a preview of an upcoming CD, to make it fully robust experience, more so than print magazines can provide. One of the more successful of these was the first shoot we ran since 9/11. Called

"Hidden Places", it was a very personal and sombre series of photos to which Björk added bits of music from her Vespertine CD, which had not yet hit stores.'

Where the Web would appear to be at a disadvantage for a fashion publication is in its reproduction of photography, but Carter insists that this is not a major problem on *Hint*: 'Occasionally, I meet a photographer or stylist who hasn't yet opened up to the internet, but once they take a look at the motion effects and funky music of *Hint*'s photos shoots, they're eager to try it out. Since *Hint* has a higher circulation than most print fashion magazines, they usually score big gigs immediately after their work goes live. *Hint* has become a sort of launchpad for new talent. Plus, since *Hint* won last year's Webby Award for Best Fashion Website, the word really got out that *Hint* is as viable a place as print magazines to appear in.

'Obviously, websites can't offer the tactile experience that glossies can, but glossies can't compete with the enhancing effects of light from a computer screen,' Carter continues. 'I found that colour and shape have more impact in Web shoots, simply because of the bright glow of a monitor.'

The Web offers great creative possibilities, but designers do face increasing restrictions, thanks in part to the rise of usability theory. Usability experts assess sites according to the ease with which users may carry out a variety of tasks. Though well-intentioned, the result of putting their findings into practice is often to make all sites look the same, with contents listed down the left-hand side, all links underlined in blue and so on. To some extent, of course, all print magazines follow familiar conventions in order to aid readers, but, online, this homogeneity reaches new levels, due, in the main, to it being such a new medium.

Bob Watts, art director of US news site *Salon* (www.salon.com), says that, for him, 'Usability drives

'Websites can't offer the tactile experience that glossies can, but glossies can't compete with the enhancing effects of light from a screen.'

just about all design decisions. The primary nod is to readability – typeface, size and variety were all decided with the reader in mind.' But the site is still visually interesting. 'We want the reader to have complete ease of use and a pleasant experience. So far, the readers have indicated that illustration and various design elements are part of that complete experience.'

Salon is one of the few sites to have successfully switched to charging subscribers, and herein lies the big problem for magazines on the Web. In many ways, reading or 'using' a magazine online can be a far richer experience than anything offered by print, but examples of financially viable magazines online are few and far between. Of the other titles discussed here, which are some of the most highly thought of on the Web in terms of design, *ShowStudio* relies largely on Nick Knight's own finances to keep it going while, despite winning Best Magazine Website at the UK's 2001 Magazine Design Awards, while *SleazeNation* made Smith and Caldwell redundant, shortly after conducting the interview for this piece. At the time of writing, the future of the site is uncertain.

It would be harsh to blame designers for this situation. Publishing houses have so far found no mechanism for bringing in revenue from websites to match the print models of page advertising, newsstand sales and subscriptions. No matter how beautiful their design, websites were seen by many publishers as a luxury add-on to the core product and, as such, they were the first to go when times got hard. Web-only magazines arguably face even greater pressures, having no print parent to subsidize and promote them (although, at least, the independent ones don't have to fulfil the voracious appetite for profit of a major publisher).

Despite the current gloom surrounding the Web, the opportunities that so excited publishers initially do still exist. The potential of this digital, networked world has only begun to be explored. At the start, it was assumed that the website would be the chief vehicle for distributing information on these networks, but, in the future, what we now think of as 'online' publishing may take many different forms. Already, email is used as an alternative to news-based sites and SMS, mobile phones and devices and interactive television offer more alternatives. And with better technology, the Web will improve in quality and speed.

The challenge for designers is to take these opportunities and use them to create products that are as useful and compelling to readers as those of their print antecedents.

Patrick Burgoyne *is editor of Creative Review and author of Browser: the Internet Design Project, Reload and Used*

Lead me...

HOW NEWSPAPERS LEARN FROM MAGAZINES: BY MARK PORTER

For most of their history, newspapers have remained largely untouched by what would nowadays be recognizable as 'design'. Typefaces were traditionally chosen to fit as many words as possible on a page, while maintaining a minimum legibility. When photography was introduced pictures were scaled, as much to ensure that faces remained recognizable through a coarse half-tone screen as to create drama and impact.

Design was part of the journalist's job, and if any attention was paid to the overall aesthetic, it would often take the form of a gentlemanly request to a respected typographer to cast an eye over the pages.

But the last quarter of the 20th century saw a revolution. Increasing demand from advertisers for colour sites forced newspapers to improve their printing. Most went from letterpress machines in the basement, using a technology which had changed little in hundreds of years, to sophisticated offset plants, which approach the depth of colour and crispness of magazine printing.

A similar transformation occurred in page production, from hot metal and photocomposition to desktop typesetting and make-up. Many PC-based newspaper systems are principally designed for efficient database and object management, and seem absurdly restricting to QuarkXpress-trained magazine designers. But when formatted pages produced on such systems are combined with Macintosh elements – from small panels and graphics to whole pages – almost anything is possible.

Technological progress reflects a more demanding commercial environment. Newspapers, as news providers, now face powerful competition from an expanding television sector and from the internet. Consumers who have lived through a design explosion have high expectations, and newspaper owners now seek a design that helps them achieve a clear positioning in the marketplace. More advertising demands editorial that reflects the products being advertised (cars, fashion, travel and food). Fierce competition has forced papers to add new sections, in an attempt to improve their offering to both readers and advertisers.

Newspapers now have more pages, with higher production values, and face stronger competition than ever before. How has design responded?

'Ten years ago, intellectuals would settle for text,' says consultant Mario Garcia, whose firm is involved in around 15 newspaper redesigns every year. 'Right now, even the most intellectual elite like some eye popcorn. That's a real shift for graphic designers.'

Newspapers have indeed had to learn some lessons from magazines, television and the internet. The 1982 launch of *USA Today* was dramatic evidence of the impact of other media on the newspaper world. Its design was heavily influenced by magazines such as *Time* and *Newsweek* (US), and most of all by television (an early advertising slogan described it as a paper 'for readers who grew up as viewers'). Colourful graphics and photography were an integral part

of the news presentation, along with a telegraphic approach to writing, which anticipated some of the forms of news delivery on the Web. The result was a seductive formula which has made *USA Today* America's biggest-selling newspaper, and which is likely to be adopted by more and more papers chasing younger readers and the ever-growing commuter market. Even the 115-year-old *San Francisco Chronicle* recently crossed the great divide by relaunching as a tabloid, with a poppy, colourful design that reflects a breathless, net-influenced approach to reporting.

Serious papers shun such 'dumbing-down', but still reveal the influence of other media. The growth of infographics, used along with sidebars and feature-length stories, in complex 'packages', has its roots in the weekly news magazines (as well as the Sunday papers of the 1970s). Magazine coverlines – punchy, alluring, but often flippant tasters of the content – are reborn in newspaper teaser panels, a sure sign of increased competition. But the influence of magazines on modern news design is probably clearest in the use of images. Many editors are now happy to respond to a major news event with a dramatic use of photographs. On September 12, 2001, many of the British papers were swathed in wrap-around photographic posters. Tabloids and broadsheets all over the world cleared their front pages for massive images, and even

Germany's ultra-conservative *Frankfurter Allgemeine* published photographs on the front page – reportedly for the first time.

But despite greater use of colour and an awareness that design can no longer be ignored, news and comment sections (which editors – and many readers – consider the heart and soul of a newspaper) tend to retain traditional values. The involvement of the art director in these areas is limited by pressures of time and space, and often by a suspicion that strong design will compromise the character of the paper. Designers clearly have a role to play in establishing an overall style and in training, but their involvement usually takes the form of giving the journalists a toolbox to produce the paper — in most cases, pages will be laid out by sub-editors rather than graphic designers. Whatever their expertise, the art director's voice will be just one amongst many in the newsroom; editors, news editors, picture editors and section editors all have strong opinions, and decisions on presentation have traditionally been their responsibility. Typographic skills can be learnt relatively easily, but news values and newsroom culture can only be grasped with experience, which is perhaps why many of the most successful newspaper designers trained as journalists. And as editions are changed during the night, the art director may not even be in the building to offer an opinion.

Die Woche
(*Germany, 12 March 1999*)
320 x 475mm/12 ⁵⁄₈ x 18 ³⁄₄ inches
This newspaper combines classic newspaper devices – the line drawing of Pegusus within the masthead – with modern editorial use of type and colour.
Design *Lo Breier*

But modern newspapers are not just about news. As recently as 1986, *The Guardian* (UK) published one 16-page broadsheet daily. It now publishes – in an average week – a daily news broadsheet, two daily tabloid features sections, a glossy magazine, five Saturday tabloids and a listings magazine, as well as frequent one-offs and specials. The proliferation of sections (most in the area of 'features' – arts, entertainment, lifestyle, celebrities, travel and personal finance) has created new design opportunities.

The first newspaper magazines appeared in America in the late 19th century, and the *Boston Globe*, *Chicago Tribune*, *Philadelphia Inquirer* and Canada's *National Post* continue the tradition with thoughtfully designed supplements on Sundays. The UK's *The Sunday Times Magazine* was launched in 1962. By the late 1960s and early 1970s, under art director Michael

Rand and art editor Dave King, it was taking advantage of its lavish budgets to break new ground in journalistically driven design. Although often best remembered for its photojournalism, such as Don McCullin's powerful dispatches from Biafra, Vietnam and Cambodia, the magazine developed a new graphic language which King called 'creating visual features'.

Possibly the most original and beautiful use of the format was Germany's *Frankfurter Allgemeine Magazin*. It thrived in the 1980s under Willy Fleckhaus, who had made his name at *Twen* in the 1960s and was returning to magazines after ten years of teaching and book design. Fleckhaus's solution to the problem of reflecting the intellectual weight of the newspaper in a colour magazine was to create sequences of lavish spreads with rigorous type, dramatically scaled photography and daring illustration, followed by unadorned pages of solid text. The beautifully composed covers had an unvarying black background. After Fleckhaus's death in 1983, he was succeeded by his pupil Hans-Georg Pospischil, who continued until the magazine was closed.

The colour supplement was reinvented again in Britain in September 1992 when *The Guardian* turned its *Weekend* section into a tabloid magazine. The design was by David Hillman at Pentagram, who had redesigned the newspaper four years earlier. Printed heat-set

Tentaciones
(Spain, 18 January 2002)
295 x 405mm / 11 3/4 x 16 inches
Design Fernando Gutierrez

D
(Italy, December 1998)
210 x 276mm / 8 1/4 x 10 7/8 inches
Art director Joel Berg

These are two examples of newspaper
magazines that have been designed by
magazine designers.

offset on enhanced newsprint, *Weekend* was a low-cost option for *The Guardian* (it was designed by sub-editors, used staff photographers and had low paper costs). The production economies were not lost on *The Guardian*'s rivals, and, for a few years in the early 1990s, the style was enthusiastically embraced by many other British newspapers. Thereafter, it was slowly abandoned in favour of more conventional magazine formats (*Weekend*, like many of its rivals, is now printed gravure on glossy paper), though it still survives in other markets.

Most magazines have a well-defined audience and can focus content accordingly. Newspaper readerships tend to be much broader, but in theory, the lack of sales pressure on the newsstand gives colour supplements greater opportunities to experiment. However, many editors still insist on imitating paid-for magazines, and the majority of newspaper magazines resemble newsstand titles in design and editorial. Supplements have occasionally been a medium for serious, groundbreaking content, for example, Tibor Kalman and Jenny Holzer's chilling collaboration for the *Süddeutsche Zeitung Magazin* in 1993, in which Holzer's texts about rape were written on women's bodies in ball-point pen, and the cover had a tip-on card printed with ink containing real blood. But the tendency is towards a formula of celebrity interviews, leavened by

culture and (more rarely) serious reportage in the front half, and fashion, lifestyle, interiors, food and health at the back. Design is often no more adventurous than that of more commercially driven, paid-for titles, but the most accomplished are certainly amongst the best-designed titles in the magazine world. Regular award-winners include the ever-impressive *Süddeutsche Zeitung Magazin*, *Guardian Weekend*, *D* (the lavish monthly fashion magazine from *La Repubblica*), *El Mundo*'s *Metropoli* and the venerable *New York Times Magazine*, currently stronger than ever under art director Janet Froelich. Even business newspapers can now produce powerful magazines, like the *FT*'s *The Business* (UK) (launch design by the prolific Vince Frost, who also gained acclaim for *The Independent Magazine* in the UK) and *Estampa* from Brazil's *Valor* (designed by Simon Esterson).

But magazines are expensive to produce and are usually only

published at the weekend. Modern papers can have a range of other sections that lie somewhere between traditional newspapers and magazines in design and content. Indeed, many papers, particularly in Germany and Switzerland, have now abandoned their magazines for more newsprint sections. The multi-section paper was pioneered by *The New York Times*, which introduced the Weekend, Science Times, Sports Monday, Home and Living sections under design director and managing editor Lou Silverstein in the late 1970s. They used large illustrations and photographs to create magazine-influenced pages, which lent the sections an identity very different from the sobriety of *The Times*, and which enriched the vocabulary of newspaper design.

A design approach that would not be tolerated at the heart of many papers is now considered acceptable – and even desirable – in features sections, which are often intended to attract readers who may

not be interested in hard news. (For most newspaper publishers this means young people and women.) The result is that some of these sections – like many weekend magazines – have a design which is totally unrelated to the parent paper, and the art directors who produce them (many from the magazine world) may never have met the editor, or attended a news conference. They have proved fruitful environments for experimentation. *Tentaciones*, the entertainment section of Spanish *El País*, designed by Fernando Gutierrez, set new standards of sophistication for tabloid supplements. In Sweden, *Dagens Nyheter*'s two tabloids, *På Stan* and *LördagSöndag*, put many magazines to shame. In Britain, *The Guardian*'s daily features tabloid, *G2* (another Hillman design, redesigned several times since), has been imitated by its rivals (*The Times*'s *T2*, *The Scotsman*'s *S2* and *The Independent Review*).

Europe also has weekly newspapers that avoid hard news and concentrate on features and analysis, and whose relaxed deadlines allow a strong influence from magazine design. The late, lamented *Die Woche*, which closed in 2002, had full colour on every editorial page and combined elegant newspaper typography with powerful infographics and a thoughtful, witty use of photography. *Dimanche.ch*, the Web-influenced Lausanne Sunday designed by Barcelona's Antoni

Cases Asociats, takes this language to a new level, using colour, type, images and complex panels and page furniture to create an intensity on the page that only the most hyperactive consumer magazines can match. Germany's *Die Zeit* is at the other extreme, sober and correct, but still clearly influenced by magazine culture.

Magazine designers tend to value execution over establishing a format. Art directors from Brodovitch to Baron have become famous by producing great sequences of pages, but the world's most celebrated newspaper designers do not make their reputations by doing layouts. Designing a modern newspaper goes far beyond typography – it requires a deep knowledge of journalism, an understanding of the architecture of a multi-section publication, and an awareness of branding and market positioning. The expertise to accomplish these tasks, and to communicate with editors and publishers and gain their confidence, is the preserve of very few. Hence the rise of the elite international newspaper designer. Consultants such as Mario Garcia, Roger Black, Antoni Cases and Ally Palmer travel the world to advise newspapers in every territory.

As in so many other areas, globalization can lead to a degree of cultural homogenization. The basic forms and techniques of the modern newspaper – teaser panels, indexes, bold section fronts and fonts from a handful of star type-

'The most accomplished newspaper supplements are certainly amongst the best-designed magazines in the world.'

designers (often chosen because of their range of weights rather than any intrinsic relationship to the character of the paper) – are increasingly formulaic.

But, for the moment, many cultural differences do persist. Formats vary from country to country. Tabloid design travels best and seems to be a more universal language, but in middle-market and serious papers there is still a wide range of approaches. The hispanic world (South America, in particular, is a vast and thriving newspaper market) tends towards textured pages heavy with boxes and panels and baroque rulework, with vibrant colour palettes. Many serious papers in the German-speaking countries, like the *Frankfurter Allgemeine* or *Neue Zürcher Zeitung*, shun modish styles

and remain confidently austere and soberly black and white. European papers tend to maintain a fairly consistent pace throughout, while North and South America often prefer dramatic, set-piece sections fronts, which can seem absurdly over-designed to European eyes. Even the work of the super-consultants reflects this. Roger Black's rich mix of internet-age sophistication and American vernacular is wildly exuberant in Mexico City's *Reforma*, but stripped-down and relatively cool in Zürich's *Tages Anzeiger*. 'Shed your assumptions,' says Black. 'If you don't start at zero and learn a culture, the design will never work.'

This is a key moment for design in the contemporary newspaper. Many have only recently acquired substantial art departments and ex-magazine art directors. On a magazine, everybody knows what an art director is, and most have an idea of what they should be doing.

dimanche.ch
(Switzerland, 17 March 1999)
320 x 475mm/12 ¾ x 18 ¾ inches
This newspaper is heavily influenced by both magazines and the Web.
Design *Antoni Cases*

But, on a newspaper, things are not so clear, and designers coming from magazines must adapt. They can expect a lot of involvement – and a great deal of freedom – in magazines and features sections; they will be kept busy with special projects and redesigns; but they may not have much influence over tomorrow's front page. *The Guardian*'s September 12, 2001 Issue (see page 157), which won a silver medal in New York's SPD awards, the first ever for a newspaper news section, probably owed more to the efforts of the journalists than it did to the art director. But the form of the paper that produced that edition owes as much to the graphic designers who shaped it over the past 15 years.

Design (and designers) have gained a foothold in the newspaper world in magazines and peripheral sections. But they will inevitably become indispensable in every part of the paper. Most print newspapers already have a symbiotic relationship with their online counterparts, and websites as well as magazines will continue to influence newspaper presentation. A new generation of editors, the rise of marketing departments, and inevitable price increases will all lead to a desire for more intensively designed newspapers. We must ensure that they are not just more designed, but better designed.

Mark Porter *is creative director of The Guardian newspaper*

The magazines

Bulgaria *(Finland, Issue 2, Summer 2002) 225 x 277mm/8 1/8 x 10 7/8 inches*
Launched to give young Finnish visual and literary talents space to demonstrate their skills in a non-commerical environment, this magazine has a deliberately obtuse name to confound expectation. This issue comes in a cloth bag (OPPOSITE) featuring a motif – co-designed by Finnish fashion designer Paola Suhonen – that symbolizes the forests which surround and protect Finland and its people. The cover (THIS PAGE) continues this idea, having the appearance of wood.
Art director Tom Bulgaria

SPECTOR CUT+PASTE ISSUE 2
JUNE 2002 YEAR 2
EURO 7,00 £ 5,00 $ 8,00
SFR 11,00

12

4 395463 407005

Spector Cut+Paste *(Germany, Issue 2, Summer 2002)*
235 x 297mm/9 ¼ x 11 ¾ inches
This magazine examines the links between different cultural disciplines. This issue was concerned with fiction and documentation and was produced in a laptop format to reflect this; the editors felt the prevalence of the computer today blurs the line between reality and virtuality. The card cover (OPPOSITE) is blank but for a repetitive pattern mimicking the metal exterior of a laptop; open it and there's the screen and keyboard (THIS PAGE): open the next leaf and there's a cut-out mouse.
Designer Marcus Dressen

Spektacle (*UK, Issue 1, 2001*) *240 x 300mm/9 ½ x 11 ⅞ inches*
Magazines on CD-Rom are normally stuck on a magazine-sized piece of card to increase their size and prominence to potential readers. This example, a music and design title, uses a piece of an old Johnny Mathis vinyl LP to increase its visible size in a striking and relevant way.
Design *Unknown*

sexymachinery (*UK, Issue 1, July 2000*) *235 x 315mm/9 ¼ x 12 ½ inches*
This architecture magazine consists of invited submissions from its readers, and changes format each issue. This launch issue came as a folder made from embossed wallpaper. Inside were a series of loose-leaf elements, a metal binder and instructions on how to bind them into a whole: 'although we suggest an order of construction, and therefore of consuming, the reader has the responsibility of his/her own likes/dislikes. One option is to throw all the contents away and use the binder for filing your receipts'.
Designers Kajsa Stahre and Patrick Lacey

I LOOK AT YOU, YOU LOOK LIKE ME

Issue SM05, an architectural production
Summer 2002
£8.75 / €13,99

sexymachinery

there are ideas in feelings

Portrait… problem of recognition,
therefore fundamental problem of
meaning, always-already. however,
fatal difficulty of the motif of 'inner life'…
window to the psyche of psychologists
(of which the most beautiful example is
the madman of Gericault) rather than to
the psyche of the theologians or ancient
philosophers, which moves in precisely
the opposite direction… hence portrait
as the thematics of remoteness, city as
'portrait' (embodiment) of collective life,
the 'incarnation' of the anonymous claim
of 'city' - solidarity (without salvation)…

Peter Carl

sexymachinery *(UK, Issue 5, Summer 2002) 165 x 240mm/6 ½ x 9 ½ inches*
This issue separates words and images to reflect the difference between the two elements. All words – the titles, texts and captions – are in a small black–and–white booklet (THIS PAGE). The front and back cover each have a large colour poster attached that folds out to reveal all the images from the issue (OPPOSITE). The two parts are linked by a system of letter–coding on the contents page. *Designers Shumon Basar, Dominik Kremerskothen, Dagmar Radmacher and Abake*

Typographic (*UK, Issue 58, 2002*) *210 x 297mm/8¹⁄₄ x 11¾ inches*
The Journal of the International Society of Typographic Designers is designed by a guest designer each issue. This issue, subtitled 'Too Much Noise Not Enough Time', consisted of an A4 magazine wrapped in an A1 sheet of grey paper. All the text of the issue was printed on the inside of the wrapper (THIS PAGE), the magazine itself being a series of flat-colour pages (OPPOSITE). In a typically iconoclastic statement, the designers defined the magazine as 'conveying everything we felt needs to be said about typography'.
Designers The Designers Republic

Re-Magazine #23
Spring 2007

Re-Magazine
Established 1997

NL / B / D - € 9,00
F - € 9,50
UK - £5.95

IT'S SPRING
TWO THOUSAND SEVEN

(2007)

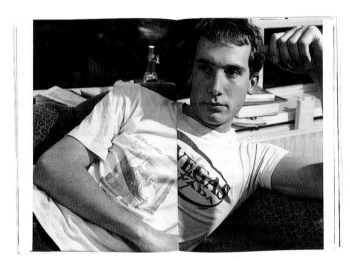

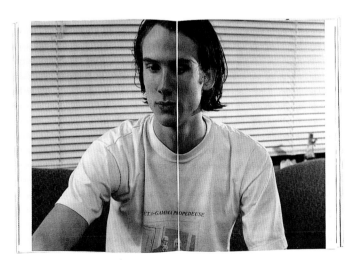

Re– *(The Netherlands, Issue 23, Spring 2007)*
220 x 300mm/8 ³⁄₄ x 11 ⁷⁄₈ inches
Published in 2002, but with every date reference including copyright details stating 2007, this issue deals with time, looking back at the present from the future. It is made up of a set of 440 x 300mm (17 ¹⁄₄ x 11 ⁷⁄₈ inches) sheets folded once and bound together by a rubber band where the spine would normally be. There are several picture stories that require the reader to remove the rubber band and separate the pages to see the full image at once. The series of portraits of men in t-shirts, 'We', by Anuschka Blommers and Niels Schumm, make best use of this unusual format. The way the individual sheets come together when bound means that pages opposite each other have similar but different images. Only the centre spread has one complete image. The rubber band is visible across this spread.
Designer Jop van Bennekom

Museo–Teo *(Italy, Issue 16, November 1999)*

300 x 210mm/11⅞ x 8¼ inches

Themed as 'On the Edge', this issue of this art fanzine was spiral bound on each edge and perforated in the middle. Readers had to tear open the perforated edge to access the pages. Once opened, the magazine became divided into two halves, which had to be read together.

Design Pigeon

STATEMENTS V

★ ★ ★ ★ ★

Statements *(Germany, Issue 5, Summer 2002) 225 x 277mm/8 7/8 x 10 7/8 inches*
Previous issues of this magazine, published in celebration of 'bathroom culture' by German bathroom equipment manufacturer, Dornbracht, have taken the form of a tabloid newspaper, a glossy spiral–bound volume, a videotape and a gallery exhibition. This issue is a white leather–bound book containing work by artists/designers Veronique Branquinho, Jeremy Scott, Raf Simons and Bernhard Willhelm.
Art director Mike Meiré

M I N E D ... field

Mined *(UK, Issue 1, May 2001) 160 x 240mm/(6 ¼ x 9 ½ inches*
Sponsored by Levi's (its name is 'denim' backwards), this 512-page combination of essays, profiles, photography and illustration is published in an unfinished, bound format. It comes untrimmed, meaning the reader has to tear or cut open the edges of each 32-page section to access the individual pages.
Art director Andreas Laeufer

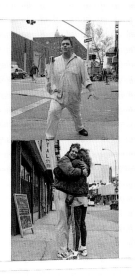

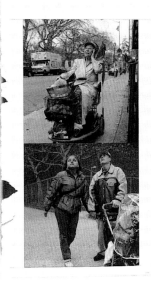

EYE LOVE TELEVISION

Your living room

It's a law unto itself, but now the third coast is finally issuing its emancipation declaration. Southern hip hop is free at last.

Tuesday, October 31, 2000. The music industry is focused on the SoundScan charts for a battle of the heavyweights. It's the North versus the South all over again. In one corner is Brooklyn, NY's Jay-Z, arguably hip hop's top MC. Across the ring is Atlanta, GA's OutKast, arguably hip hop's most artistically consistent and innovative group. Today, both acts are releasing albums. Jay's riding the momentum of his trifecta of blockbuster party anthems, "Big Pimpin'," "Hey Papi", and "I Just Wanna Love Ya", while the Kast are armed with an arsenal that includes the musical-imagination-stretching club thumper "B.O.B.", their abyss-deep credibility, and a secret weapon: a soon to be released ditty called "Ms. Jackson".

A week and one day later, as the results of the SoundScan charts are released, the opening round goes to the side of the Yankees. Jay, also known as Jigga, barely staves off the duo from Atlanta to debut numero uno. The final tally: Jigga's Dynasty: Roc La Familia sells just over 557,000 copies, while OutKast's Stankonia comes in at number two, scanning a little over 525,000. But over seventeen weeks later, it is the Dixie flag waving victoriously across the rap world as Stankonia goes on to sell over three million copies, compared to the Dynasty's two million. Now more than ever, MCs from the South are not only revelling in a surge in sales, but they are becoming major contributors to the hip hop culture.

"I hate it when people say that every coast has its time to shine," says Jermaine Hall, music editor at the hip hop website, Hookt.com. "That's a cop out. I'm not saying that the South's reign is totally scientific, but there is always a method to the madness."

That method has been for acts from down South to always go against the grain. They've never been focused on copying sounds from other regions, they've always been into making music derivative of where they're from. "You got people from the East Coast and West Coast making down South songs," says New Orleans native Lil Wayne, a platinum plus artist on Cash Money Records (CMR). "But do we make East or West Coast songs? No. We make Down South songs." It was Wayne, along with his CMR brethren - which also consists of the Big Tymers, Juvenile, Turk, and B.G. - that burst on the scene in 1998 and changed the game. Juvi's 400 Degreez, powered by smashes like "Back That Thang Up" and "Ha", went on to sell four million units and jump-start the fame of the new kids on the hot block. Meanwhile, B.G.'s family pause out "Bling, Bling" solidified that fame as the phrase - which signifies shining jewellery - crossed over from hood slang to household terminology. Cash Money were instant cons. Certain ways they wear their clothes, like tying handkerchiefs around their wrist or having sweatshirts draped over one shoulder, have been mimicked by other rappers such as Jay-Z and multi-platinum, St. Louis rapper Nelly, who is sparking his own rap renaissance in the Midwest.

"As obvious as it may sound," analyses Hall, "imitation breeds popularity."

No! I don't know what I'm missing!
(see the back of this card to find out more)

YES! I do/*NO!* I don't* realise that *Catalogue* is a new magazine.
YES! I would/*NO!* I wouldn't* like to know more.
YES! I do/*NO!* I don't* agree that art should lose the capital A.
YES! I do/*NO!* I don't* agree that change brings discussion.
YES! I like/*NO!* I hate* the idea of a guest editor for every issue.
YES! I do/*NO!* I don't* think this could introduce fresh perspectives.
YES! I would/*NO!* I wouldn't* like to be considered as a guest editor.
YES! I do/*NO!* I don't* realise that by doing so I have the freedom to
feature one or more artists, whom I feel deserve that much
attention for what they have been doing or saying recently.
YES! I do/*NO!* I don't* realise that 'that much attention' is 48 pages.
YES! I do/*NO!* I don't* realise that artist is a vague term.
YES! I do/*NO!* I don't* realise that I must invite others to comment.
YES! I do/*NO!* I don't* realise that all commentary will be published.
YES! I do/*NO!* I don't* have an opinion.
YES! I do/*NO!* I don't* respect everyone else's.

(*delete do's and don'ts)

PORT
BETAALD
AMSTERDAM

Catalogue

Nieuwezijds Voorburgwal 96
1012 SG Amsterdam
The Netherlands

(ref: Cat.001. Spring 2001)

Lucas Lenglet

Blue Movie in the Bijlmer: 'An adequate expression for communal living'

"Well, it's not perfect, it's too far from the city to be perfect, but you know what it's like with new flats?" "No." "Well, they have their disadvantages, they're too far from the city." "I already said that, and there's the noise problem, and the rent is just a bit too high for what you get. They'll be glad if they get another tenant.'"

This dialogue comes from 'Blue Movie' (1971) a film by Wim Verstappen, produced by Scorpio (Pim de la Parra) and Dieter Geissler. This film starring Hugo Metsers, Kees Brusse, Carry Tefsen and Bill van Dijk, among others, caused quite an uproar, mainly because of the amount of (undisguised) nudity, and attracted more than a million visitors. The story concerns a young man who, after serving five years for a mild sex offence, is given a flat in the Bijlmer by his probation officer. Here he catches up on the backlog that built up while the sexual revolution was going on on the outside. In other words, everyone does it with everyone. The camera sees a lot, if not everything.

I saw this film first in the beginning of the nineties, and since then it has, for me, symbolised both the rise and the fall of the Bijlmer. When you say Bijlmer I see views of meadows, wonderful architecture, carefully decorated interiors, young people, children, and unknown freedom. Despite the film being plagued by failing dialogue, later, by intention, your first impression is one of ideal living.

The plan for the Bijlmer, which began to take shape in the fifties, and which finds it roots in the post-war renewal, is ambitious and idealistic. It's spoken of as the City of Tomorrow. The aim is a city modelling a model-city. The design process of the Bijlmer revolves around a single word, posterity. This future-value had to be realised on all levels. The apartments had to be bigger and wider, well

equipped and reasonably priced. The immediate surroundings were to be low-traffic with a high concentration of collective facilities and plenty of green and space. Finally the future value was also projected in the transport system. For this purpose an ingenious system of separate traffic-streaming on different levels and for different transport media was designed. The building of the metro as the most important connection between the city and the new area played an important part in this.

The spacial construction of the city was to lead to the creation of an urban community with specific socio-cultural characteristics. The principle of urban living is always and everywhere to be recognised in the spacial structure, the design of both block and area ought to be an "adequate expression of collective living".

The typical honeycomb design of the Bijlmer was generated by exactly these principles. By its placement between the metro and the motorway it is optimally accessible. You ride into 'your' parking area, after having done your shopping or used the other facilities that lie within a radius of 500 metres, you walk through the corridor to your flat. Once home you look out of the window onto a huge green park. You have an optimum amount of sunlight in your apartment, which is situated within the whole structure to give you the maximum amount of privacy. Your children play safely in the park below, in front of the shop that your neighbour has started with some friends to provide the needs of the neighbourhood. "Life in the city was never as good as this" you think, as you lean over the balcony in the evening and hear a nightingale sing.

Michael (Hugo Metsers), the protagonist of the film arrives in the Bijlmer despite his probation officer's misgivings, because it is difficult to find anywhere else in the city. Michael actually has no problem with his new surroundings. You see him going cheerfully down the walkway with his shopping, or knocking at the neighbour's door for a cup of sugar. He has decorated his flat with the aid of friends in the building, he looks after the neighbour's little girl, and gives parties. In the time left over he screws almost every female in the block, which visibly raises the quality of life. *(On 30 June 1970 38.8% of the residents were single, to the extreme dissatisfaction of the probation officer, who would preferred an area with families, children and old people according to the governments stipulations.)*

Issue 2, Spring 2001

was not the intention. Ideology has been replaced in this consensus-state by a very general moralism that, in principle, is valid for all, and that serves as an opposition to the expert-culture. We understand nothing of what experts do, but we all make a moral judgement on it, which restricts what they do. The most important paragraph in the article is this one:

"This all culminates in our extreme, and not in itself undemocratic, need for consensus. Because, in the first place, the opinion of experts, ideally at least, does not invite disagreement. When we want the consensus so badly, our perverse handling of facts and norms will promote its realisation. The result is a socio-political reality in which consensus is both means and end, and harmony is the highest law."

In the eighties the society-splitting character of architecture was alleviated, by buildings that were no longer to be seen as products of a particular lobby or ideology, such as a bank, a landlord, or a socialist housing association, but as an expression of a common and deeply-rooted competency. Moralism and expertise in architecture are thus woven together. Because of this the 'perspectivity' in regard to architecture has disappeared; architecture has been absorbed lock, stock and barrel by the good intentions of the government.

In 1991 the Dutch Architectural institute organised the exhibition 'Modernism without Dogma' to foreground the new generation of urban-renewal architects. These were, unlike the first generation in the seventies, not simply politically intent on the preservation and improvement of the small-scale worker's neighbourhood. Rather, they were interested in architecture as a cultural activity. The young architects made wide-spread use of the modernist style, without its political forthrightness.

due to impossible efforts at pruning this article, it will be continued under the photos by Misha de Ridder

In the mean time this architecture was still a part of urban renewal: an enormous socio-economic operation in the old quarters which transformed them from a small-scale market phenomenon to a government service. Thus it was a fundamentally political event. During the first wave of urban renewal in the seventies, the architects were explicit about the political agenda with which they were working; during the second wave, the national art historians of the Dutch Institute of Architecture surrounded the content of this architecture with a smoke screen. Modernism without dogma was not only the start of the Holland Promotion of cheerful, young, creative, modern Dutch architects, it was also the start of the embargo on openness.

The sudden metamorphosis of urban renewal from a political to a cultural activity had a lot to do with the fact that what had at first been a perfect social-democratic project was slowly confronted with a number of painful dilemmas. The most important of these was that whenever a deprived area needs to be improved, a greater support of services has to be created, and the purchasing power of the neighbourhood has to rise. The addition to a neighbourhood of attractive, new housing inevitably means the displacement of part of the poorer population by the less poor. People talk about a varied structure; but an unavoidable consequence of the improvement of an area is that the poor are driven from their own poverty-ghettoes. This can be found at the foundations of every urban-construction engineering and architectural project in the existing city. By presenting urban renewal as a cultural project, openness about its consequences could be avoided. Ankersmit says: "Today's architecture andcity-building plays a crucial role in the spread of disinformation. Information distributors are well payed for this. Our culture is not improved by it."

Issue 2, Spring 2001

was not the intention. Ideology has been replaced in this consensus-state by a very general moralism that, in principle, is valid for all, and that serves as an opposition to the expert-culture. We understand nothing of what experts do, but we all make a moral judgement on it, which restricts what they do. The most important paragraph in the article is this one:

"This all culminates in our extreme, and not in itself undemocratic, need for consensus. Because, in the first place, the opinion of experts, ideally at least, does not invite disagreement. When we want the consensus so badly, our perverse handling of facts and norms will promote its realisation. The result is a socio-political reality in which consensus is both means and end, and harmony is the highest law."

In the eighties the society-splitting character of architecture was alleviated, by buildings that were no longer to be seen as products of a particular lobby or ideology, such as a bank, a landlord, or a socialist housing association, but as an expression of a common and deeply-rooted competency. Moralism and expertise in architecture are thus woven together. Because of this the 'perspectivity' in regard to architecture has disappeared; architecture has been absorbed lock, stock and barrel by the good intentions of the government.

In 1991 the Dutch Architectural institute organised the exhibition 'Modernism without Dogma' to foreground the new generation of urban-renewal architects. These were, unlike the first generation in the seventies, not simply politically intent on the preservation and improvement of the small-scale worker's neighbourhood. Rather, they were interested in architecture as a cultural activity. The young architects made wide-spread use of the modernist style, without its political forthrightness.

due to impossible efforts at pruning this article, it will be continued under the photos by Misha de Ridder

In the mean time this architecture was still a part of urban renewal: an enormous socio-economic operation in the old quarters which transformed them from a small-scale market phenomenon to a government service. Thus it was a fundamentally political event. During the first wave of urban renewal in the seventies, the architects were explicit about the political agenda with which they were working; during the second wave, the national art historians of the Dutch Institute of Architecture surrounded the content of this architecture with a smoke screen. Modernism without dogma was not only the start of the Holland Promotion of cheerful, young, creative, modern Dutch architects, it was also the start of the embargo on openness.

The sudden metamorphosis of urban renewal from a political to a cultural activity had a lot to do with the fact that what had at first been a perfect social-democratic project was slowly confronted with a number of painful dilemmas. The most important of these was that whenever a deprived area needs to be improved, a greater support of services has to be created, and the purchasing power of the neighbourhood has to rise. The addition to a neighbourhood of attractive, new housing inevitably means the displacement of part of the poorer population by the less poor. People talk about a varied structure; but an unavoidable consequence of the improvement of an area is that the poor are driven from their own poverty-ghettoes. This can be found at the foundations of every urban-construction engineering and architectural project in the existing city. By presenting urban renewal as a cultural project, openness about its consequences could be avoided. Ankersmit says: "Today's architecture andcity-building plays a crucial role in the spread of disinformation. Information distributors are well payed for this. Our culture is not improved by it."

A good example of how architecture and city—the social-democracy dilemmas discovered by the ma—this moment in the Bijlmer. The gigantic honeycomb flats, the parks, the motorway and the metro-viaduct all stem from a city-possibility been implemented with demonstrative idealism. It was to be a new city for a kind of city-dweller. You had to be able to see that it was new. The city was not inhabited by those who built it, but by foreigners, mostly from other continents with other cultures, and for those Dutch people prepared to live in gallery flats among the foreigners: minorities. Since the architecture is not used as it was intended to be, new forms and manners of usage arise. The parking-garages for example are used as collective vehicle repair workshops, churches and practice-rooms. The scale of the architecture causes a completely different form of urban usage. In general the majority of residents are pleased with the present structure of the Bijlmer, they profit pragmatically from the exceptional opportunities as regards view, parkland. They pride themselves on the grand scale and 'otherness' of their surroundings. An example: the children are playing outside and one of them calls its mother; suddenly the whole gallery is full of mothers, peering concernedly downwards. In other words they profit from the spacial indeterminity of the Bijlmer. The clear official disapproval of the Bijlmer has caused an absence of the normally intensely present consensus democracy. The lesson we learn from the Bijlmer is one of perspectivity in city-building we learn that there is a major difference between city liv

Issue 2, Spring 2001

Catalogue *(The Netherlands) 148 x 210mm/5 ⁷/8 x 8 ¹/4 inches*
The relatively low print-run of around 1500 copies enables this magazine to add a different extra element every issue. Issue 1 (OPPOSITE) included pull-out posters, while issue 2 (THIS PAGE) had colour pictures stapled in by hand. *Design Goodwill*

Eat *(Japan, Issue 7, November/December 2001)*
225 x 277mm/8 ³/₄ x 10 ⁷/₈ inches
A special 'Packaging' issue of this Anglo-Japanese food
magazine came with a chocolate-style wrapper that slipped
off to reveal a photograph of chocolate on the front cover.
Art director Tin Brown

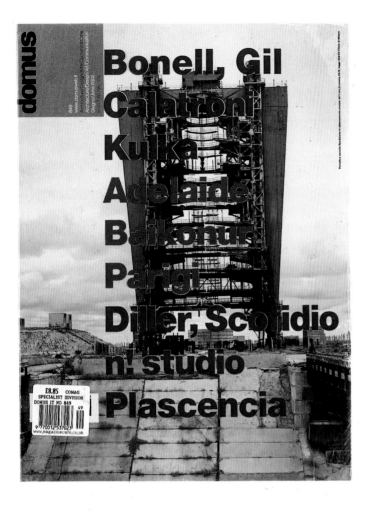

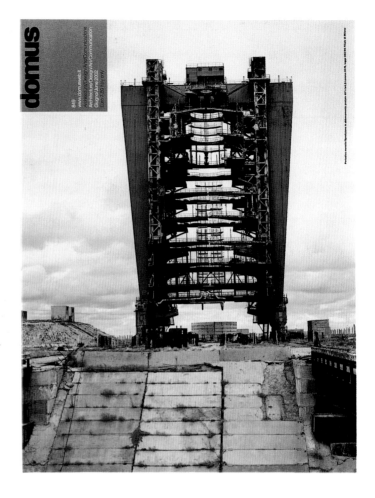

THIS PAGE **Domus** *(Italy, Issue 849, June 2002) 245 x 320mm/9 ³/₄ x 12 ³/₄ inches*
This architecture magazine comes shrinkwrapped in plastic with bold coverlines printed on it: ideal for the sales shelf (LEFT). Remove the plastic and you have a plain pictorial front cover that will look appropriate in the reception area of all architects' practices (RIGHT).
Art director Simon Esterson

OPPOSITE **No. A/B/C...** *(Belgium, Issue A, Summer 2001) 230 x 297mm/9 x 11 ⅛ inches*
Each issue of this fashion magazine is titled a single letter and overseen by a different editor, in this case Dirk Van Saene. The issue has no cover: instead it starts with the contents page and is wrapped in plastic printed with its title, 'A'.
Art direction Paul Boudens and Madelaine Wermenbol

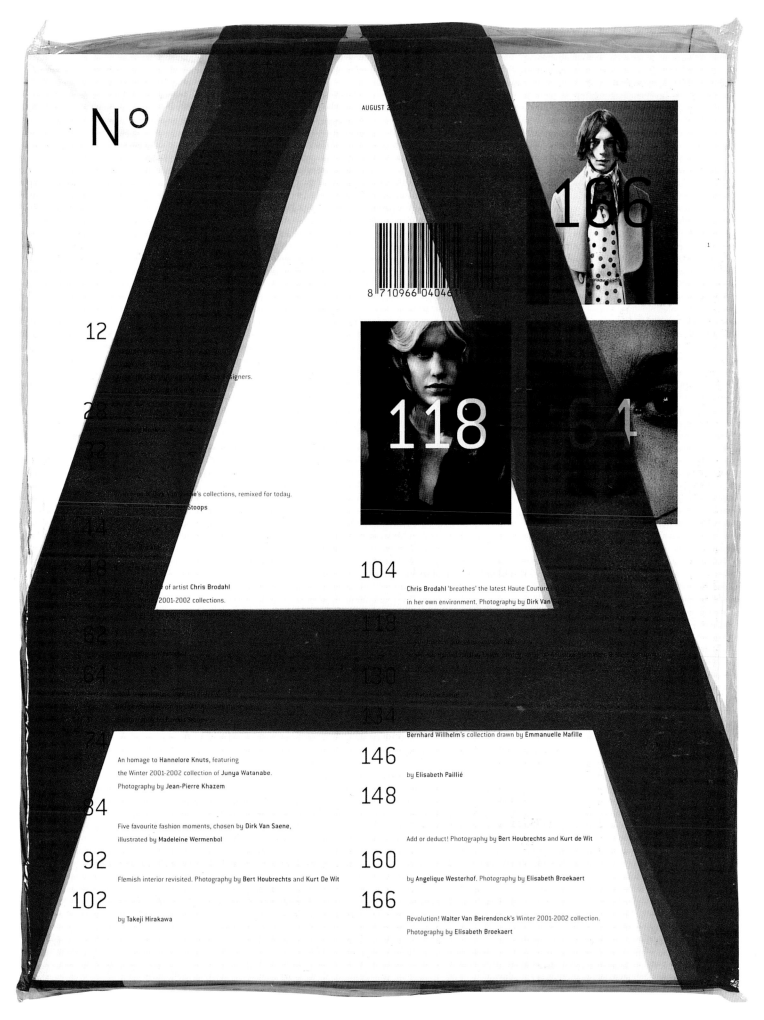

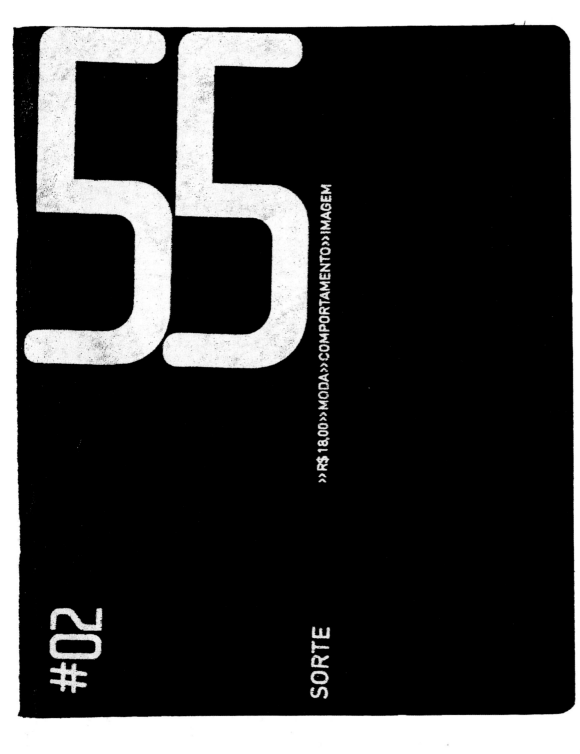

#02

55

>> R$ 18,00 >> MODA >> COMPORTAMENTO >> IMAGEM

SORTE

THIS PAGE **55** *(Brazil, Issue 2, 2002) 254 x 303mm/10 x 12 inches*
This fashion magazine retains its size but changes its cover material every issue. The first issue had a transparent plastic sleeve around it, while this issue is bound in fake suede with the type screenprinted on.
Art director Helio Rosas

OPPOSITE **Nice Magazine** *(UK, Issue 1, Spring 2002) 230 x 300mm/9 x 11 7/8 inches*
The ultimate experiment in magazine format? At first glance it's the same size, thickness and weight as a standard consumer magazine, and has its title printed clearly on the front. But pick it up and it's a solid piece of wood. Is this an artful joke about the state of magazines or a serious comment about the destruction of forests for paper? Either way, it's been a bestseller at all stores selling it.
Designer Unknown

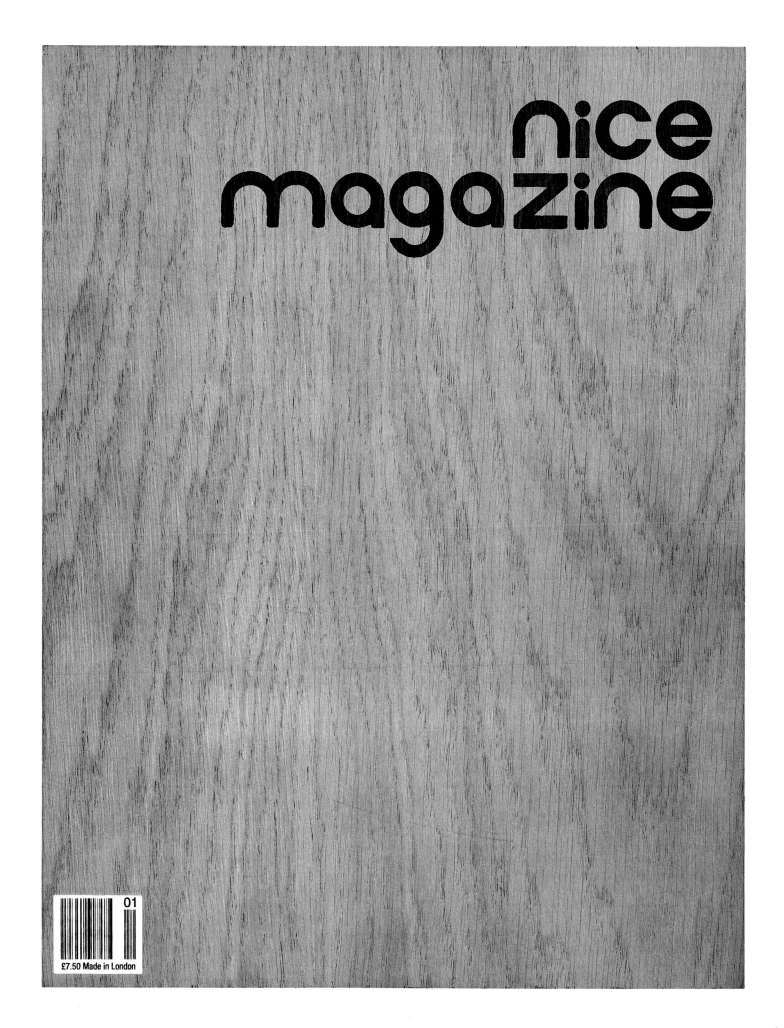

£7.50 Made in London

01

Issue 1, Autumn/Winter 2000

Issue 2, Spring/Summer 2001

Issue 3, Autumn/Winter 2001

Issue 4, Spring/Summer 2002

032c

1ST ISSUE "PROFESSIONALISM", BERLIN WINTER 2000/2001
€ 4 www.032c.com

Issue 1, Winter 2000/01

032c

2ND ISSUE "DESTRUCTION", BERLIN SUMMER 2001
€ 4 www.032c.com

Issue 2, Summer 2001

032c

3RD ISSUE "WHAT'S NEXT?", BERLIN WINTER 2001/2002
€ 4 www.032c.com

Issue 3, Winter 2001/02

JANUARY 2001

WIRED
DESIGN

TOUCH
ME
ALL OVER

Flash Forward!
The Reinvention
of Polaroid

Zip Drive!
Building the
Fast Track
to Mars

Border War!
Why Mexico's
Richest Man is
Gunning Down
US Telcos

COMAG£3. 99
WIRED
JANUARY 01
01
9 771357 097029
www.magazinecafe.co.uk

OPPOSITE **Exit** *(UK) 230 x 315mm/9 x 12 ½ inches*
Commercially, the complete absence on the cover of information about the contents of this fashion magazine may seem perverse but in fact these minimalist covers stand out well against the manic shouting of so many other magazines.
Art director *Mark Juber*

THIS PAGE **032c** *(Germany) 230 x 315mm/9 x 12 ½ inches*
A biannual fanzine produced by art/design/event studio, 032c, it takes its name from the Pantone colour reference for a bright red. The covers always take the form of a large swatch of the Pantone red, only the details at the bottom left change from issue to issue.
Art director *Vladimir Llovet Casademont*

Wired *(USA, Issue 9.01, January 2001) 230 x 273mm/9 x 10 ³/4 inches*
This blank cover changes when touched by the reader. Heat–sensitive ink reacts to the the reader's hand, representing a feature in the issue about design being human– and not technology–led.
Design director *Daniel Carter*

ADBUSTERS

Magazine

220 g $5.75

OPPOSITE **Adbusters** *(Canada, Issue 29, Spring 2000)*
230 x 272mm/9 x 10 ¾ inches
The label 'Magazine' is bolder than the magazine's own name on
this cover, to acknowledge the role of magazines as product.
Art director Chris Dixon

THIS PAGE **10,000 Maniacs** *(Italy, Issue 3)*
210 x 297mm/8 ¼ x 11 ¾ inches
This edition of the graffiti magazine features a textured cover
paper with a die-cut hole through which the title is visible.
Art director Cristian

Dot Dot Dot *(UK, Issue 2, Winter 2000)*
165 x 234mm/6 ½ x 9 ¼ inches
The title on the cover of this design journal is written using
characters constructed from their own postscript code.
Design Jurgen Albrecht, Stuart Bailey, Peter Bilak and Tom Unverzagt

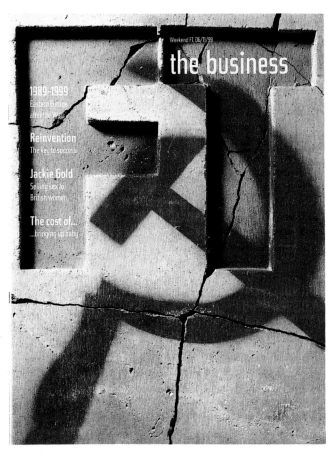

6 November 1999

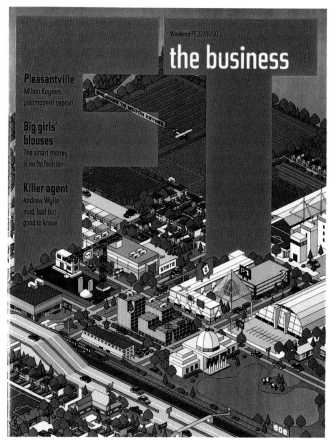

22 January 2000

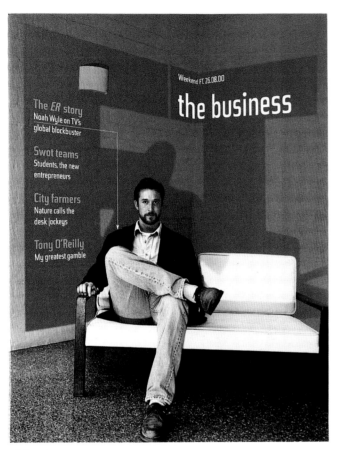

Weekend FT. 26.08.00

the business

The *ER* story
Noah Wyle on TV's
global blockbuster

Swot teams
Students, the new
entrepreneurs

City farmers
Nature calls the
desk jockeys

Tony O'Reilly
My greatest gamble

26 August 2000

Weekend FT. 20.10.01

Meals on wheels
TV chefs and the economics of cooking on the road

20 October 2001

FT: The Business (*UK*)
165 x 234mm/6 1/2 x 9 1/4 inches
In this supplement, the letters of the main
title *FT* were used as a movable graphic
element that worked as part of the image,
the execution of which changed each week.
Art director *Gary Cook*

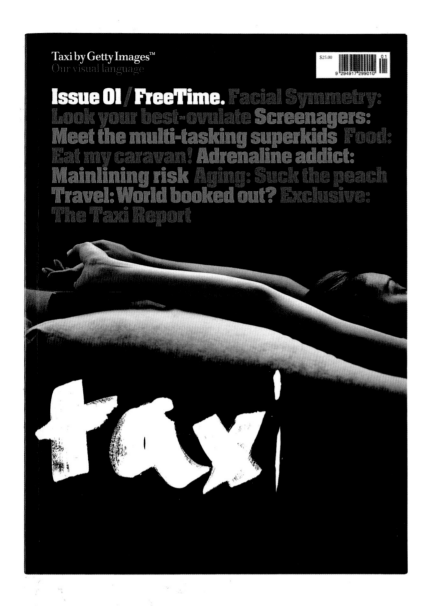

Issue 10

Issue 14

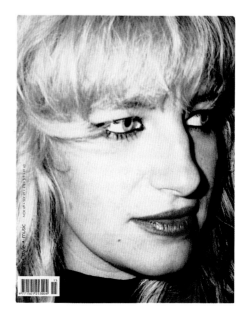

Issue 15

THIS PAGE **Taxi** *(UK, Issue 1, Summer 2002)*
240 x 320mm/9 ¹/₂ x 12 ³/₄ inches
Published internationally by the GettyImages picture library as an editorialized image catalogue, this magazine not only relegates its name to the bottom of the cover, but uses different hand-written versions of the name for different issues. This first issue included an appeal to readers to send in their version of the name in their handwriting.
Design director Chris Ashworth

Hot Rod *(Norway)*
165 x 210mm/6 ¹/₂ x 8 ¹/₄ inches
This microzine is published in Oslo and is the personal project of its publisher/editor/designer. The baroque logo design on the top two examples gives nothing away about the content: the bottom example doesn't even include the logo.
Designer Jan Walaker

OPPOSITE **Coupe** *(Canada)*
245 x 294mm/9 ³/₄ x 11 ³/₄ inches
This uses the magazine format to take a close look at the 'wonders of the modern electronic age'. It does so through busy collages of text and image, following none of the rules of magazine design. Rules are avoided on these covers too: all that links them together is the page size. Issue 5 features the magazine's name in spot varnish only, which is invisible in this reproduction.
Art direction The Bang

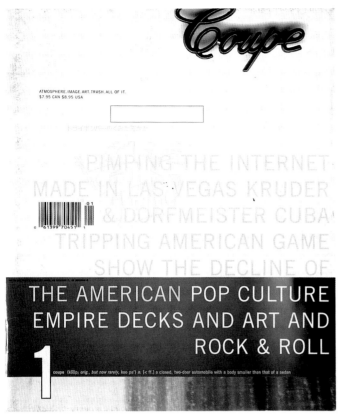

Issue 1, 1999

Issue 3, 2000

Issue 5, 2001

Issue 6, 2001

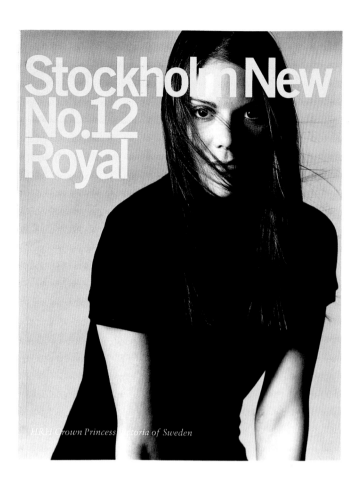

HRH Crown Princess Victoria of Sweden

jeunes créateurs.young blood

M 1447 - 8 - 60,00 F - RD

MOVING
MOVING PICTURES FOR BUSINESS AND PLEASURE

TAKESHI KITANO
And the Beat goes on...

DANCER IN THE DARK
Does Zentropa know what it's doing?

THE 100 MILLION QUESTION
How will Canada cope with
its new cash injection?

STUDIO CITIES
Where's the production running to?

MOVING PICTURES ISSUE 4
DECEMBER 2000 £4/$6/FF40

PICTURES

WHERE TO GET A DECENT MEAL IN HAVANA AN ALTERNATIVE NAPOLEON EUROPE'S OSCARS HOLLYWOOD'S CIGAR SMUGGLERS

THIS PAGE **Stockholm New** (*Sweden, Issue 12, 2002*)
218 x 280mm/8 ¾ x 11 inches
The title, issue number and theme become a single graphic entity.
Art director Joel Berg

Young Blood (*France, Issue 8, June 2001*)
230 x 297mm/9 x 11 ¾ inches
The name takes second place to the issue number, the bitmapped numbers serving as the recognizable logo element of the cover.
Art director Pierre Henri Brunel

Moving Pictures (*UK, Issue 4, December 2000*)
225 x 275mm/8 ⅞ x 10 ¾ inches
Magazines with long names are always awkward for the designer. Here, the problem is solved by using the name to frame the cover image.
Art director Michael Booth

OPPOSITE **BEople** (*Belgium, Issue 2, February/March/April 2002*)
230 x 305mm/9 x 12 inches
Each issue of this magazine about Belgium features a person obliterated by the title in a white circle, rendering the individual irrelevant and emphasizing the generic nature of its name.
Art direction Base Design

BEople

a magazine
about a certain
Belgium

FEB MAR APR 02
Art
Religion
Architecture
Dance
Music
Fashion
Literature

Europe € 9
UK £ 7
US $ 9.95

02

8 710966 035139

02

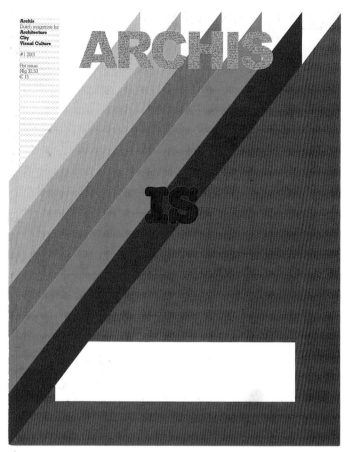

Issue 1, 2001

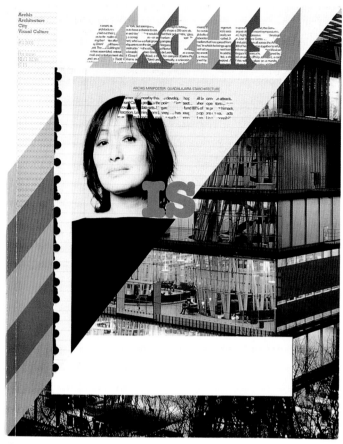

Issue 2, 2001

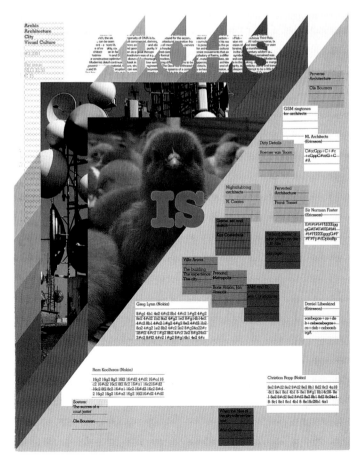

Issue 3, 2001

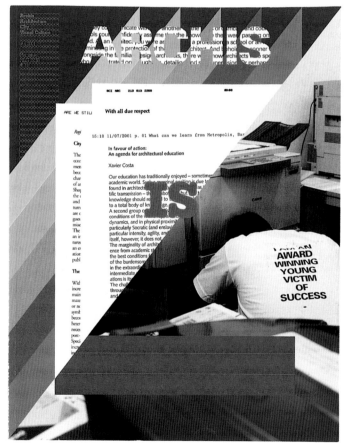

Issue 4, 2001

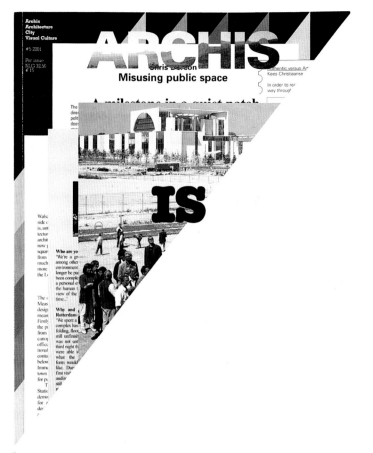

Issue 5, 2001

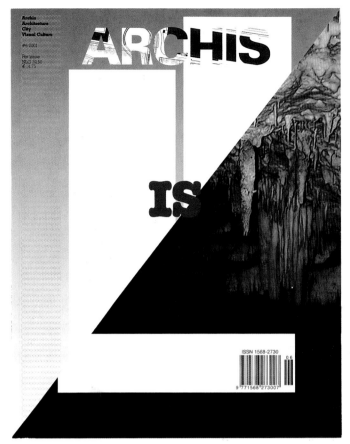

Issue 6, 2001

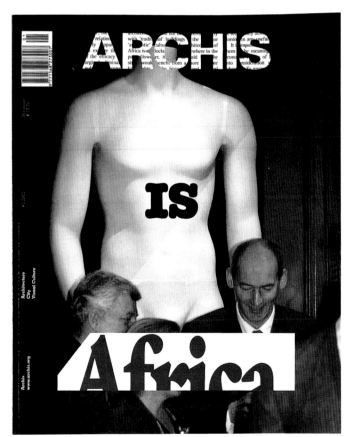

Issue 1, 2002

Archis *(The Netherlands) 230 x 275mm/9 x 10 7/8 inches*
This series of front covers ignores all the rules of cover design,
instead relying on a strong visual identity featuring a multi-layered
mix of samples from each issue's content – both text and image –
and a pattern of stripes created from the colour codings used for
sections inside; mundane colours inspired by office filing systems.
Art direction Maureen Mooren and Daniel van der Velden

AM7

PRINTED IN EUROPE

WWW.AMSIEBEN.COM

07>

2 112000 102001

AKADEMISCHE MITTEILUNGEN SIEBEN

EIN MONOTHEMATISCHES MAGAZIN
ZUM THEMA KOMMUNIKATION
ENTSTANDEN AN DER ADBK STUTTGART

K1/K2/K4

STENCIL [ACAMONCHI]
POSTER [THE SUN YEARS]
STICKER [TRANSIT GRAFIK]

K5 UND K3

TRANSFER [FILE EXCHANGE]
ESB/NYC [FARBEN IN NYC]

GENERAL NOTICE

FOR ADDITIONAL INFORMATION
PLEASE VISIT OUR URL
WWWDOTAMSIEBENDOTCOM

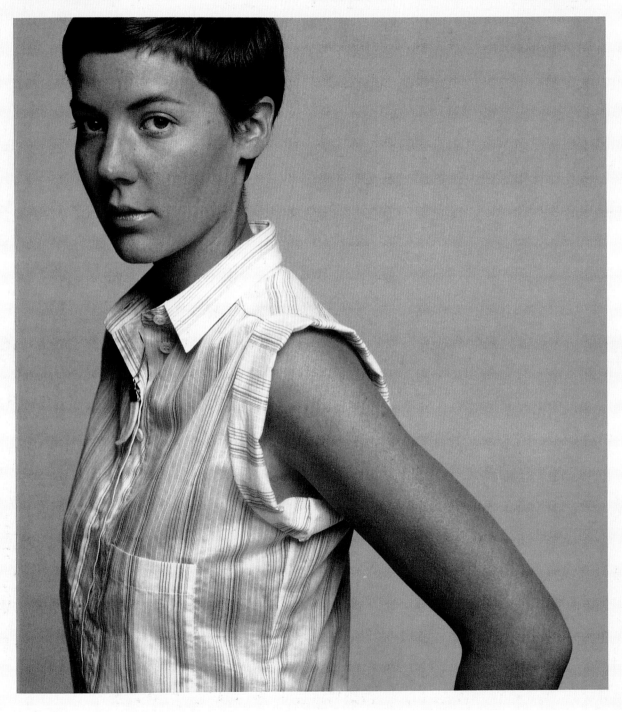

тиω7 ழவଧୌଡ଼ [02] கிச்ச [43] тиω7 ழவଧୌଡ଼ [44] கிச்ச [99] ழಧஙூଜ୕ଜୠଓ ಓ ವೕವଚಳಚ

ந்ணிணிச்ண் тиω7 ໂಗಟௌ ಓ 3527-3539 WWW.AMSIEBEN.COM
 வ்ଧ଼ୌଚ଼ண ண்ண ෝ෪෪ண ಓ ವ಑ವෝಧ 07>
�ண்ணௌச்ଜவಣ୕ଜ୕வଚಓ ෝ෪෪ண஧ିଣ ௌ෪෪ண஧ிଜ
෪ஙண෪ண්ண෪ண்ஙෝவಓ ணூ஧ிணಣ ಳ஧ಣ
ণ೪வச்ண்வ ෝ෪ಓவ வಣುண்சௌ஧஧வ
ಳ೪வಣವ ෝவಳவௌ஧ண் ஧෪ಓ஧ ஞவ஧வ஧ணಣ஧ಣ ಳ஧೪ಣ
வ்வ஧ண வண்ଜవ஧෪ணಣவ.வಳ౺ ஙণಓವಧவ೪೪வ౺™
வ்ணॿ ಓ஧ வ்வ஧ண ෝ஧ண்வ ஧வಓ ෝ஧வಳௌௌவ஧வ஧ண

U21/U22/U24 U25 ಣவ஧ U23 ழவ஧வ஧ண்ண ண்ண்வ

ஞ೪வண்வ൝ [த்வண்வண்ண்ண்] ௌ஧ண்வஞ஧෪வ஧ [෪ண] ෝவ஧ ண்ண்ண෪ண்ண்வ
ಳ೪வ ஞ೪வஞ෪ண஧ [தண] வ஧ணௌ [ෝ஧ண்வண ಓ ணௌ] ෝ஧ண்ண்ண஧෪ண஧வ்ண ௌ೪வ ෪ௌ
ஞ೪வ஧ண஧ண [ௌணಣண෪ண] வ்வ.த்ண்ண්வ஧வண்ண

[Decorative/stylized script, illegible] [Decorative/stylized script, illegible] WWW.AMSIEBEN.COM

ISSN 3527-3539 07>

2 112000 102001

AM7 *(Germany, Issue 1, Summer 2002) 230 x 290mm/9 x 11 ½ inches*
A choice of covers: the front cover (OPPOSITE) and back cover (THIS PAGE) of this magazine
about communication give very different levels of legibility.
Design Daniel Fritz and Maik Stapleberg

www.brandeins.net brand eins 1. Jahrgang Heft 01 Oktober 1999 9 Mark

brand eins

Wirtschaftsmagazin

Die Lust am Neubeginn: Metallgesellschaft, Amiga, Ostdeutschland

Handwerk: Annette Humpe, Musikproduzentin und wie sie aus Unbekannten Stars macht

Vision: Transrapid, Schwebeprojekt und warum wir diese Chance nutzen sollten

Konsequenz: Tom Dixon, Designer und wie er die Einrichtungskette Habitat aufmöbelt

// restart

October 1999

March 2000

April 2000

May 2000

September 2000

February 2001

April 2001

May 2001

July/August 2001

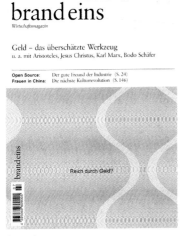

September 2001

Brand Eins *(Germany)* 210 x 280mm/8 1/4 x 11 inches

Despite working to a tightly formatted design, these covers display a variety of solutions to potentially dull business subjects. Typography, photography, illustration and colour are all used to vary the end result. Art director *Mike Meiré*

[100分で日本の深層を読む！]
the info-ninja magazine [才蔵]
http://www.ultracyzo.com/

サイゾー

イームズ大ブームの「インテリア業界」を大解剖

鈴木宗男と愉快な仲間たち

告発！ムネオハウスだけではない
新たなるODA疑惑があった

爆笑問題［日本原論］

april 2002　**4**

ファッション業界
「蔦原、まだまだオイシイぜ」

IT業界
「今度はコレやります」

マンガ業界
「へのつっぱりはいらんですよ」

映画業界
「なんで「アメリ」が！」

中目黒業界
「業界人で大賑わいナリ」

カフェ業界
「古いよ、もう」

あなたの業界は
あと2年もちますか?

おもちゃ業界
「一寸先は闇でチュー」

インテリア業界
「コレいい感じじゃない♥」

出版業界
「ワァオ、西和彦だぁ」

永田町業界
「マキコがいぬ間に……」

流通業界
「悪い噂には慣れました」

金融業界
「こっちがカネ借りたいよ」

料理業界
「栗原はるみになるワ」

芸能界
「ワシが有名にしたる」

[100分で日本の深層を読む!] 「日本復活案」を小泉サンに提言！ ジャニーズ・ホモセクハラ裁判の結果

the info-ninja magazine [才蔵]
http://www.ultracyzo.com/ 定価690円

サイゾー

怒るで！しかし

復活せよ！

元気のないあなたに再生策を提言

[実業!]「ワールドカップで景気がよくなる?
「鈴木宗男」「復活村議に転った!」をかける巨大権力
激震の中東、「予言使者」の兆しで世界大戦の恐怖再び
日本のダメ、薄っぺら「リバイバル計画」を怒る ほか

2002 5

Cyzo *(Japan) 210 x 283mm/8 1/4 x 11 1/4 inches*
Started as an alternative to the Japanese edition of *Wired*, this 'info-ninja' magazine
acts as a controversy-attracting critique of the Japanese economy, and in particular
of its new technology sector. Its covers feature a mix of western and Japanese
influences: the bold red-and-white logo reflects the very direct approach of western
magazine mastheads, while the pictorial catalogue (OPPOSITE) and the cut-out image
on a graphic background (THIS PAGE) are typically Japanese in their approach.
Art director Kobahen

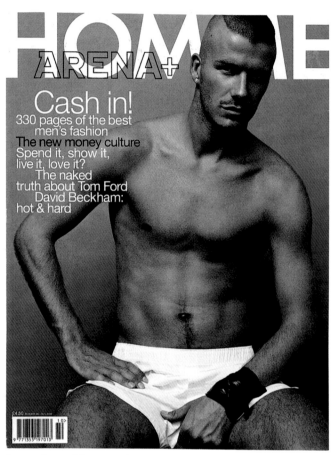

HOMME
ARENA+

Cash in!
330 pages of the best
men's fashion
The new money culture
Spend it, show it,
live it, love it?
The naked
truth about Tom Ford
David Beckham:
hot & hard

£4.50

Issue 14, Autumn/Winter 2000/01

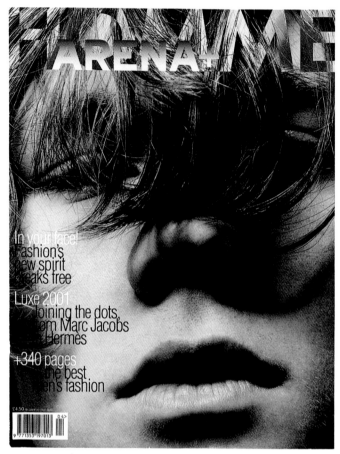

HOMME
ARENA+

In your face!
Fashion's
new spirit
breaks free

Luxe 2001
Joining the dots,
from Marc Jacobs
to Hermès

+340 pages
of the best
men's fashion

£4.50

Issue 15, Spring/Summer 2001

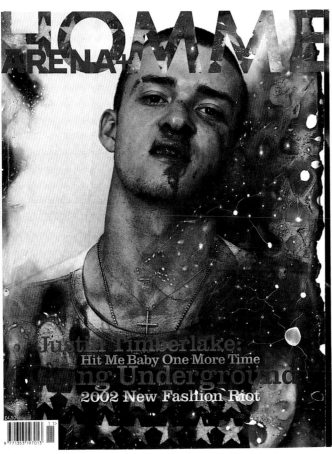

Issue 16, Autumn/Winter 2001/02

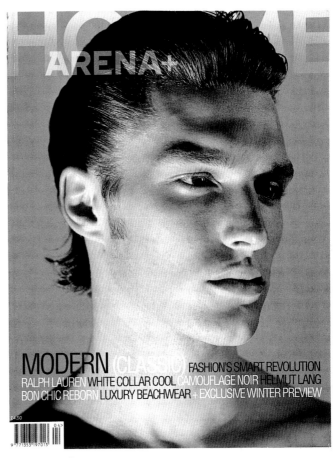

Issue 17, Spring/Summer 2002

Arena Homme Plus *(UK)*
230 x 300mm/9 x 11⅞ inches
The magazine logo and cover image blur together.
On issue 14 (OPPOSITE, LEFT) the logo is clearly
visible: by issue 17 it has almost disappeared.
Despite this, the strength of the photography and
styling mean the covers maintain their identity.
Art direction *Joseph Logan and Tim McIntyre*
(Baron & Baron)

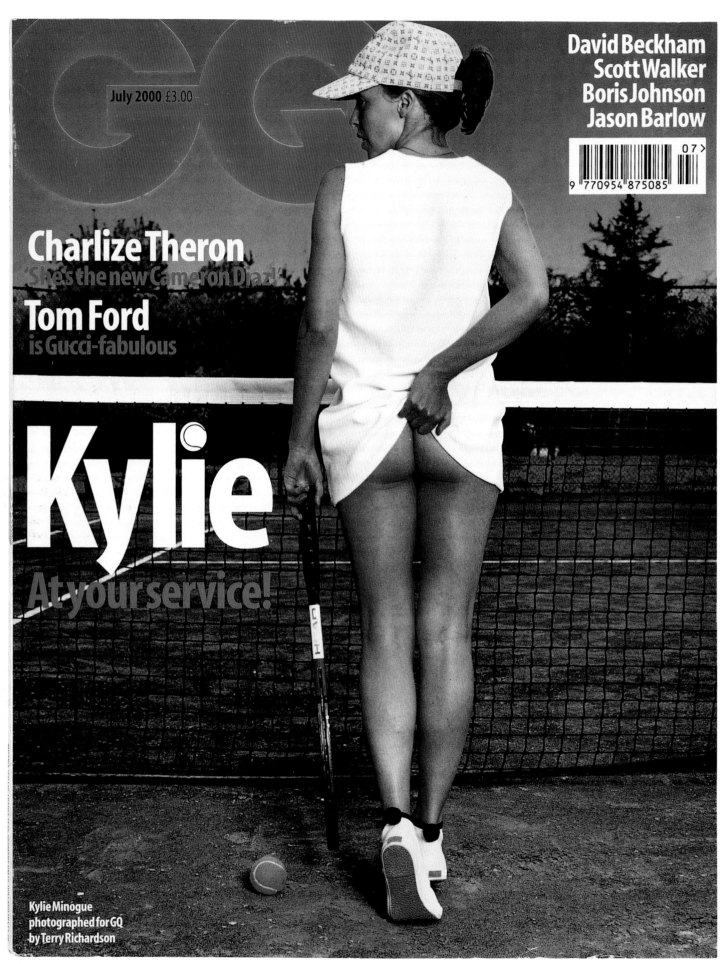

GQ

July 2000 £3.00

Charlize Theron
'She's the new Cameron Diaz'

Tom Ford
is Gucci-fabulous

Kylie
At your service!

David Beckham
Scott Walker
Boris Johnson
Jason Barlow

9 770954 875085 07 >

Kylie Minogue
photographed for GQ
by Terry Richardson

July 2001

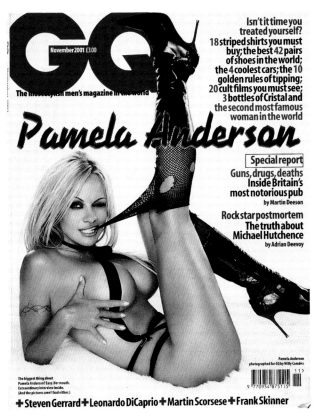

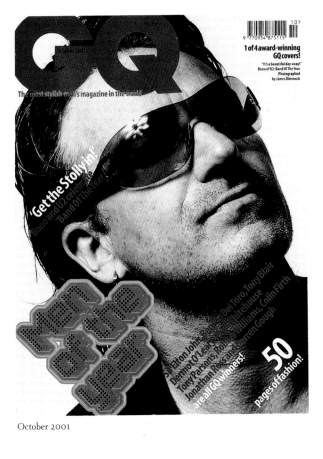

November 2001, 220 x 284mm/8 ¾ x 11 ¼ inches

October 2001

You're working on mainstream magazines but you're not at the more commercial end of it, as *Woman's Journal* was.
We have all the commercial pressure of being a Condé Nast title, which makes it hard sometimes to do really good work. We're not as fortunate as *Pop* or *Arena Homme Plus*, or Italian *Vogue*: they're beautiful but they're basically glorified trade magazines. We don't have the advantages of that market but as you say we're not *Woman's Journal* either. It's a nice middle ground. It's rewarding to achieve good design despite those commercial pressures.

You can be out there pushing the boundaries with your extraordinary fashion spreads but you have to balance that with a bit of value for every reader. Which is what *Vogue*

does brilliantly. For the young girl who spends her £3.00 there is a lot in the front section, then you've got the Juergen Teller/ Terry Richardson fashion shoots that she probably finds a bit odd but that the upmarket reader finds beautiful. They do it brilliantly, whereas others, like *Nova*, had the Terry Richardson shoots but no content up front. You have to provide a balance.

GQ is in the men's magazine market: a market currently perceived as a failing one.
Our sales have been consistently OK; they undulate. We'll have a good year and a not-so-good year but we've never had a terrible year. Condé Nast [the publisher] have been very good in allowing things to evolve. We've never had the pressure for a panicked redesign. They've

always been confident in the content and design. The editors have changed in response to the market but the design has remained constant. That's mainly because it's not too flashy. I wouldn't say it was conservative but it does its job very well and it looks good for what it is – an upmarket men's magazine. Advertisers like it. Everyone encourages the design to stay at a high level because the feedback from the advertisers is that they like the environment *GQ* gives their advertisements. The public, the people who buy the magazine, like things to look good too. Everything is much better than ten years ago; design is now seen as a badge. That's where we are as a mass-market magazine – our readers want well-designed cars, suits and magazines.

How do you go about producing the covers? I'm thinking here of the Kylie one.
Oh that! The situation was quite manipulated from both sides. The story got into the press that we had Photoshopped her underwear out of the cover shot but we never did that. She was well into it, and our press department and her record company played a good game with it. Kylie was wearing a thong. She was cool – everyone knew what was going on. It was the picture inside that was retouched, where her skirt had come up and the top of the thong was visible, so we just took that out because it looked stupid rather than anything else. But it did look a little extreme.

That cover broke a lot of design rules – there was no eye contact, it was very much not a

normal cover. We chose it at the last minute. The concept was planned and shot but we had a more conventional shot for the cover which ended up inside.

How do you decide who goes on the cover?
It has to be a girl, the exception being our Man of the Year issue. Thankfully, we're trying to be more upmarket again at the moment. It's a double-edged thing; you're making your money from issue sales and advertising. A competitor like *FHM* [the highest seller in the UK men's market] makes most of its money from issue sales while we make more money from the high-end advertising we carry. But we need our sales to be high to sell the advertising. It's a vicious circle, but that's how it works. Since September 11 we've

Interview
Tony Chambers
Art director
British *GQ*

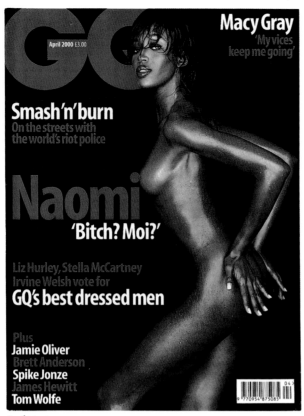

April 2000

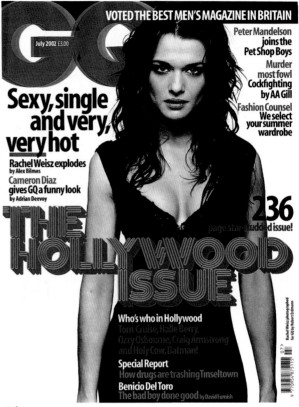

July 2001

gone back to our core values to make sure we don't lose the advertising. Before that we had gone a bit more mad [he points to the Pamela Anderson cover], which I liked but I know a lot of people hated. They didn't get the irony. Pammy is mental – she's the most extraordinary, pop-culture, sexual being. We did our best, using playful lettering and stuff. It's fun. But some people didn't get that and some advertisers couldn't see the difference between that and a *Loaded* cover with a badly photographed Jo Guest. I've always thought that with the branding of *GQ* and Condé Nast behind us we could get away with more, like when *Vogue* put the Spice Girls on their cover. Maybe that's just wishful thinking. But now we've gone a bit more upmarket again.

There are still women in bikinis though…
'Libido' is the word the editor always uses. That's what British *Esquire* has lost. I admire their attempt to rise above it (featuring only men on their covers), and I'd rather put men on our covers, or at least half men to women. It's easier to cover men. It's hard showing sexy – the Pamela cover was easy because she can be sexy – but so many of the other cover stars don't want to appear sexy, only to promote a movie.

But it's a difficult balance to get right and I think we've gone too far sometimes. What happened with the Pamela cover was that a competitor, *Esquire*, went into full PR mode, attacking our cover to the advertisers. I believe that cover was good – if you're going to do

a girl in a bikini then do it properly; it's far more honest. But if the opposition are going to the fashion advertisers in Milan and saying drop *GQ*, advertise with us instead, we have to respond. We're British, we've got a bit of tongue-in-cheek but the head of Armani won't necessarily understand that. He'll say 'I don't want my ad in that…'. You want to push it a bit, have a bit of personality but in the mass market it's difficult.

The Chairman of Condé Nast, Jonathan Newhouse, described *GQ* as a magician's act. You've got to communicate one thing to the reader – that it's a great read with lots of football, girls and booze. And you've got to tell a completely different thing to the advertisers – that we hang out with Richard James and Oliver Peyton and we

wear Cartier watches. We have to produce a magazine that does both. I'm lucky in that it's the look that is talking to Richard James and Cartier. It's the content that has to provide the football and girls. Even when we were flirting with being more populist, the look was the thing – the content could push the taste barriers but the look was upmarket because Gucci, Prada and Armani wanted that.

It's interesting, we're not talking much about design.
It's all relevant though. As a magazine designer you have to have empathy with the editor, publisher and advertising sales teams. You can't let them think you're just some aesthete who wants to use pink for the sake of it. That's rubbish, and you'll be told to do it red or run along.

Any art director is only as good as the editor and publisher. I have been very fortunate, the three editors I have had at *GQ* have all been very different but they've all had the correct relationship with me as art director; they've trusted me to do my side of the job. I'll always argue for what I think is right and that instils confidence.

On many magazines there isn't that good relationship and it shows, where the editor puts too much pressure on them about how they see the magazine should evolve. That's become more common in the past ten years. It's bred a generation of art directors who are really good designers possibly but they're not having the input and the overview that they should. No magazine can be successful under those circumstances.

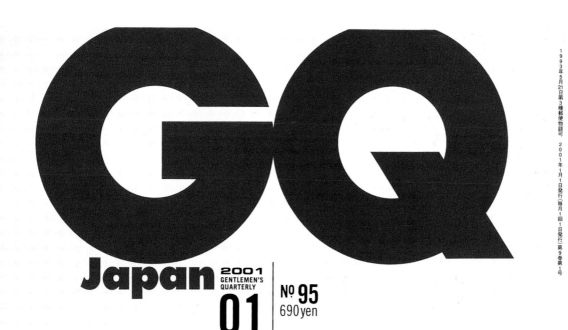

GQ Japan

2001
GENTLEMEN'S
QUARTERLY

01 JANUARY

№ 95
690yen

1993年5月21日第3種郵便物認可　2001年1月1日発行（毎月1回1日発行）第9巻第1号

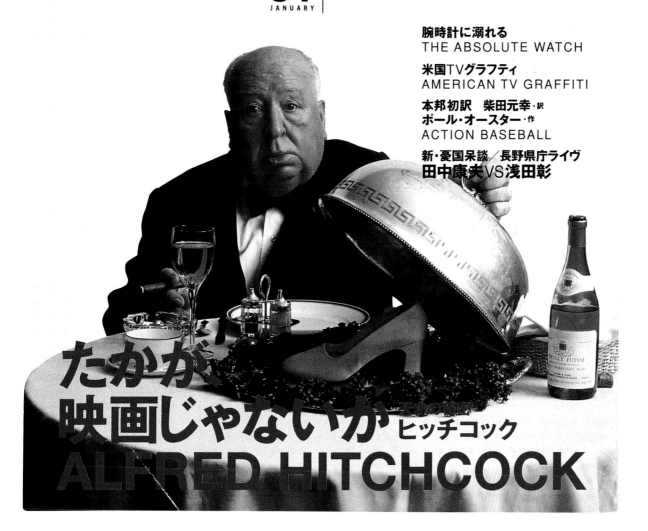

腕時計に溺れる
THE ABSOLUTE WATCH

米国TVグラフティ
AMERICAN TV GRAFFITI

本邦初訳　柴田元幸・訳
ポール・オースター・作
ACTION BASEBALL

新・憂国呆談／長野県庁ライヴ
田中康夫VS浅田彰

たかが
映画じゃないか
ヒッチコック
ALFRED HITCHCOCK

GQ *(Japan, Issue 95, January 2001) 207 x 275mm/8 ¹⁄₈ x 10 ⁷⁄₈ inches*
Aside from the immediate difference in the way the *GQ* logo is used,
a different market means a different approach to the content of covers.
In Japan *GQ* uses its western roots to sell itself, featuring icons such as
Marilyn Monroe, Andy Warhol, The Beatles and Alfred Hitchcock.
Art directors *Shoukon Paik and Takahito Noguchi*

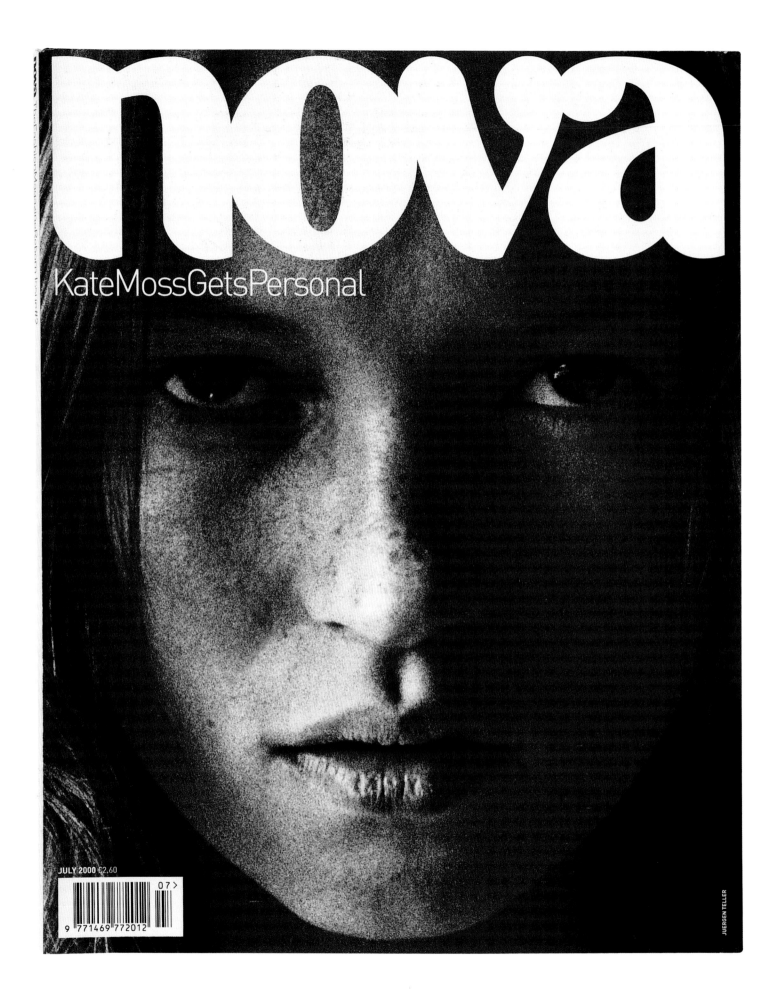

nova

KateMossGetsPersonal

JULY 2000 £2.60

07>

9 771469 772012

JUERGEN TELLER

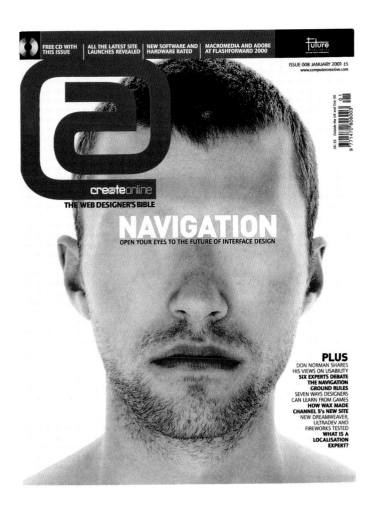

FREE CD WITH THIS ISSUE | ALL THE LATEST SITE LAUNCHES REVEALED | NEW SOFTWARE AND HARDWARE RATED | MACROMEDIA AND ADOBE AT FLASHFORWARD 2000

future

ISSUE 008 JANUARY 2001 £5
www.computercreative.com

cre@teonline

THE WEB DESIGNER'S BIBLE

NAVIGATION

OPEN YOUR EYES TO THE FUTURE OF INTERFACE DESIGN

PLUS

DON NORMAN SHARES
HIS VIEWS ON USABILITY
SIX EXPERTS DEBATE
THE NAVIGATION
GROUND RULES
SEVEN WAYS DESIGNERS
CAN LEARN FROM GAMES
HOW WAX MADE
CHANNEL 5's NEW SITE
NEW DREAMWEAVER,
ULTRADEV AND
FIREWORKS TESTED
WHAT IS A
LOCALISATION
EXPERT?

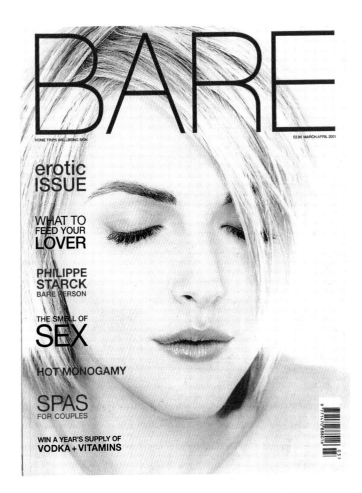

BARE

HOME TRIPS WELLBEING SKIN

£2.95 MARCH.APRIL 2001

erotic
ISSUE

WHAT TO
FEED YOUR
LOVER

PHILIPPE
STARCK
BARE PERSON

THE SMELL OF
SEX

HOT MONOGAMY

SPAS
FOR COUPLES

WIN A YEAR'S SUPPLY OF
VODKA + VITAMINS

OPPOSITE **Nova** (UK, Issue 2, July 2000)
230 x 284mm/9 x 11 1/8 inches
Eye contact on covers is regarded as essential to attract readers.
This example takes full advantage of Kate Moss's celebrity
status, her larger-than-life face staring out at the reader.
Art director Gerard Saint

THIS PAGE **Cre@te** (UK, Issue 8, January 2001)
210 x 280mm/8 1/4 x 11 inches
Here, Photoshopping out the eyes creates a disturbingly
engaging image.
Art director Paul Kurzeja

Bare (UK, Issue 4, March/April 2001)
230 x 300mm/9 x 11 7/8 inches
Sophie Dahl's closed eyes exude relaxation and calm.
Art director Kirsten Willey

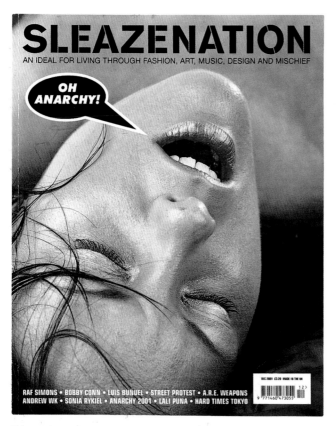

February 2001

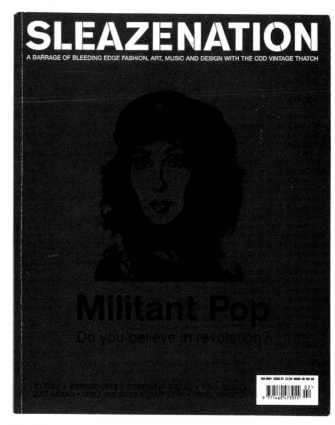

November 2001

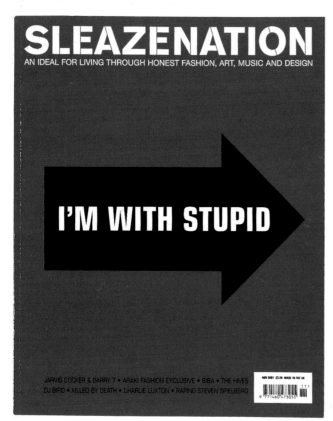

December 2001

SleazeNation (*UK*) *230 x 285mm/9 x 11 ¼ inches*
Experimenting with very direct single messages on its front cover, this style magazine's approach ranges from the subtle mimickry of 'Militant Pop' to the in-your-face directness (stupidity?) of 'I'm With Stupid', itself mimicking a t-shirt slogan. The two photographic examples are subtler but still very direct. 'Oh Anarchy!' uses an ironic combination of picture and text that illustrates a feature inside the issue, which asks why anarchy is sexy. The cover opposite pushes irony a step further, taking the standard components of a glossy cover – pouting model, screaming headline and fluorescent fifth colour – and subverting them through the wording of the headline.
Creative director *Scott King*

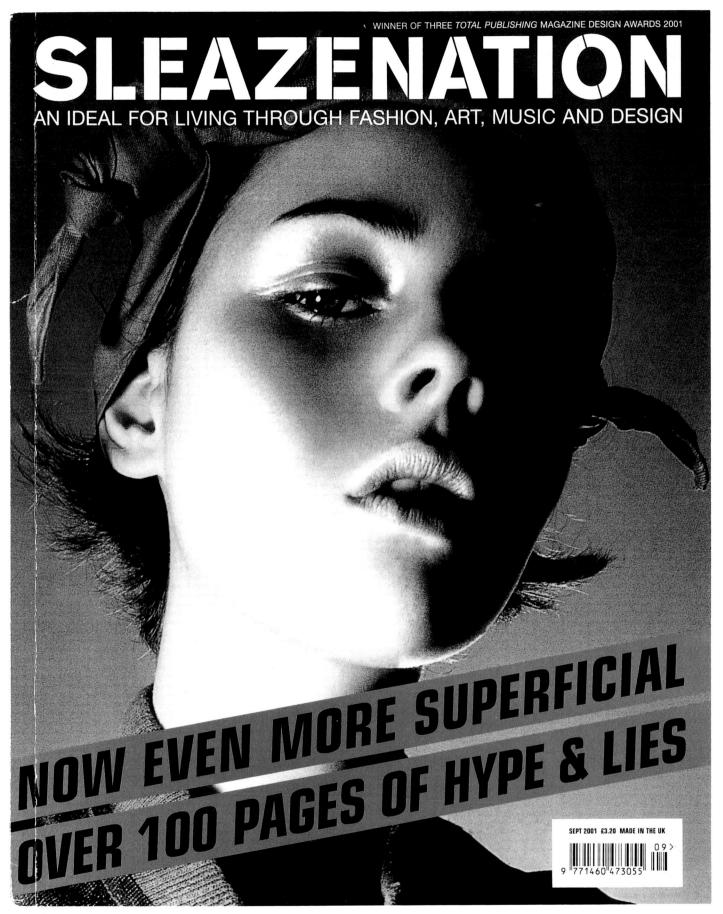

SLEAZENATION

AN IDEAL FOR LIVING THROUGH FASHION, ART, MUSIC AND DESIGN

NOW EVEN MORE SUPERFICIAL
OVER 100 PAGES OF HYPE & LIES

SEPT 2001 £3.20 MADE IN THE UK

09 >

9 771460 473055

September 2001

THIS PAGE **Eat** (*Japan, Issue 11, September 2002*)
230 x 297mm / 9 x 11 ¾ inches
The subject of fast food is announced by a large removable sticker that mimics the lid of a pot noodle container, which when peeled off reveals a photograph of the noodles inside the pot.
Art director Tin Brown

OPPOSITE **Time Out** (*UK, Issue 1595, March 14–21 2001*)
215 x 300mm / 8 ½ x 11 ⅞ inches
At first glance, it looks like the butcher's knife has cut some fresh, bloody meat: a closer look reveals it has cut some tomatoes; a visual trick that neatly introduces the subject of vegetarianism while not excluding carnivores.
Art director Balwant Ahira

Time Out

London's living guide
March 14-21 2001 No.1595 £2.20

TIM BUCKLEY
FUN LOVIN' CRIMINALS
LAURA LINNEY
THE PRISONER
CITIBANK PHOTO PRIZE
36-PAGE TV SECTION

**'DON'T
HAVE
A COW,
MAN'
VEGETARIAN
SPECIAL
FOR LONDON'S
CONFIRMED
CARNIVORES**

COVER: ALAN MAHON

9 770049 391100

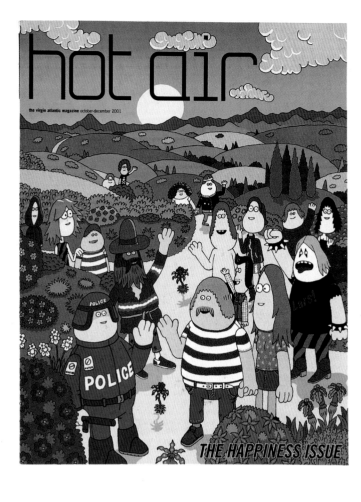

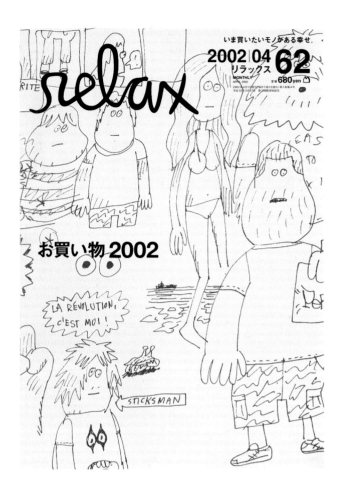

THIS PAGE **Hot Air** (*UK, Issue 75, October–December 2001) 228 x 300mm/9 x 11 ⅞ inches*
The illustration commissioned for this cover is used to describe the theme of
the issue – Happiness – rather than any specfic story inside.
Art director Warren Jackson Illustration James Jarvis

Relax (*Japan, April 2002) 210 x 297mm/8 ¼ x 11 ¾ inches*
Same illustrator, different message. This time the work featured relates to a
review in the magazine of a book of the illustrator's work.
Art direction NANA Illustration James Jarvis

OPPOSITE **M-real** (*International, Issue 4, November 2001) 280 x 2800mm/11 x 110 ¼ inches*
The cover of this magazine with no name (it is published on behalf of a Finnish
paper company and aimed at magazine creatives) changes to reflect the theme
of the issue, in this case, 'Response'. This illustration relates to a piece in the
magazine about the ideal components for a succesful magazine cover.
Art director Jeremy Leslie Illustration Austin @ New Studio

LOGO

52 COLOUR PAGES

SEX HAIR CHOCOLATE

← TEXT ALIGNED TO LEFT SIDE
QUOTES IMPLY ACCESS:

TOP DESIGNER REVEALS
WHY WE ALWAYS HAVE
ARGUMENTS
ABOUT THE COVER

NUMBERS BOLSTER THE IMPRESSION
OF ~~QUALITY~~ QUANTITY

BEWARE
GREEN AND BLACK
AND WHITE

SEE PAGE 6 (START OF THE FEATURE ABOUT COVERS)

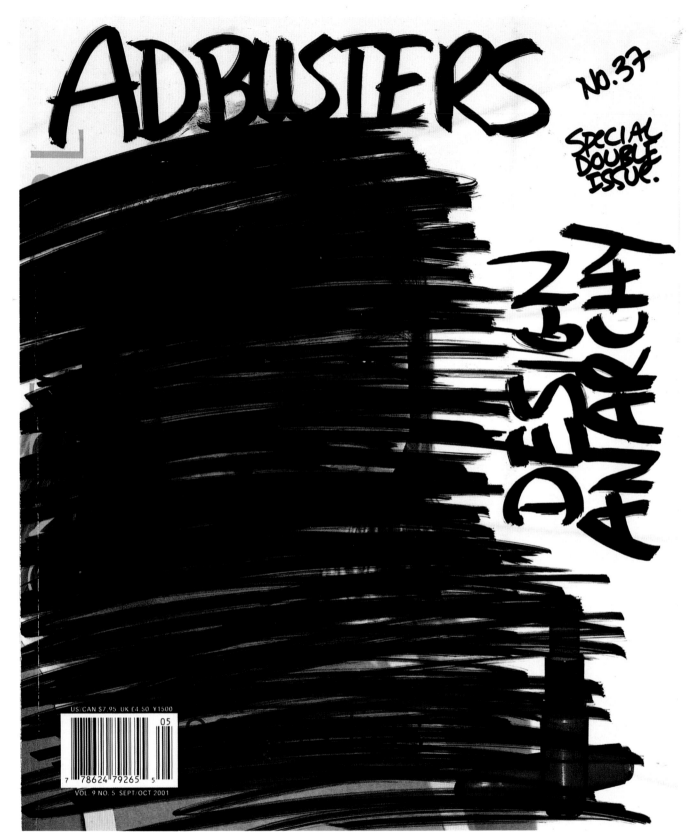

ADBUSTERS

No.37

SPECIAL DOUBLE ISSUE.

DESIGN ANARCHY

US/CAN $7.95 UK £4.50 ¥1500

7 78624 79265 5 05

VOL. 9 NO. 5 SEPT/OCT 2001

Adbusters (*Canada, Issue 37, September/October 2001) 228 x 274mm/9 x 10 7/8 inches*
This cover features heavy black marker pen scrawled over a glossy lipstick ad to announce its 'Design Anarchy' theme.
Guest art director *Jonathan Barnbrook*

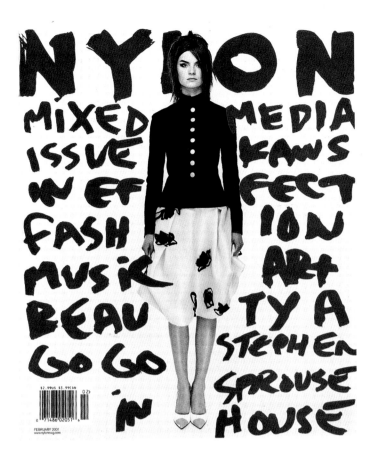

N Y L O N

MIXED MEDIA
ISSUE KAWS
IN EF FECT
FASH ION
MUSIK ART
BEAU TY A
 STEPHEN
GO GO SPROUSE
 'N HOUSE

$2.99US $3.99CAN

FEBRUARY 2001
www.nylonmag.com

BlackBook

Spring 2002 Progressive Culture

NATALIE PORTMAN
BY GEORGE PLIMPTON

COY

PROWESS
SPRING HE'S SO
FASHION
ALL STANDS BY
CRAFTED BY
ACUTE
FOXXY

SEA SEX + SUN
ABLE

JIM JARMUSCH
Rolls the RZA PAPERS

DEEP
FICTION by
HANIF
SHADY Kureishi
SLYING
COMING

ANTHONY BOURDAIN
BITCH IN WOUNDS
Kitchen goons
CAGEY
#ONE
DEFT

INSIDIOUS
POETIC VIRILITY

WILLY

COMAGE 4.00
BLACK BOOK
SPRING 02

BLACKBOOK
rules

CRAFTY!

9 771521 840017

LEFTSIDE DRAFT 2

£5

Nylon (USA, February 2001) 230 x 274mm / 9 x 10 7/8 inches
Art director Lina Kutsovskaya
Black Book (USA, Issue 22, Spring 2002) 228 x 274mm / 9 x 10 7/8 inches
Art director Paul Che Ritter

Two glossy fashion magazines use handwritten covers to state their independence from the mainstream.

Leftfield (UK, Issue 2, November 2001) 280 x 280mm / 11 x 11 inches
Rubdown lettering is used to give a rough-and-ready impresssion on the cover of this independent magazine, which is a college project.
Design Cai Taylor and Kyn Taylor

Bare *(UK, Issue 2, November/December 2000) 230 x 300mm/9 x 11 7/8 inches*
The contents page is the first place the reader goes to for information on content and navigation. In this example a clean grid of annotated images acts as contents page.
Art director Kirsten Willey

Plus Eighty One *(Japan, New Year 2002) 225 x 270mm/8 7/8 x 10 3/4 inches*
This special 'Photographers Issue' of this Asian creative arts magazine used portraits of the photographers set in stylized slideholders on its contents page.
Art director Kazunari Nomoto

021 contents

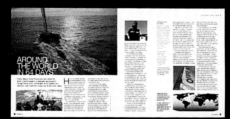

O (*UK, Issue 21, Summer 2002*)
260 x 260mm/10 ¼ x 10 ¼ inches
Miniatures of page layouts are used on the contents page of this customer magazine for Orange mobile phone users, to announce a redesign and encourage the reader to enter the new-look magazine.
Art director *Simon Robinson*

Paris

Liberation Style *(France, Issue 7, Summer 2002) 240 x 330mm/9 ½ x 13 inches*
This contents page leads with generic subject headings, only including more specific information as a secondary element alongside the page numbers. By doing this, the page becomes a signifier of what the magazine represents, rather than a precise piece of navigation. Art direction *Andreas Bozajic and Fredrika Jacobsson*

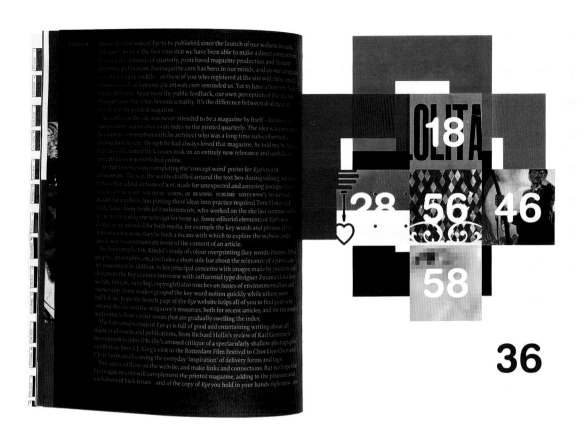

Eye *(UK, Issue 32, Spring 2002) 235 x 297mm/9 ¼ x 11 ¾ inches*
In addition to a brief written list of contents, which appears
elsewhere, this design magazine also runs this abstract visual
contents list opposite the drily presented editor's letter.
Art director Nick Bell

M *(Brazil, Pilot Issue, 2001) 228 x 297mm/9 x 11 ¾ inches*
This is a purely visual contents page: there are no text or page
numbers, just pictures presented as a flow diagram.
Art direction Roberto Cipolla and Helio Rosas

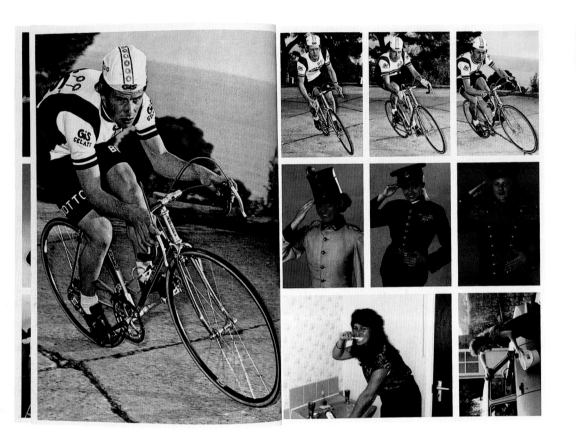

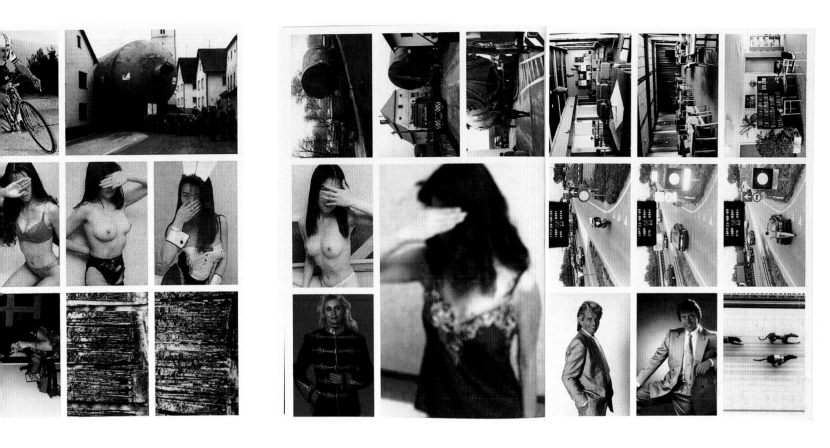

Useful Photography *(The Netherlands, Issue 1, 2001)*
210 x 297mm/8 1/4 x 11 3/4 inches
A collection of random, found, photographs are featured
here, edited together to form a gently paced series of
gridded layouts that flow from page to page. A number of
repetitive/series pictures continue from one page to
another, inviting the reader to apply a narrative of their own.
Design *Hans Aarsman, Claudie de Cleen, Julian Germain, Erik
Kessels and Hans van der Meer*

DARREN ALMOND
INTERVIEWED BY PHIL HEBBLETHWAITE

British artist Darren Almond addresses an obsession with time, space and their respective relationships with man-made forms. BIG spoke with him about his latest piece - a transatlantic adventure.

Phil Hebblethwaite: Tell me about the piece.

Darren Almond: At the end of August 2001 my installation piece entitled *Meantime* was activated – it is basically a continuously running clock powered by an internal generator - and set to Greenwich Mean Time. The piece was put on the back of a truck and driven down to the port city of Southampton on the south coast of England. The shipping company P&O Nedloyd agreed to transport the piece, and kindly allowed myself and Richard Dawson to make the transatlantic journey with it and document the journey photographically. The photographs in turn became part of the work itself, which was to be exhibited at a gallery in New York. The installation, the process, the journey of the piece in space and time itself would ultimately be the subject of the exhibit, which will continue around the world in a succession of spaces. We started our six day journey to New York in early September. The shipping company loaded the container so that as we set sail the digits of the clock were facing the city of Southampton. The container itself was designed in the United States. It is 40 feet long and can carry 40 tons of cargo. The transport of containers around the world is very often not a simple transaction. Shipping containers are like units of currency travelling the world, sometimes never arriving at an assigned destination. The whole mass of container units are like a floating stock market. Containers can stay afloat for years at a time with the produce intact, get turned away and sit idle in stock yards.

PH: What type of clock is the installation?

DA: It's an electro-magnetic clock so the readout is similar to the read-out of a Casio watch, but it's a mechanical version of that. You always see them in British railway stations, usually broken down. It shows seconds so it develops its own sense of rhythm, which the container itself amplifies when closed. One part of the second display has already turned over nearly a million times in its short life. You need to spend some time with it to get into the repeated cycle of the rhythm. It can be quite meditative. Or, if you are in front of it for a while, the sound can slip into the subconscious and disappear and become silent, as most sounds can. The clock is a huge object in human terms, but in relative terms it isn't that big. You can't tell what time it is when you stand in front of it. The numbers only appear clearly when you get some perspective.

PH: How is this piece related to your other work?

DA: The journey of the installation from London to New York is, in a way, a counterpoint to the films that I make. The films generally have an association to railways and have tended to follow an easterly route. I was born and grew up in the seventies in England, so I was part of the cold war generation. Yet I seemed to be very much on the fence between the two sides of the war. I grew up on the cusp of what I imagined to be the East and the West, the new and the old.

PH: You've been to New York before, but only by air. How did the experience of travelling by boat compare to simply boarding a plane?

DA: To travel to the States via the ocean is a totally different experience to flying. There's much more room for contemplation. Twenty-four hours after you leave Southampton you're not even past the most westerly point of England. Early on it was beautiful - very calm in the Channel and the sun was shining. I was down at the bow of the boat and there was no breeze - there was a wind pocket, because of the design of the ship. On a plane, the oxygen is removed from you. Any sense of taste is removed from you. And any sense of speed and temperature and connection is removed from you. You are vacuum-sealed, alienated from time and motion. When I was on the boat, the occasional plane would fly overhead. I would look up and think that those people were missing out on so much. There is a tangible sense of moving through space and time which passengers on modern airliners are deprived of. You gain an hour of sleep each night of the crossing so one doesn't experience jet-lag and the familiar sense of dislocation that you experience when you arrive in New York. But mostly, as you travel, it is far easier to get your head around the scale of the journey and the distance and how that effects things culturally. This must be exaggerated with the even greater oceans, greater distances.

PH: So you gain a different perspective on the earth itself?

DA: The deck of the ship is a vantage point – you are relatively high in relation to the surface of the ocean. With this perspective you can actually experience the curvature of the earth. It becomes clear that we are on a huge globe, moving through space. The sciences that, as a child, I thought were courageous acts of mental ability all of a sudden appeared to be visual reactions to quite natural existence.

PH: Was there a feeling of sensory deprivation whilst on the ocean?

DA: It was strange. The route we took is the busiest shipping route in the world but we only saw one other vessel during the whole journey. We could just about see it with our binoculars in the distance. Occasionally you get dolphins at the bow jumping over the waves and large seagulls and albatrosses floating around. We also saw a couple of whales. Other than that we were left looking at the weather, which is a beautiful thing to sit and watch in itself. You look at the sky not the sea because you are in the sea - you're in the present moment - and you're concerned about what is going to be in front of you. You can see storms and you can look through storms and see that a clear patch is behind. The captain of the ship was able to navigate his way across using the installation. With Greenwich Mean Time and knowing what time that you left the dock you work out your relative position. And then you use the stars to work out your other co-ordinates.

PH: Did sailing with this clock give you a heightened sense of time?

DA: No, but arriving in New York itself did. I'd spent six days in an extremely calm environment, despite the fact that we crossed the Flemish Cap - a submerged mountain off Newfoundland. Out there the sea goes from being a couple of kilometres deep to being a hundred metres shallow. This affects the weather patterns above. The water is warmer and three weather fronts can sometimes collide. We experienced extremely violent seas - the boat was bending, which it is designed to do, and disappearing under waves. The clock could have been washed off - something I was unaware of. Ships sometimes lose containers. But being on the boat meant that I became unused to the verticality of a city like New York. The horizon had become the norm. It was quite confrontational. The clock took a bit of a battering during the course of the journey - more so in New York than it did on the boat. It's going to get fixed there and then it's going to move on. The idea is to put it on a train across the desert to the West Coast, then on a ship across the Pacific until, eventually, it'll do a whole revolution. All along it will show Greenwich Mean Time so it can work out where it is.

PHOTOGRAPHY: RICHARD DAWSON

Above: The London Orbital, M25.

Above: Mid Atlantic.

124

125

Left: The Hudson River and The George Washington Bridge. *Above:* Newark Docks.

140

141

Left and above: Arrival at The Matthew Marks Gallery, W.22, New York.

Big *(USA, Issue 41 The Transatlantic Issue, 2002) 235 x 297mm/9 ¼ x 11 ¾ inches*
Artist Darren Almond's installation piece, 'Meantime', featured a large digital clock set into a freight container. The container was transported from Almond's studio to Southampton Docks and then by sea to New York where it was exhibited in a gallery. The project was photographed by Richard Dawson and his pictures later ran in this Transatlantic Issue of the magazine. The pictures were published in chronological order but spread throughout the issue, bringing an awareness of time to the readers' experience of the project.
Art director Darren Ellis

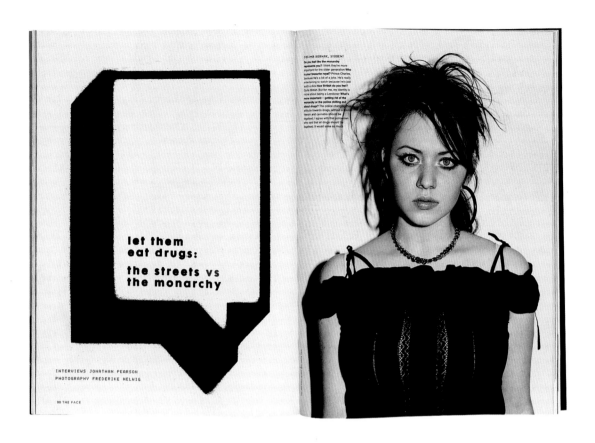

let them
eat drugs:

the streets vs
the monarchy

INTERVIEWS JONATHAN PEARSON
PHOTOGRAPHY FREDERIKE HELWIG

00 THE FACE

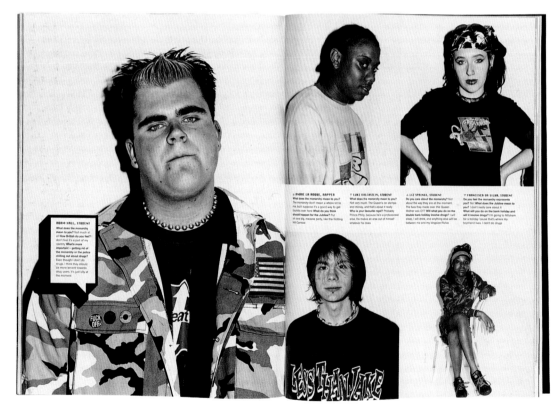

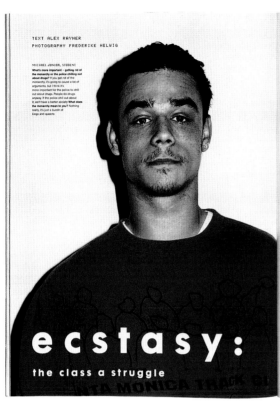

TEXT ALEX RAYNER
PHOTOGRAPHY FREDERIKE HELWIG

MICHAEL JUNIOR, STUDENT
What's more important – getting rid of the monarchy or the police chilling out about drugs? If you get rid of the monarchy, it's going to cause a lot of arguments, but I think it's more important for the police to chill out about drugs. People do drugs anyway. If the police chill out about it, we'll have a better society What does the monarchy mean to you? Nothing really, it's just a bunch of kings and queens

ecstasy:
the class a struggle

You can toke weed with impunity these days. Will 'killer drug' ecstasy be the next for reclassification, ensuring shorter sentences for possession and a future for legal highs?

uestion: what are your views on the politics of ecstasy? Did you know that the pill in your pocket could cost you a seven-year prison stretch – the same as a little bag of heroin? Now that the government are about to reduce penalties for cannabis possession to a bureaucratic wrist slap, the next great divide between street tolerance and statutory punishment lies with ecstasy. Flouted en masse by the public and debated by our politicians, ecstasy's legal position as a class A drug looks set to change. In a climate that's overdosing on economic, medical and judicial opinion, what's the real future for the biggest example of mass civil disobedience since the cannabis furore?

'There's a risk. Ecstasy can kill, but compared to alcohol or cigarettes it's nowhere near as bad. The problems are blown out of proportion in the press, because papers cater for comfortable fortysomethings' – Alex, 22, record shop worker

Alex is one of the the subjects THE FACE interviewed in a big London club one April Friday night. Everyone we spoke to was well-informed. Some knew that ecstasy is a class A drug, punishable with stern sentences and fines under British law. A few were aware that the UK has one of the highest incidences of ecstasy use in Europe, just behind that of Holland and Switzerland, along with the highest rate of imprisonment of drug users in the European Union and some of the harshest penalties, longest prison sentences and greatest expenditure on prohibition. But almost all agreed that the laws governing Es need changing. What's surprising is that MPs, advisory committees, think tanks, policemen and drug workers and medical professionals agree too. Pressure to reclassify E has never been higher.

'Es are as illegal as heroin and crack? Are they? I think ecstasy is a lot more productive a drug. Seven years, for possession? That's way too fucking long in a really fucking nasty place for just an E, man' – Mark, 22, office worker

When Britain began its collective love affair with ecstasy in the late Nineties, it seemed inconceivable that just over a decade later, Whitehall would eventually come as close as it has to getting 'on one', legislatively speaking.

'I think the government will go for ecstasy reclassification,' says Labour MP Paul Flynn, a critic of the government's current drugs policy. 'Though the changes are coming about not via the politicians, but through civil disobedience. The laws are being flouted by the public and Downing Street is trying to keep up.'

Britain's drug legislation is governed by the 1961 UN Single Convention on Narcotic Drugs, which obliges all member states to work together to stamp out global drug abuse. Britain's subsequent Misuse of Drugs Act of 1971 divided controlled substances into three classes: A, B and C. In 1977 Ecstasy was bracketed as class A drug, alongside heroin and cocaine. These substances carry a maximum penalty of seven years for possession and life imprisonment with an unlimited fine for supply. Class B drugs, including amphetamines and barbiturates, carry a maximum of 14 years for supply and five for possession, while for Class C drugs it is five- and two-year sentences respectively. Flynn isn't alone in thinking that 'our' drugs legislation isn't working.

THE FACE 97

'We know from thousands of years' experience with opium, alcohol and tobacco, that we should lead a drug-free life,' he argues, 'but people will continue to take drugs because they're so enjoyable. We've failed to prevent them; instead we should offer people truthful advice and encourage them to refrain.'

'Can you really get seven years for possession? That's insane. If you go out, get drunk and start fights you don't get seven-year sentences, and that's a far worse thing to do' – Anna, 20, graphics student

In the corridors of power, the pro-declassification of ecstasy has some unusual supporters, one of whom is Viscountess Ruth Runciman, Chairman of the Police Foundation's Independent Drugs Inquiry of 2000 and former head of the government's drug advisory committee. 'These penalties are inaccurate in their reflection of damage done to society and totally disproportionate to the crime committed,' she says. 'We felt that ecstasy is a harmful drug, yet it has more in common with amphetamines, which is a class B substance. We need accurate drug education legislation, so we can get on a level with young people.'

Her inquiry proposed the self-evident notion that not all drugs are equally bad and that prison is an inappropriate punishment for pill poppers. It suggested that there should be no jail sentences issued for B and C class possession and that lumping heroin and crack in with E may engender a casual attitude towards the more dangerous substances.

Unsurprisingly, the Police Foundation's ecstasy recommendations were largely ignored by the government, as have most pre-declassification arguments offered to MPs since Labour published their ten-year strategy for combating drug misuse – 'Tackling Drugs To Build A Better Britain' – in April 1998. The document emphasised education and prevention, rather than reclassification, yet within two months the Advisory Council on the Misuse of Drugs – whose job it is to consult the government on drugs legislation – began to suggest a relaxation of ecstasy laws. Their recommendations were rejected.

The pressure to reclassify has been mounting for some time. In November 1999 the European Monitoring Centre for Drugs and Drug Addiction put Britain at the top of their European Union league of illicit drug consumption. Countries with more liberal legislation – such as Holland, Switzerland and Portugal – had proportionally fewer users. In October 2001, the Association of Chief Police Officers told the Observer newspaper that they believed ecstasy should be treated as less dangerous than heroin or cocaine. In March 2002 the government published a 'Safer Clubbing' pamphlet, acknowledging ecstasy usage in nightclubs and advising club owners on how to minimise the dangers. Also in March, governmental think tank The Foreign Policy Centre published From War to Work, a report attacking the government's war on drugs. The think tank's patron is Tony Blair.

Now the government's own Home Affairs Select Committee is due to deliver its report on the misuse of drugs. It has been suggested in the press that ecstasy reclassification will be among its recommendations.

'Crack and heroin are bad, but Es? Don't take them every day but if you're going raving, they're good. Seven years is stupid. Maybe for the dealers, but, seven years?' – 'C', 19, raver

Support for reclassification doesn't just come from those who are out taking the current estimate of two million pills which are consumed every weekend in clubs around the UK. Hope and Mick Humphries, a middle-aged couple from Somerset, have a son who could have been one of the clubbers THE FACE chatted to on Friday night – had he not been sent to prison midway through his university degree. 'He got into the Manchester club scene,' says father Mick, who'd prefer not to give his son's first name. 'He was persuaded to buy more Es than he should.' The student was found guilty of possession with intent to supply in 1995 and sentenced to two and a half years in prison.

Mick and Hope believe their son was a victim of ecstasy politics; they've given evidence to both the Runciman Inquiry and the Home Affairs Select Committee. Hope is in the process of setting up a charity called Mothers for Effective Drug Laws.

The Humphries are a conservative couple in every respect, apart from their view on street narcotics, which they believe should be taken out of the black market and run by the state. Theirs is a sound argument, whereas arguments of others pushing for equally sweeping changes to Britain's drug laws vary from the emotional to the opportunistic. At one end of the spectrum are Paul and Jan Betts, parents of totemic ecstasy fatality Leah, who warn of 'Colombian drug dealers' on every street corner should Britain follow Holland's lead and legalise certain MDMA variants. At the other are voices with in the pharmaceuticals industry who question the black market's ability to manufacture pills reliably. As one employee

THE FACE 99

In October 2001 the Association of Chief Police Officers told the Observer newspaper that they believed ecstasy should be treated as a less dangerous drug than heroin or cocaine

The Face (UK, Volume 3, Issue 65, June 2002) 222 x 297mm/8 ¾ x 11 ¾ inches
The stylized speech bubble is used here to both symbolize the subject of and link the pages of a voxpop feature. Each time the speech bubble appears it has a different function: first it holds the headline, then a voxpop answer, then a drop capital at the start of the text, and finally, a pull-quote from the text. Art director Craig Tilford

Pace / 95

Spector Cut+Paste *(Germany, Issue 1, 2001)*
235 x 297mm /9 ¼ x 11 ¾ inches

A series of spreads are held together by a strong graphic device based on a football theme. Spread by spread, the number of pictures decreases as the volume of words increases, gently drawing the reader into the article.

Designer *Marcus Dressen*

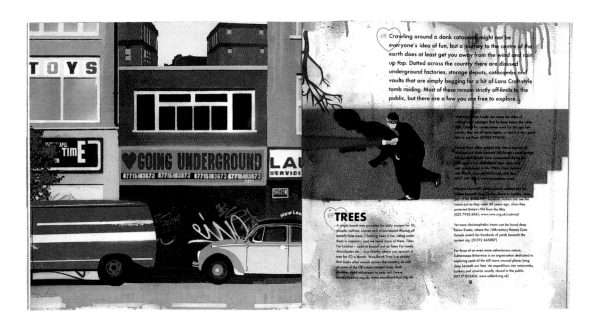

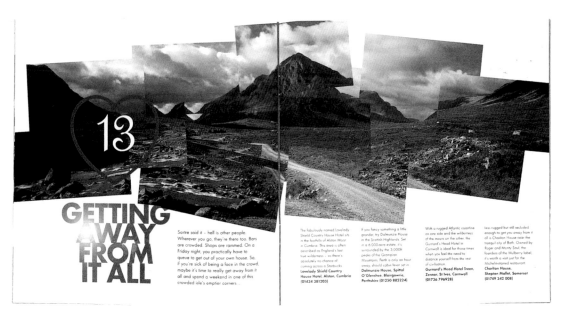

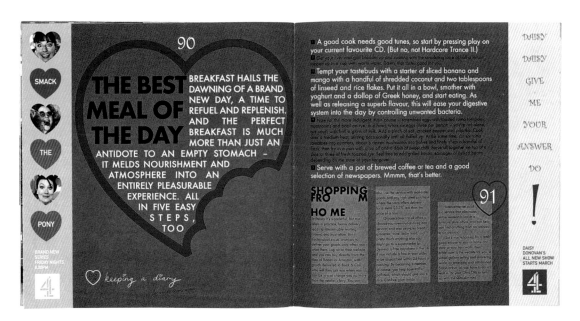

The Good Book (*UK, Issue 1, Spring 2002*) *195 x 195mm/7 ³/₄ x 7 ³/₄ inches*
This promotional magazine for the new television season for Channel 4 listed '103 Reasons to Love Life'. This numbered editorial structure meant every page had a different subject matter. As a result the design of every entry reacts to its content making a very varied set of pages. The pace is relentless but somehow the randomness of the pages holds together well.
Design 4 Creative

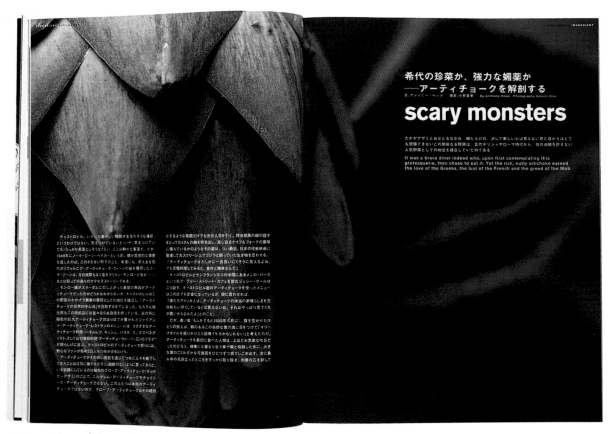

希代の珍菜か、強力な媚薬か
──アーティチョークを解剖する
文／アンソニー・ヘッド　撮影／小野聖美　By Anthony Head　Photography Satomi Ono

scary monsters

たかがアザミとあなどるなかれ　棘だらけの、決して美しいとは言えない見た目からはとても想像できないこの美味なる野菜は、古代ギリシャやローマ時代から、他の珍味を許さない人気野菜としての地位を確立していたのである。

It was a brave diner indeed who, upon first contemplating this grotesquerie, then chose to eat it. Yet the rich, nutty artichoke earned the love of the Greeks, the lust of the French and the greed of the Mob

Eat, Issue 8, January/February 2002

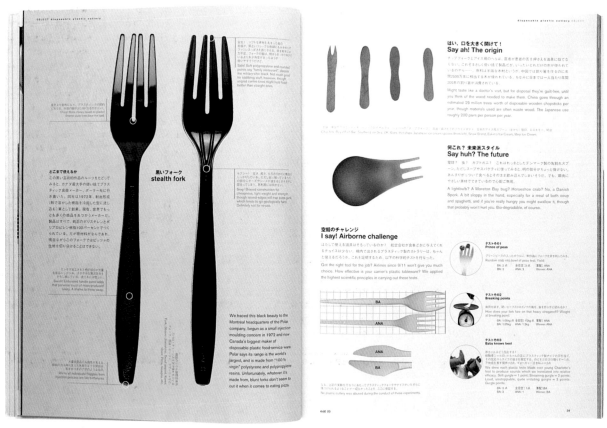

Eat, Issue 9, March/April 2002

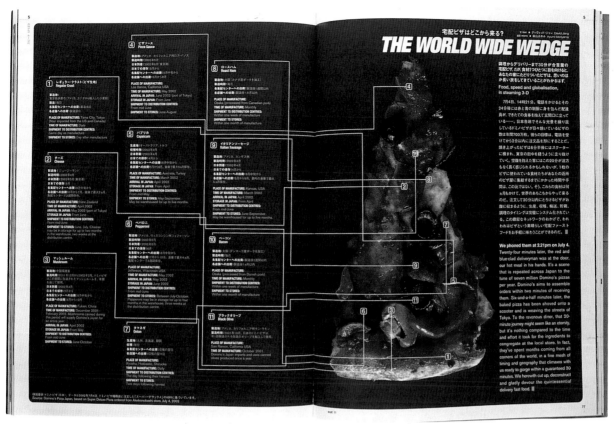

Eat, Issue 11, September 2002, 230 x 296mm/9 x 11 ¾ inches

How large is the Japanese publishing industry?

The total number of magazines bought in 2000 was 4,620 million, of which 2,960 million were monthlies. A lot of these sales were Manga comics, which can sell over 3 million per issue.

Is the industry based on newsstand sales or subscriptions?

99% newsstand. There are a few subscription based magazines and you can subscribe to others, but most people don't. You can't legally discount a magazine from the cover price, so there are no special discounts.

Are Japanese editions of western titles regarded as successful in their own right or are the original western magazines seen as 'cooler'?

The Japanese editions of western magazines that have been most successful are those that have adapted their content to the Japanese market. Many have not worked very well – *Vogue* has had numerous relaunches and the present incarnation has had, I think, three editors in two years.

Sports Graphic Number is one of the most successful sports magazines here and was originally the Japanese version of *Sports Illustrated*. *Elle* has probably been the most successful of the fashion magazines, but has lost some of its image recently by trying to make up for falling revenue with a spin-off range of branded items ranging from slippers to even toilet seat covers!

Original foreign magazines don't really compete with the above. Some western magazines are bought for flicking through, as a lifestyle accessory – most big bookshops in Tokyo and other major cities will have a foreign magazine section – but total sales are not large. *Fortune* is one of the biggest sellers with 4–5,000 copies. *Wallpaper** is always quoted, but about 1,000 per issue are actually sold here.

What are the main differences between Japanese and western magazines?

The big difference is the way Japanese magazines read from what we regard as the back through to the front. This is a must if you want to use vertical text, because it has to be read from right to left. If a story is restricted to a single spread then there is no problem, but if the story runs across multiple spreads then the page direction becomes important. Most magazines are therefore read right to left, using vertical text for the body plus horizontal for captions, notes and sidebars. You can run Japanese horizontally and then it runs left to right, but the traditional way is easier for Japanese readers. There are exceptions, primarily in design-related magazines that want to try something different, such as *Axis*, *Idea* and *Composite*.

Japanese people are far less confused by western titles than we are by theirs; they have been brought up with English, it's everywhere you look here in Tokyo. Western magazines are familiar things, whereas in the west you are unlikely to see a Japanese magazine unless you really want one.

Design-wise there's not much difference after that. Many westerners think that the average Japanese magazine looks very messy – this is partly to do with what you're used to, but I think for a lot of the cheaper information-based magazines content is far more important than design and it shows. On the other hand there are some beautifully designed magazines, so I guess that's much the same as anywhere.

One significant difference is the way magazines are put together. There is an editor-in-chief that runs the show, but there is another tier of editors that are allocated a section of the magazine to put together each issue. Often these editors are freelance and sometimes sections are farmed out to separate editorial companies. In

Interview
Steve Martin
Creative director
***Eat* magazine**

Studio Voice, January 2002, 226 x 300mm/8 ⅞ x 11 ⅞ inches

both cases the editor is expected to come up with idea, the layout, to book a photographer and have all content ready for production. This is why some magazines seem to change personality as you flick through.

This editorial dominance follows through to the top; it's the editors you hear about. One exception to this is a designer called Yasushi Fujimoto. In keeping with the system I mentioned above, he has his own company (Cap) and so works independently of the magazines he designs for. He and his team have art directed *Studio Voice, Taiyo, Ryuko-Tsushin, Marie Claire Japan, Ritz, Dune* and *GQ Japan*.

What do these differences mean for *Eat*?
The text in *Eat* is printed in both English and Japanese – half the editorial and design team are Japanese, half are English – but we follow the western model of production. Everything is done in-house with our dedicated team. But we can't just write in one language and translate to the other. There are the obvious cultural differences. When we ran a detailed story about Jewish culture and food it had absolutely no context in the Japanese world view so we couldn't include a Japanese translation – we just didn't have space to explain what is common knowledge to the westerner.

But there's also the different expectations from readers to take into account. Japanese readers don't like too many new facts in their writing, as it is considered offensive, while westerners expect to learn lots as they read. So while the English version of an article might be packed with information, the Japanese may be more vague and descriptive.

The exception to this is product information. Japanese lifestyle magazines work on the basis of 'If you want to be X, then you need to have this, wear that...' and there then follows 20 pages of product photos, much of which has been put together with the manufacturers. And you get the same formula for every target audience. In this way, the product is rarely criticized and thus the good relationships between the magazines and their clients are maintained.

Do companies pay for editorial space?
Absolutely. That is probably where most of the non-circulation income comes from. Companies are far more interested in paid editorial than straight advertising. It's a bit like 20–40% of the magazine being an advertorial, but without the little line at the top of the page to that effect. This is why there is less conventional advertising. It's changing a little, but we have had a major struggle trying to avoid tie-up at *Eat*.

After two years of publishing *Eat* I feel we've probably chosen the most difficult way to do everything. Being independent and doing the whole thing ourselves – content, production, sales (trying to do it with straight advertising instead of selling editorial) and distribution, we are doing the complete opposite of what is acceptable here. Just breaking even is a success for us

and we rely on other projects to pay the bills. But I think there is a change taking place and we are starting to become more accepted, so we'll keep at it.

We are also constantly challenging our own staffs' assumptions about magazines. The Japanese team question the English and how we lay it out and vice versa. This makes us think differently.

Which are the other ground-breaking titles?
There are a lot of interesting magazines that come and go. But to have a major impact here you have to be mass market and that brings its own limitations. *Brutus* is probably the most ground breaking – it is a bi-monthly men's magazine that when it first launched was different for being a young lifestyle magazine.

WATCH OUT WATCHES!

世界標準の時計選びを教えます。

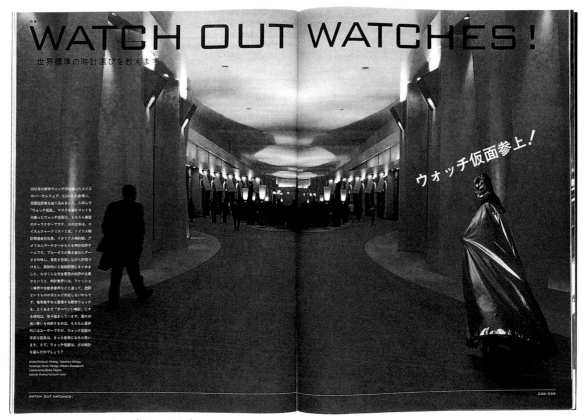

ウォッチ仮面参上！

Brutus, June 2002, 210 x 285mm/8 ¼ x 11 ¼ inches

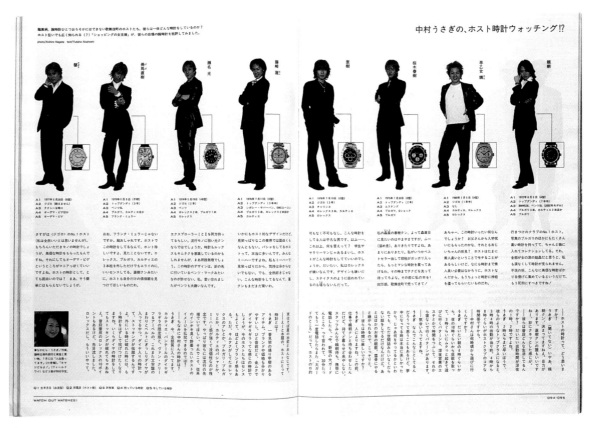

中村うさぎの、ホスト時計ウォッチング!?

Brutus, June 2002

Viviane Sassen

Ian Lopez

Politieburo
Koninginneweg

Paul Bellaart
Germaine Tournier

Tommy Wieringa

Agata Zwierzynska

Stuart Bailey

n Rothuizen

Karen Heuter

Johannes Schwartz

ert Houbrechts

Martine Stig

Arjen Mulder

Mascha Smitt

Devon Ress

Sec (*The Netherlands, Issue 6*) *165 x 220mm/6 ½ x 8 ¾ inches*
This magazine sets up art projects and publishes the results as magazines. In this example, one photograph was interpreted through text by four different writers, each of which were then in turn interpreted by three different artists. The project was published with the back and front covers (THIS SPREAD) acting as a diagramatic guide to the project and the way it is layed out in the magazine. Each block of colour represents a page, the top left hand corner being the front cover. This is followed by the original picture that started the process. Four colour lines lead out from this picture and direct the reader to the pages with the four written texts and from each of them three lines spread out to the artists' interpretations. The coloured lines appear on the pages themselves (OVERLEAF).
Design *OK, T/F*

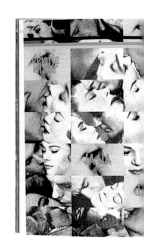

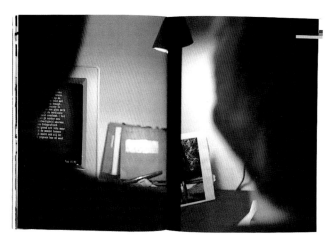

The English translation of this Sec.: www.veenman-druk.nl

Sec. has started from the idea of creating a space for autonomous work by various artists. It should be considered as a collection of personal images, that was created without any commercial purpose. Sec. welcomes all suggestions and participation. You can send us your images / ideas (please only recent or unpublished work) as follows:

Send colorcopies at A4 - size (maximum). We will ask for the originals if necessary. Put name / adress / phonenumber and all credits on the back of every copy. Any introduction / information about the work is welcome.

Send it to:
Sec.
p/a Saxen Weimarlaan 14-II
1075 CR Amsterdam
T +31 (0)20 67 67 774
F +31 (0)20 67 67 764
E marlien@xs4all.nl

We would like to keep the colorcopies, as we are starting up an archive that could be used later on. Originals (when asked for) will be returned after the issue has been published.

Editorial staff:
Martien Mulder, Vivienne Sassen, OK!
Generously printed by:
Veenman drukkers,
Postbus 18, 6710 BA Ede
Lithography: Nauta en Haagen, Oss
Design: OK!, T/F +31 (0)20 68 23 211

With the support and enthusiasm of:

LEVI'S

FANCLUB ✧F

Thanks to: Annemiek Terlinden

PLEASE NOTE:
For the previous issue of Sec. (PS) we asked Margit Lukács to interprete some of the photographs which were selected for Sec.5. She chose the photographs made by Marnix Goossens (these photographs are shown above), for the reason she liked these the most. This has led to a completely different series of images (besides: 'paddestoelenmeisies', 'natuur2', 'natuur' and 'wurlspaddestoel') which should be considered as a seperate piece of work. In our enthousiasm we forgot to ask the photographers and especially Marnix for their permission. We realize this mistake and we would like to apologise again to all and mainly Marnix.

Sec. editorial staff.

Pace / 105

Sec.08 Winter 2000/2001

Sec.08 Winter 2000 / 2001

X : -0,75 Y : 0,00 Z : 2,10

Sec *(The Netherlands, Issue 8, Winter 2000/01) 165 x 220mm/6 ½ x 8 ¾ inches*
The magazine as art gallery: this issue is based on an art exhibition. The content of the issue was displayed in a gallery where guests were invited to view the work. This event was photographed. The magazine consists of these photographs of people viewing the art, the pages running in the order in which the works were hung. The artists' names are identified through map references to their works' position in the gallery (each page has a diagram of the gallery showing where the work was hung).
Design Yolanda Huntelaar, Roosje Klap and Richard Niessen

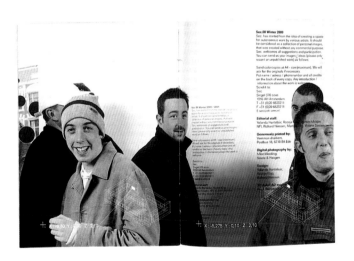

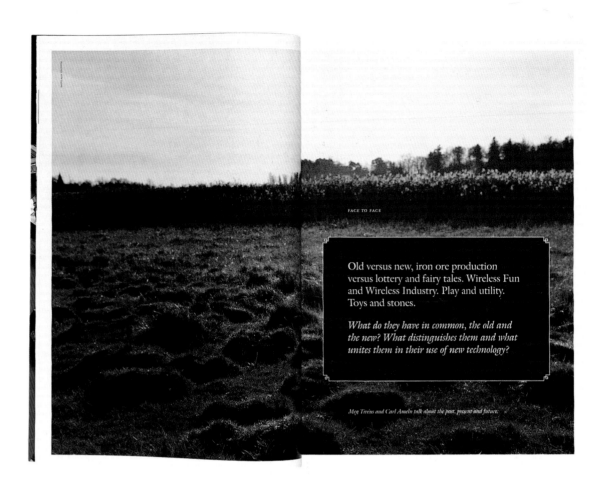

FACE TO FACE

Old versus new, iron ore production versus lottery and fairy tales. Wireless Fun and Wireless Industry. Play and utility. Toys and stones.

What do they have in common, the old and the new? What distinguishes them and what unites them in their use of new technology?

Mts Tréus and Carl Ameln talk about the past, present and future.

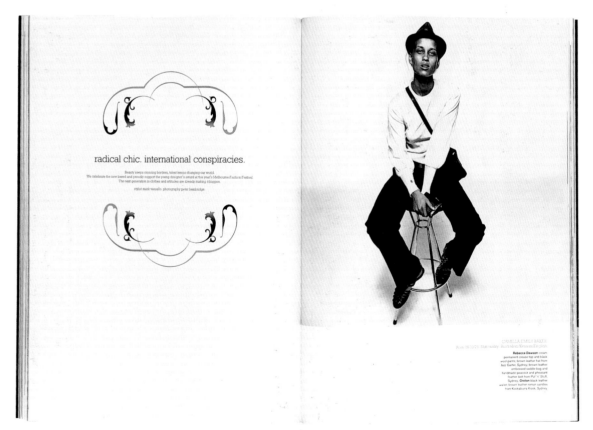

radical chic. international conspiracies.

Beauty keeps crossing borders, talent keeps changing our world.
We celebrate the new breed and proudly support the young designer's award at this year's Melbourne Fashion Festival.
The next generation in clothes and attitudes are already making it happen.

stylist mark vassallo. photography peter bennbridge.

TOP **Brainheart** (*Sweden, Issue 5, January 2002) 210 x 297mm / 8 ¼ x 11 ¾ inches*
This magazine, covering Sweden's wireless technology industry, eschews the brash hi-tech styling generally associated with such magazines. Instead, it uses a nostalgic mix of small headlines, serif fonts and decorative borders to present its cutting-edge content.
Art director *Peter Assarsson*

BOTTOM **Oyster** (*Australia, Issue 39, April/May 2002) 240 x 330mm / 9 ½ x 13 inches*
Adaptations of traditional decorative flourishes are used in this fashion title to bring character to the simple layouts.
Art director *Tim McIntyre*

Sound of the Suburbs

TRANSMISSION ONE 107.4
ROBERT WYATT

Heirs and Graces

CHRISTIAN LESEMANN

All Creatures Great and Small

TIM WALKER

Big (USA, Issue 34, 2001) 235 x 297mm/9 ¼ x 11 ¾ inches
Each issue of this fashion/style magazine is themed, the whole look and feel being created
each time by a different team of editors and designers. This issue about modern England used
traditional book-style typography and decorative flourishes to emphasize its Englishness.
Art director Daren Ellis

(...)
Re-Magazine #7

– NOT IN THIS ISSUE –

– Essay by cultural philosopher Frederick Buston on the influence of remote control on non-linear thought:

In his essay Frederick Buston explains that with the dawn of remote control, people no longer physically walk to their television sets to change channels, but instead decide lazily from the comfort of their chair, what they want to see. He philosophizes that the remote control has directed the speed of the media and not vice versa. In addition he argues that the credits for the development of our current media culture all belong to the under-appreciated inventor of the remote control.

– NOT IN THIS ISSUE –

– Series by Terry Richardson. Different female models pose smoking or drinking against a white wall in different positions, compromising or not. The series consists of the following pictures:

Picture 1
– A white blonde model stands before a white background. [...]

Picture 2
– A young blonde girl with thirty features sits on an upholstered stool against a reddish brown background. [...]

Picture 3
– A blonde model stands naked in front of a white background. [...]

Picture 4
– A white middle-aged woman with half-long dark blond hair stands before a white background. [...]

(...)

RE-VIEW PART 1 – "I DECIDED TO STAY IN"

By Jokif Smith
Photography Vivinne Sassen

Introduction.

Being anybody but himself started to confuse the award winning ghostwriter John Smith. There was a world outside clamoring to be described, as if everything needed a voice. It was an overburdening responsibility, a responsibility too big too shoulder. John Smith decided to stay inside and lock himself in for a while.

– Selected Quotes –

– "I don't see my house as an extension of myself, nor is it an expression of my personality. It's just that I'm able to cope with the low level complexity of my apartment. I guess I'm the kind of person that prefers to understand a lot about a little instead of understanding a little about a lot."

– "At first I was talking to myself unconsciously. I was giving words to what I was doing or seeing. Like mantra's, how my acts were related to what I was thinking. That was a liberating observation."

– "Isn't it funny that the first thing in life you receive is not a thing but a sound? I was named John Smith; Dijon Smit. That's the sound I've lived with ever since. There's an enormous variety of sounds but not every sound is a good name. The sounds of, for example a car driving past or a sheet being torn in two are not good sounds for a name. Yet it is these sounds that are related to my name; Dpjsssssssssssmmmmmm (car), Ssssssshhhhhhhmmmmm (sheet)."

– "Staying inside doesn't mean being locked up in yourself. No, it's about relationships between things. Things need each other. Things need to be connected! I like to see myself as a thing as well."

– "Eventually I started writing, resulting in Texts Meant To Be Written, Not To Be Read. One could say I was giving new meaning to the notion of ghostwriter."

– Selected Quotes –

–"INBOX"

Re– *(The Netherlands, Issue 7, Autumn 2001) 220 x 297mm / 8 ¾ x 11 ¾ inches*
Every page is styled as if it had been torn from some other publication, one which uses a book-like grid, applied rigidly to every page whatever its content.
Art director Jap von Bennekom

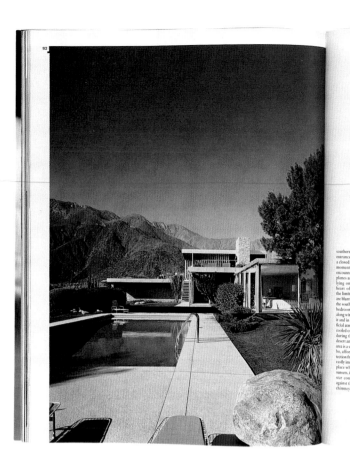

HOUSES TO STIMULATE THE SENSES

southernmost pavilion next to the main entrance is a garage. Here the building has a closed, almost forbidding aspect. But the moment you step through its entrance you encounter a breathtaking interplay of forms, planes and spaces. Guided by a slice of wall lying on the ground, you are led into the heart of this spatial continuum in which the limits between the interior and exterior are blurred. The living area opens up towards the south with direct access to the east-facing bedrooms. The pool immediately outside, along with the polished terrazzo paving around it and in the courtyard areas, creates an artificial atmosphere. The stone surfaces can be cooled or warmed as it can get extremely hot during the day in the Southern Californian desert and very cold at night. Above the living area is a small roof terrace which, with its gazebo, affords a panoramic view as well as protection from the sun and the elements. One can easily imagine the powerful fascination of this place when nature displays its sunrises and sunsets, its dramatic storms, cloud formations, star constellations or flashes of lightning against the desert sky. Alongside the massive chimney, which lends an important vertical accent to the spatial and structural composition, the covered patio constitutes part of the building's silhouette. Further pavilions contain guest rooms and the service area, comprising a kitchen and rooms for storage and for the staff. Neutra's family houses always feature small, compact kitchens which still look perfectly modern today. That is not to say that his purpose in designing rooms was ever reductive, as was the case in early modernism (it was not until the 1960s in Europe that he first encountered the problem of restricted floor space and cubic volume). What he aimed for was clarity and suitability, as well as "stimulation of the nervous system", as he described it, through the choice of materials, particular spatial forms, and the design and position of apertures to create movement or visual relationships.

In 1954 Neutra published a book entitled *Survival through Design*, comprising forty-seven essays outlining his theoretical views. The Kaufmann House marks the first of a series of family houses built after World War II through which Neutra was able to hone his theory of the house as an ecosystem. His houses were designed as living spaces, and they were meant to be noted for their atmospheric qualities rather than their aesthetic virtues. The architectural profession continues to ignore this aspect of the development of modernism and does no real justice to Richard J. Neutra or Frank Lloyd Wright. The icons of modernism are, as before, Rietveld's Schröder House (1924), the Villa Savoye by Le Corbusier (1929/31) and Farnsworth House by Mies van der Rohe (1950). But the rediscovery of the "holistic" Neutra is in the offing. Many things point towards this, not least of all the photographs of his architectural works. What they convey is not some cool aesthetic that predetermines a certain demeanour. Rather, his rooms relate in a very special way to people in their entirety as natural and cultural beings. Few architects have ever attempted this. The Kaufmans Desert House is one of the very important family houses of a modernism that still remains to be discovered, whose aesthetic perfection was never an end in itself but came to represent the creation of a living space which aims to strike a harmonious balance between man, nature and technology – and which, when all is said and done, is simply beautiful.

www.neutra.org

ARCHITECTURE 93

THE HOUSE IN THE DESERT

Premium (*Germany, Issue 2, 2001*) *230 x 300mm/9 x 11 7/8 inches*
Using 'The Culture of Luxury' to promote Ford's Premier Automative Group brands, the design of this magazine is intensely detailed. Quiet typography is mixed with distorted elements of tramline rules to produce a simultaneous modern–traditional impression.
Art director *Paul Neulinger*

WORDS LUCY CAVENDISH
PHOTOGRAPHS WOLFGANG LUDES
ART DIRECTION KIRSTEN WILLEY
MAKE-UP SONIA KASHUK @ THE WALL GROUP
HAIR SATORU @ ORIBE SALON

CHRISTY TURLINGTON

WHEN PEOPLE FIRST *christy turlington*
MEET ME, THEY
ALWAYS ASSUME I'LL
BE STUPID OR BORING.

lucy cavendish WHY DO THEY THINK THAT?

OH, BECAUSE ALL
MODELS ARE DUMB.
DIDN'T YOU KNOW
THAT?

lucy NOT REALLY.

IT'S HARD TO GET *christy*
TAKEN SERIOUSLY.
I MEAN WHAT COULD
BE MORE RIDICULOUS
THAN A FORMER
MODEL WHO NOW
LIVES HER LIFE ON
AYURVEDIC
PRINCIPLES AND HAS
STARTED UP A
SKINCARE BUSINESS?

IT HAS TO BE SAID that Christy Turlington isn't ridiculous or stupid or boring. She may be slightly long-winded at times – her devotion to Ayurveda is almost fanatical – but her knowledge is admirable. I meet her early on a Friday evening at her hotel suite in London. She opens the door. For a minute I am not sure if the person standing in front of me is Christy Turlington or whether the other tall, preposterously slim person standing next to her is Christy Turlington.

That, in itself, is quite off-putting. How can I not recognise one of the most photographed women of the Nineties? The face of Calvin Klein and Maybelline? It's a model thing. The whole point is that their looks can be endlessly →

Bare *(UK, Issue 3, January/February 2001) 230 x 300mm/9 x 11 7/8 inches*
Soft photography and a gentle approach to type and colour give this
magazine a distinctly different feel to other titles in the women's market.
Art director Kirsten Willey

images

41

rétrovision

57

Magazine *(France, Issue 13, February/March 2002)*
200 x 260mm/7⅞ x 10¼ inches
This magazine about magazines has an extremely simple yet sophisticated design that lets the content – sample pages from other magazines – stand out.
Art director *Rachel/H5*

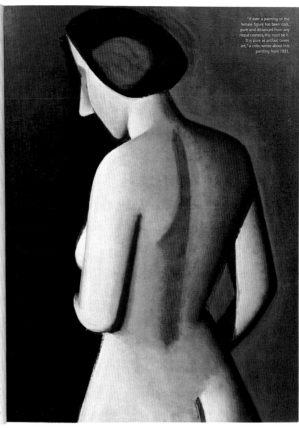

"If ever a painting of the
female figure has been cool,
pure and distanced from any
risqué coyness, this must be it.
It is pure as archaic Greek
art," a critic wrote about this
painting from 1931.

Feeling Blue

At the time of his death in 1950, Vilhelm Lundstrøm had become one of the most influential Danish painters of his time. For 35 years his art had been considered provoking and had been admired and despised, and diagnosed as downright insane by representatives of the medical profession. Today his works can be found in every major Danish art museum, and when the occasional Lundstrøm painting is sold, the prices they fetch are ever increasing.

Vilhelm Lundstrøm was born on Amager. He was a weak, tubercular boy who kept to himself. His father forced him to take on an apprenticeship as a decorator, but when he was 20 the young Vilhelm was accepted at the Royal Academy of Art in Copenhagen where he astonished everybody by drawing a model in a pure cubist style.

From then on he was an artist with capital A, and he took part actively in the vibrant artistic environment in Copenhagen. During World War I the Danish capital was often referred to as 'the waiting room for Paris' since many Norwegian and Swedish painters, sculptors, writers and musicians were living in the city. They discussed and exchanged ideas with Danish artists and enjoyed not having shortage of food or drink.

The relative wealth, owing to Denmark's neutrality policy, meant that much of modern French art could be seen in Copenhagen. The Scandinavian artists got a taste of what was to come when the war ended and it became possible once again to move freely through Europe. The Danish National Gallery had a large exhibition of French art in 1914, and the merchant Christian Tetzen-Lund purchased great modernist works and was pleased to put them on display. Among other he acquired two late cubist works by Picasso, which are said to have had a significant influence on Lundstrøm.

Vilhelm Lundstrøm exhibited a number of clearly cubist inspired compositions in 1917 at the Artists' Autumn Exhibition. He mixed slag in his colours and used collage elements in his naturalist paintings. Today this might seem quite innocent, but at the time the technique caused offence:

"When a person ventures to paste old newspaper clippings, dirty chemise lace and tin foil scraps on his dirty oil smeared canvas, then one can go no further in achieving the highest personal freedom to offend and ridicule the noble audience," the art critic of the newspaper Politiken wrote.

Then Vilhelm Lundstrøm was just 20 years old and had not yet developed the calm nature and self-confidence which later would leave him indifferent to criticism. In a letter to a friend living in the USA, Knud Merrild, he wrote about his experiences:

"I dare not show up at the exhibition on Sundays for fear of being apprehended and murdered. It is not amusing, I had not expected so much consternation, the press has not merely been satirical, but mean."

The following year Lundstrøm went all the way and exhibited three abstract compositions made from old wooden crates. These were deemed even more provocative, but to make matters worse, the exhibition coincided with the publication of a rather bizarre theory on modern art by an otherwise well-reputed professor. Bacteriologist Carl Julius Salomonsen believed that modern art was simply caused by a contagious mental illness, during which the artists entered a state of sick, hysterical excitement >

30 Copenhagen Living

Hooked: timber, steel, fruit and cars are shipped
to and from the world's fifth largest port

Photos : Hartmut Nägele

THE BEST KEPT SECRET

The age of secrecy is over. Secrets have had their day, like the Secret Seven and, more recently, the secret services. The need for secrecy has gone into sharp decline. Nothing remains undisclosed and little is hidden from the public eye. We are living in the information age. We know everything, have seen and experienced so much. Been there, done that. What next?.

So what do you know about Antwerp?

Oh, Antwerp. That's in Flanders, isn't it? Don't they speak Flemish there? But wait a minute, is it in Belgium or Holland? Antwerp, Anvers. Very old city, with a great past. How did we get onto Antwerp of all places? And what's its population?

Antwerp, city of secrets.

Welcome to the first issue of MINIInternational, a brand-new magazine for a brand-new car. The car is the MINI, a unique car, an icon that bridges nations, classes, generations and cultures with an elemental lightness and an effortless smile. The MINI is built in Oxford by the BMW Group. The first issue of the magazine is dedicated to Antwerp, a city in Flanders beloved of trendsetters and businesspeople from Paris to Sydney because for several years it has been generating some of the most thrilling fashion designers around and, for a population of around 650,000, has a fantastically high proportion of creatives and artists. Or to put it another way, when fashion editors from New York's Madison Avenue or Tokyo's Shibuya district learn how to spell and pronounce such Flemish names as Ann Demeulemeester or Walter Van Beirendonck, to mention but two, there's got to be something behind it.

And that, reader, is more or less what you will discover in this magazine. It's not your run-of-the-mill customer car magazine, it's much more than that. MINIInternational is a magazine with an international spirit. It values style and creativity. Each issue of MINI International will focus on an exciting city. Cities are the habitat of an urban, cosmopolitan generation, the arena in which modern life is played out.

Yet the notion that cities have to be big to be exciting and inspiring seems all-too antiquated these days. It's partly down to our increasingly mobile society, the media, and modern-day communication channels such as the Internet. Metropolises have their clichés too, and though the provinces still exist as a geographical phenomenon, as a mindset they're well up in the league of endangered species – which happens to be good news for a change.

In the 21st century there's nothing secretive about secrets. Secrets are what you don't yet know. Prepare for some surprises as we unveil the well-kept secrets of the old, new city of Antwerp. And prepare to be surprised by a car that is all-too-often underrated. Enjoy unwrapping the secrets of Antwerp with MINIInternational, the urban magazine, and with MINI, the car designed for an urban generation.

MINI**International** ANTWERP 9

Season to taste

Cooking in a way that's in tune with the seasons doesn't mean that you have to rush to the market every day. Instead, you can create new recipes by combining your usual ingredients with the pick of seasonal produce. In June, for instance, add lush summer treats such as fresh peas, sorrel or sea bass to your shopping basket. Then, whether friends are dropping by for dinner or you just want to rustle up a quick weekday supper, it's easy to make wonderful dishes that have a true taste of summer.

Words & recipes	Sybil Kapoor
Photographs	David Loftus
Food styling	Louise Mackaness
Styling	Daniella Shone

Recipes start
on page 95

36

Crab cake salad
This makes a light supper or a sophisticated first course. Fresh white crab meat is mixed with spring onions, red peppers, lime juice and mayonnaise to make patties, which are covered with dried breadcrumbs. Serve hot on a bed of salad leaves with a wedge of lime

37

OPPOSITE **Copenhagen Living** (*Denmark, Issue 4, Winter/Spring 2000/01*)
204 x 275mm/8 x 10 7/8 inches
Creative director *Andres Peter Mejer*
Mini International (*Germany, Issue 1, 2001*)
207 x 265mm/8 1/8 x 10 1/2 inches
Art director *Mike Meiré*
These examples show design stripped down to basics for different purposes. *Copenhagen Living* (TOP) uses modernist principles – the headline ranging right to balance the standfirst to its left and the line length of the text carefully kept to a legible length – to express its Scandinavian origin. *Mini International* (BOTTOM) uses a similarly spare design but knowingly breaks such rules, relying on its relationship with the photography and illustration throughout to lift it above the mundane.

THIS PAGE **Waitrose Food Illustrated** (*UK, June 2002*)
220 x 300mm/8 3/4 x 11 7/8 inches
A simple, clean design similar in approach to *Copenhagen Living* but where the addition of colour and tight kerning and a spatial relationship with the accompanying photograph make it more reader-friendly.
Art director *Brian Saffer*

IndomabileAnjelica

Una grande figlia d'arte scopre la regia: *Agnes Browne*, ambientato nell'amata Irlanda della sua infanzia, è il felice debutto della Huston, attrice da Oscar, sulle orme di papà John
di Silvia Bizio
Foto di Helmut Newton

D (*La Repubblica delle Donne*) *(Italy, 29 July 1999)*
210 x 276mm/8 1/4 x 10 7/8 inches
High production values and good quality paper enable this weekly newspaper supplement to use white space, typography and spare design with the confidence of a monthly magazine.
Art director Joel Berg

Es uno de los pocos modistas de alta costura que marcaron la pauta fuera y dentro de España. Desde la familia Franco hasta la reina Sofía, ha vestido al poder femenino de este país durante más de medio siglo. Ahora, con casi 80 años, sigue con la aguja en la mano para crear ropa de hombre.

Manuel Pertegaz

Sesenta años creando moda

Por **Arcadi Espada**. Fotografía de **Carles Ribas**

La anécdota germinal de la vida de Manuel Pertegaz (Olba, Teruel, 1922) tiene lugar en una sastrería del paseo de Grácia de Barcelona, donde el aprendiz cose con 20 años. Una de las oficialas le enseña un corte de abrigo y le comenta que no sabe a quién dárselo.

–Ya te lo haré yo, mujer.

–¿Tú, Manolo?

Se lo dio. Siempre hay un ángel neorrealista en los milagros. A los pocos días, la mujer entró con su abrigo en la sastrería. La dueña no daba crédito.

–¿Pero de dónde has sacado ese abrigo, Conchi?

–Manolo...

A partir de ahí empezó una vida de >

EP[S] (*El País*) (*Spain, 10 March 2002*)
212 x 272mm / 8 ³/₈ x 10 ³/₄ inches
A simple set of elements – two typefaces and three colours – are used to create a clean, modern design that retains a newspaper's journalistic seriousness while not denying its 'magazine-ness'.
Art director *David García*

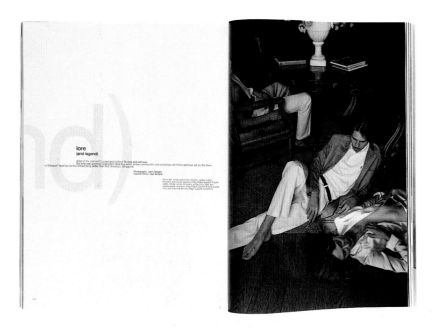

lore
(and legend)

[End of the cold rich? Loved and rushed. Revved and refined. But who can question aristocratic style in a world where communism and anarchists still follow fashions set by the Duke of Windsor? And how do the refined thing better than that, American, Mr Lauren.

Photography Joe Vorgas
Fashion Editor Karl Templer

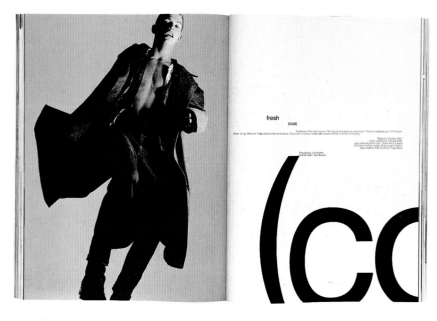

fresh
(coat)

A preview of the next season. The big coat is back on your trace. Classics leading out of the part.
Wam, Lang, Maxine, Raps and cottes and boos. Cool with a hoby, mixed with what's new for a sense of mystery.

Striped polo tee-shirt,
black waistcoat with pockets
grey textured wool skirt, black skinny jeans
and black leather boots all by Jean-Paul Gaultier.
Black leather belt by René Hugo Boss.

Photography Goed Sims
Fashion Editor Karl Templer

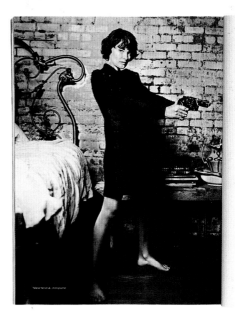

friends
(Helmut Lang version)

Has the mirror of the raw, authentic classic. The non-uniform uniform of this creative class.
How, are some culture workers dressing tips to wear it personally or a sleeve.

Photography Craig McDean
Fashion Editor Sandra Semburg

Arena Homme Plus (*UK, Issue 17, Spring/Summer 2002*)
230 x 300mm/9 x 11 7/8 inches
A rare 80-page run of black-and-white fashion stories here is broken up by small headlines at the start of each separate story. Impact is added to these start pages through the use of random fragments of the headlines blown up out of all proportion on the page.
Art directors *Joseph Logan and Tim McIntyre*

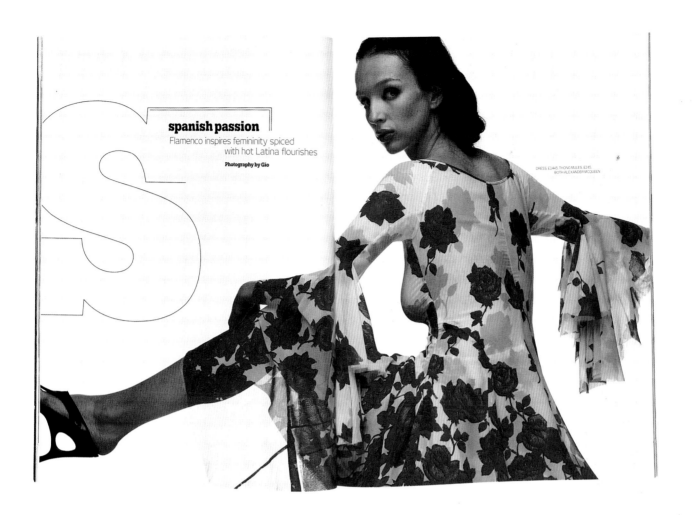

spanish passion

Flamenco inspires femininity spiced
with hot Latina flourishes

Photography by Gio

DRESS, £1445, THONG MULES, £245,
BOTH ALEXANDER MCQUEEN

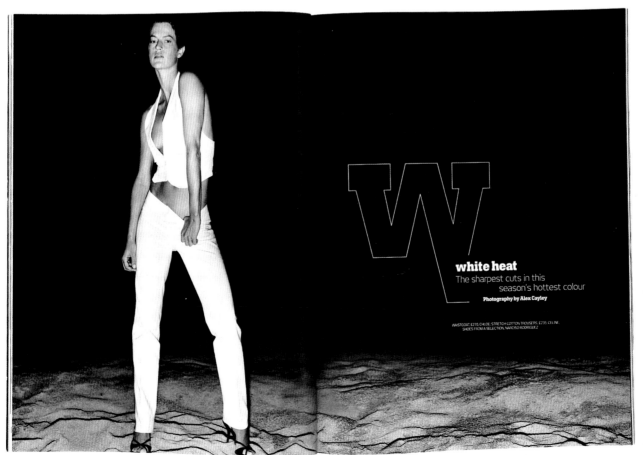

white heat
The sharpest cuts in this
season's hottest colour

Photography by Alex Cayley

WAISTCOAT, £270, CHLOE; STRETCH COTTON TROUSERS, £235, CELINE;
SHOES FROM A SELECTION, NARCISO RODRIGUEZ

Harvey Nichols Magazine *(UK, Issue 27, Spring 2002)*
220 x 285mm / 8 ¾ x 11 ¼ inches
Drama is added to the opening pages of these fashion stories by using an enlarged,
outlined version of the first letter of the headline.
Art director *Sam Walton*

THIS PAGE **Label** (*Italy, Issue 2, Summer 2001*)
190 x 300mm / 7 ½ x 11 ⅞ inches
The problem of presenting text in two languages simultaneously is overcome by running Italian on a black background and English on white. The grey boxes add shape and dynamism to the spread.
Art director *Roberto Maria Clemente*

OPPOSITE, TOP **Neo2** (*Spain, Issue 17, May/June 2001*)
215 x 275mm / 8 ½ x 10 ⅞ inches
The randomly shaped text columns and overblown pull-quotes lend an air of chaos to this piece about the probability of catastrophy.
Art directors *Ipsum Planet*

OPPOSITE, BOTTOM **Another Magazine** (*UK, Issue 2, Summer 2002*)
250 x 320mm / 9 ⅞ x 12 ¾ inches
Here, the relationship between the text columns and the inset pictures varies to avoid the usual gutters of white space between the two.
Creative director *Alex Wiederin*

texto_cdepravados@eresmas.net>

APOCALIPSIS

01. que sí, ya falta poco//. El apocalipsis se ha convertido últimamente en un lugar demasiado concurrido. Ya casi parece un parque de atracciones con sus trenes del terror, sus payasos locos y los niños con sus videojuegos. "¿Has visto lo del apocalipsis? ¡Sí, cómo mola!"

Cuando preparaba este E-dikto, inspirado por los últimos informes sobre vacas locas y los terremotos de la India y El Salvador, dudaba ya de la consistencia de este manoseado apocalipsis. Sonaba demasiado a película de serie II. Hasta que leí lo de las novatadas en la Casa Blanca. Es tradición, por lo visto, que el poder derrotado deje la gran mansión echa unos zorros, como cuando en el último día de curso marcabas tu nombre en el pupitre. Los de Clinton se habían excedido en la broma, según los chicos de Bush. Imaginando ese patio de colegio aberrado volvieron con fuerza renovada mis antiguos temores apocalípticos. También vi de otra manera el vilipendiado recuento electoral yanqui. No creo que se trate de una chapuza del sistema, sino al contrario, el sistema funcionó tan bien que detectó la chapuza de la democracia de fin de siglo. (En Europa todavía no se hila tan fino, aquí los recuentos son arcaicamente concluyentes). Y es que llegados a este punto de la función, ¿a quién le importa quién gane? Algorín o Jorgito, ambos dejarán su nombre en el pupitre al final de curso.

De repente, toda la paranoia catastrofista recobra validez: el mundo lo domina una panda de bromistas infantiloides con las mismas inquietudes y valores que el mocoso de tu sobrino. Con el reloj del Apocalipsis puesto a punto otra vez, visité los clásicos sitios conspiranoicos y comprobé que el asunto está que arde. La mayoría han dejado de lado las fantasías extraterrestres y las fabulaciones sobre JFK. Ahora se refieren a artículos del ABC News, a investigaciones científicas y a premios Nobel. Las claves con las que juegan los nuevos apocalípticos son absolutamente reales. Los profetas iluminados ya no tienen voz ni voto. Hoy son los científicos quienes nos hablan del fin del mundo. Para empezar, hablemos del teorema matemático del cosmólogo

Brandon Carter, base fundamental y aterradora de cualquier pensamiento apocalíptico. Basándose en las más elocuentes leyes de la probabilidad, dice Carter que si el mundo se acabase en los próximos 50-100 años, a nosotros nos habría tocado vivir en el tiempo de máxima densidad planetaria, concretamente en el tiempo en el que vivió un 10% de toda la humanidad. Si, por el contrario, la humanidad perdurase durante miles de años más, multiplicando progresivamente su población, nuestro lugar en el tiempo pertenecería a un ridículo y poco probable 0,1% o 0,01% del conjunto total de los humanos. Es decir, que por simple probabilidad, es mucho más factible que formemos parte de ese 10% que de ese 0,01% de los humanos, con lo cual se debe quedar poco para el fin de la especie. El teorema, llamado El Argumento del Juicio Final, irrita a científicos de todo el

LA IMPOSIBILIDAD DE DETECTAR SEÑALES PROCEDENTES DE CIVILIZACIONES EXTRATERRESTRES PUEDE DEBERSE A QUE TODAS ELLAS SE AUTO-DESTRUYEN POCO DESPUÉS DE DESARROLLAR CIERTAS TECNOLOGÍAS AVANZADAS. (John Leslie, profesor emérito de Filosofía de la Universidad de Guelph).

mundo por el simple hecho de que matemáticamente es irrebatible y filosóficamente antinatural.

El teorema de Carter no especifica cómo será ese final, pero indudablemente, acelera cualquier amenaza apocalíptica. Todo lo que sigue a continuación sale de la boca y la pluma de científicos y periodistas informados. No se habla en ningún momento de teorías paranoides, sino de realidades presentes y de consecuencias lógicas. La ficción la dejamos para otro capítulo, esto va en serio.

02. catástrofes (geo-terror)//. Ya hemos hablado en otros E-diktos de cómo la teoría de Gaia de James Lovelock se puede volver fácilmente en contra de los postulados ecologistas de nueva izquierda. Si, como dice Lovelock, el planeta es capaz de reajustar el ecosistema en su propio beneficio, sería muy lógico que empezase por eliminar parte o toda la raza humana, su peor enemiga. Gaia tiene a su disposición todo un arsenal geológico (y biológico como veremos más adelante) para ganar esa batalla sin dificultad. Salinización de los océanos, terremotos, maremotos, aumento de la temperatura global, e incluso, si entendemos Gaia como ente cosmológico, asteroides desviados. Si la Tierra se enfrenta al hombre, ¿en qué lugar quedan los ecologistas? Habría que inventar un nuevo crimen para ellos: traición a la especie.

En 1976, un terremoto se llevó por delante a unas

CUALQUIER TERRORISTA PODRÁ DISEÑAR UN VIRUS DE RÁPIDA PROPAGACIÓN CON UN ÍNDICE DE MORTALIDAD DEL 100%. LA NANO-TECNOLOGÍA LE PERMITIRÁ CONSTRUIR UN SISTEMA DE DISPERSIÓN PARA QUE EL VIRUS SE EXTIENDA POR TODO EL PLANETA EN POCO TIEMPO. (Will Ware, Foresight Institute).

750.000 personas en Tangshan, China; 900.000 personas murieron en 1887 a causa de la inundación del río Huang He; también en China. Y más de 1 millón de vidas se extinguieron el 13 de noviembre de 1970 en el Delta del Ganges en Bangladesh. El efecto de El Niño superaba también el millón de pérdidas humanas durante los últimos años 90. Muchos meteorólogos y astrólogos pronostican que entramos en una era de grandes catástrofes naturales o "clima violento" como denominan con cierto pudor. No hace falta más que ver los informativos.

Pero quizá una de las mayores amenazas que se discuten es la del impacto de asteroides. Según John Leslie, es más fácil morir a causa del impacto de un asteroide que ganar la lotería. Se ha estimado la probabilidad de morir así como de 1 entre 20.000. Ya se están gastando millones de dólares en la búsqueda de asteroides cercanos a la órbita terrestre, pero el trabajo es lento y extenso. Dentro de 25 años se podrán haber detectado cerca del 90% de todos los objetos de diámetro superior a 1 km. Hasta entonces habrá que esperar. El astrónomo de la Universidad de Cambridge P.C.W. Davies ha calculado que en el año 2126, el cometa Swift-Tuttle (un trillón de toneladas de hielo a 65 km/seg.) cruzará la órbita terrestre a una distancia de sólo 2 semanas de nosotros. Uno de los mayores problemas con los asteroides es que, en ocasiones, su ruta se desvía inesperadamente. Otro problema grave es que, a juicio de algunos observadores, las medidas que la NASA dispone para evitar una colisión son mucho más peligrosas que la colisión misma.

03. guerra (ciber-terror)//. Ahora que las armas nucleares están al alcance de cualquier chiflado, ya no tiene sentido pelearse por ellas ni por su distribución. Sólo nos queda confiar en eso de la buena voluntad del ser humano. Los temores bélicos modernos son más cibernéticos. La ciberguerra está ya en marcha y si da más miedo que ninguna es porque es más barata y accesible que cualquier otra en la historia bélica. Para muestra, el famoso Efecto 2000, que ya no se sostiene ni como chiste, pero en su día tuvo en vilo a más de uno. Y es que la tecnología nos ha conducido a un punto de indefensión tan ridículo como el de depender de los dígitos de un reloj. Si el Efecto 2000 no provocó ningún desastre no fue porque supieran detectarlo a tiempo, sino porque no era tal peligro, claro que esto no supo determinarlo nadie hasta que no hubo pasado de largo. Cada día se producen millones de errores en los sistemas informáticos de todo el mundo. Errores que pasan completamente inadvertidos porque a simple vista no causan daños. No son

PHOTOGRAPHY OLIVER HELBIG
TEXT AMANDA GRISCOM

buck the system

INSTALLATION – THE FRONT MEADOW IS A LIVING MUSEUM OF THE SOLAR PANEL. IT FEATURES MODELS FROM FOUR DIFFERENT DECADES.

From the San Francisco airport, it's a seven hour drive, due north, to the homestead of Richard and Karen Perez. From the vineyards through the cattle farms and into the snow-capped Sierras,

EXTENDED FAMILY – PHILANA IS A DANCER AND ART STUDENT. HER BOYFRIEND, BEN, IS HOME POWER'S DESIGNER

nature supplies the entertainment. As you head down the far side of Mt Shasta, the highway becomes a road that ribbons through the foothills along the Oregon border. If you know where you're going, the road becomes a trail.

The last outpost of man is a lean-to liquor store with a gas-pump and a donut stand. Beyond here, you will find mastodon bones and Indian burial sites and the occasional software programmer gone AWOL, but not much else. As you head into the hills, the sign nailed to the Ponderosa trunk warns: "California Energy Grid Ends Here."

Living "off the grid" means out of range of the power company. No one really knows how many off-gridders there are in the US. The usual estimate is 200,000 "homeowners", which doesn't tell you much. The Amish are off grid – they shun electricity (and other modern amenities). There are fringe groups off grid – they shun the state. And there are many others who, for one reason or another, choose to rely on themselves for their basic needs. Not only do they generate their own electricity, but they grow their own food, pump their own water, burn their own garbage and maintain their own roads.

The only thing that can be said for certain about off-gridders is that their number is rising. Sales of small-scale solar generators – the kinds for homes and small farms and businesses – are growing at 30 per cent a year. It is one of those cases of an industry and its market converging: the technology gets cheaper,

DO IT YOURSELF – JOE, HOME POWER'S "CHIEF WRENCH", TESTS NEW PRODUCTS AND GIVES READERS HANDS-ON TECHNICAL ADVICE.

more efficient and easier to use, while the users discover they can afford, install, operate and maintain it for themselves. Richard and Karen Perez have played a big part in that. If going off grid is a grassroots movement, their magazine, Home Power, is the first leaf.

OFF THE GRID – FOR SHASTA THE DOG, IT'S A MAN OF LIFE

The modern photovoltaic cell, a wafer of silicon that converts sunlight to electricity, noiselessly and without fuel or moving parts, was born unexpectedly in 1953, the accidental brainchild of scientists at Bell, a corporate lab then at the heart of what is sometimes called the American military industrial complex.

The Cold War was freezing in the mid 1950s, the space race was on its starting line, and the photovoltaic cell, a break-through without a purpose, was about to find its calling. On March 17, 1958, the US Navy launched its first satellite into orbit. The Vanguard IV – solar panels encircling its tiny frame, sunshine powering its radio – would stay in touch with Earth for years to come. The age of telecommunications had dawned, with a little help from the sun.

When Richard Perez heard about the photovoltaic effect in his high school

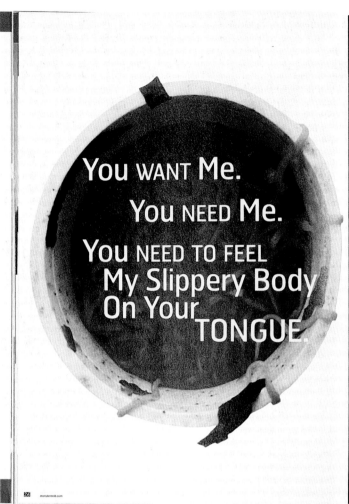

You WANT Me.
You NEED Me.
You NEED TO FEEL
My Slippery Body
On Your
TONGUE.

ALONG with television, the internet and omnibus editions of *Hollyoaks*, Pot Noodles are one of the greatest ideas of the 20th Century. Considering common perception used to be that it was only eaten by students and street dwellers, the wholesome snack's had a remarkable rise to the top of the food tree. Just ask Noel Gallagher, All Saints, Martine McCutcheon, 911, Jamiroquai or Zoe Ball – they can't get enough of the post-pub treat while 20 million other users worldwide regularly sample the delights of the pot snack.

The Pot Noodle first arrived in 1979 and was developed from an idea discovered in Japan. It came, it was eaten, it conquered – with even the most culinary-challenged able to follow the simple add-boiling-water-stir-and-stick-in-mouth instructions. Take it to work, college, a party, even munch on the succulent strands as you stroll down the street (you'd look stupid, but you could).

But gone are the days when supermarkets would only stock the traditional Beef & Tomato flavour. These days there's everything from Pot Mash to Pot Rice to Pot Cous Cous. So selecting your easy-cook meal of choice for that all-important "Come round to mine and I'll cook" third date is now a treacherous minefield.

But what's the ultimate all-conquering snack in a pot? In an attempt to answer the question once and for all, four self-confessed Pot Addicts (who, when not 'cooking', double as students) were invited round for some extra-scientific testing.

"My parents like them because it means they don't have to cook for me," laughs Hamish.

"They're the perfect 4am snack," says James, a self-proclaimed 'full-time lazy sod'. "They're absolutely the best cure for munchies."

"I eat them at college all the time," pipes Shelley. "My parents think they're disgraceful – they say they're like cardboard, but I eat them because I can't be bothered to make sandwiches."

Meanwhile, last of the hardy testers Penny claims to be blond and proud of herself, no matter what she does. But the anxious look on her face as she examines the reconstituted foodstuffs in front of her suggests she may be about to change her mind.

Kettles switched on and forks at the ready. Let the tasting begin...

Words: Damian Hall
Pictures: Christophe Tweedie

Mob (*UK, Issue 1, Summer 2001*) *220 x 297mm/8 ¼ x 11 ¾ inches*
Deliberately styled to look slightly messy and unkempt to reflect the subject matter and the target audience (teenage users of Monstermob mobile phone ringtones), the type and image combine to become more than the sum of their parts in this feature about pot noodles.
Group art editor Martin Tullett

I'd Like To Buy The World a Shelf-Stable Children's Lactic Drink

Coca-Cola confronts a global marketplace that has lost its thirst for bubbly brown sugar water.

Kazuki Yamane, Makoto Sato and I hop out of our chauffeured car at the corner of a busy Tokyo intersection. The two men are wearing suits, and I follow them into the bustle, distracted by teeming madness all around me. Some sort of shrieking dance squad is handing out free cosmetics samples. Multiple massive TV screens beam loops of commercials down to the street. The pedestrian flow is a blocks-thick surge of teenagers tapping at their cellphones.

This neighborhood, Shibuya, is the frenzied, wired heart of nearly all Japanese teenage culture. It is also an important consumer lab for the Coca-Cola Company. Yamane and Sato — both middle-aged Coke execs — have taken me here to view the newest Coke innovation. They're sure it's another triumph of Coca-Cola marketing genius, and angling fast through the crowds now, dicing up flocks of schoolgirls, I can tell this main attraction is drawing near. The excitement builds on Sato's face. Our steps begin to slow. And then, at last, beside the entrance to a busy shopping boutique, I come face to face with the gleaming future of soft

By Seth Stevenson

Photographs by Thomas Hannich

New York Times Magazine (*USA, Issue 1, 10 March 2002*)
240 x 297mm / 9 ¹/₂ x 11 ³/₄ inches
A feature about what Coca-Cola is planning for the future of its drinks brands is illustrated through a combination of text and image. The photograph reflects the headline ('I'd like to build the world a shelf-stable children's lactic drink') and the shape of the text echoes the photograph.
Art director *Janet Froelich*

Sehr witzig: Tom Green

DER EIERMANN.

Lob von allen Seiten: David Letterman, Jay Leno und Jim Carrey sagen über Tom Green, er habe den Humor in eine neue Dimension geführt. Das beweist der 29-jährige Amerikaner bisher bei seiner Show auf MTV und jetzt auch im Kino. In zwei Wochen startet „Road Trip" in Deutschland.

7 August 2000

Das langweilige Gesicht ist Tom Greens Stärke. Bei seinen Opfern schafft es Vertrauen und bei seinen Zuschauern dieses leichte Gefühl der Abneigung, das ein Komiker braucht, um die Leute zum Lachen zu bringen. Wenn Tom Green singt, sieht er aus wie ein braver Pfadfinderführer. Sein berühmtestes Lied geht so: „Hey, Kids, fühlt eure Hoden, damit ihr keinen Krebs bekommt. Fasst euch an die Eier, dann kriegt ihr keinen Krebs! Und ihr sterbt auch nicht! Ich weiß es, denn ich hatte Krebs in den Eiern, und ich bemerkte es beim Onanieren! Zum Glück tue ich das oft!" Dann der Refrain: „Warum fasst ihr euch an die Eier? Weil wir keinen Krebs wollen. Warum? Weil wir uns gerne an die Eier fassen." Den Song hat er neulich vor 10 000 Schülern vorgetragen. Alle haben mitgesungen.

In den USA ist Tom Green ein Superstar, seitdem er in seiner MTV-Show aus Bildern der eigenen Hodenoperation ein „Nut-Cancer-Special" gemacht hat. Die Programmchefs von MTV waren sich nicht ganz sicher, ob es eine gute Idee sei, in der „Tom Green Show" Scherze über ein solches Thema zu machen, doch Tom überzeugte sie: „Gott sagte zu mir: Heilige Scheiße, Tom, ich schenke deinen Geschlechtsteilen eine heilbare Form von Krebs. Und dir die Lizenz, darüber im Fernsehen Witze zu machen." Die besten Szenen der Operation wurden gezeigt, das vom Krebs angefressene Testikel im Reagenzglas, die weinenden Eltern, Diskussionen mit den Ärzten – die Show war Tom Greens Durchbruch: David Letterman, Jay Leno, Conan O'Brian, Jim Carrey, die Farrelli-Brüder, also alle, die sich mit Witzen auskennen, gratulierten: Green habe den Humor in eine neue Dimension geführt und von allen Fesseln des guten Geschmacks befreit. Bei der Oscar-Party klopfte ihm George Clooney auf die Schulter: „Junge, das mit deinen Eiern war das Lustigste, was ich jemals gesehen habe." Green sagt: „Ich bin für die Leute jetzt nicht mehr der durchgeknallte Typ von MTV. Ich bin jetzt der Typ, der nur noch ein Ei hat."

Greens Humor funktioniert eigentlich ganz einfach: Er konfrontiert Menschen mit absurden Situationen, taucht mit der Kamera auf und macht ein Gesicht, als wäre alles in bester Ordnung. Dabei ist er immer höflich, sachlich, heimtückisch. Wenn er einem Kind ein Autogramm gibt, fragt er, wie der Name buchstabiert wird: S-T-E-V-E-N. Green schreibt dann: „Für Stephen". Und lächelt freundlich. Als er bei einem Baseballspiel in der amerikanischen Provinz den Stadionsprecher spielte, redete er so lange Unsinn, bis er von den aufgebrachten Hinterwäldlern verprügelt wurde. Als Polizist verkleidet führte Green einmal eine Kuh in einen Supermarkt und brachte Kunden dazu, an ihren Eltern zu nuckeln. Und Monica Lewinksy schleppte er nach Ottawa, um ihren Eltern mit ihr einen Überraschungsbesuch abzustatten. Tom Greens Eltern stehen häufig im Zentrum seiner Aktionen. Möglicherweise ist das die späte Rache dafür, dass Herr Green, ein Offizier, den kleinen Tom früher jeden Morgen um 7.30 Uhr aus dem Bett holte, indem er ihm die Decke wegzog. In

seiner ersten eigenen Show beim kanadischen Fernsehsender CNBC malte Tom Green dendenfalls sein Elternhaus in der Nacht psychedelisch an. Und filmte dann die Reaktionen am nächsten Morgen. Seitdem sind Tom Greens Eltern seine Lieblingsopfer: Mal überraschte er sie mitten in der Nacht mit einem Kamerateam und zwang sie, ein Bon-Jovi-Video zu schauen. Mal stellte er seinen Eltern eine Skulptur, welche die beiden in einer eindeutigen Sexposition zeigte, in den Garten: die Greens schalteten ihren Anwalt ein, verhinderten zunächst die Ausstrahlung, und beruhigten sich erst wieder, als Tom ihnen Tickets für die Oprah-Winfrey-Show besorgte.

Wie viele andere Komiker auch, ist Tom Green zu seinem Beruf gekommen, weil er sich als Kind nur mit Witzen bemerkbar machen konnte. Der entscheidende Moment kam in der 6. Klasse beim Schulwettbewerb im freien Vortrag. Tom hatte in den vorangegangenen Jahren knapp gegen seinen Widersacher Darryl Page verloren. Diesmal referierte Tom über Comedy-Theorie. Mutter Page meldete sich mit Zwischenfragen, weil sie spürte, der Sohn könne verlieren: „Du sagtest, Witze seien ein gutes Mittel, um sich aus schwierigen Situationen zu befreien. Aber du hast kein Beispiel gegeben." Tom konterte mit einem lahmen Gag über Zeugnisse, den er in irgendeinem Witzbuch gelesen hatte. Ein schlechter Witz, aber aus seinem Mund lustig. Tom erinnert sich: „Das war die beeindruckendste Erfahrung meines Lebens. Alle lachten. Die Lehrer, die Eltern, die Schüler und auch Lesley Dewsnap. Später durfte ich sie sogar küssen."

Später, mit 15, war Tom ein hervorragender Skateboarder. Und als er einmal mit seinen Kumpels Phil Giroux und Glenn Humpnik auf den Brettern durch die Straßen von Ottawa jagte, kam ihm die Idee, die seinen Humor so einmalig macht. „Als Skateboarder hatten wir damals nur Ärger, und wir entschlossen uns, die schlechten Dinge gut zu finden. Wir nannten das ,flippen'. Ein gebrochener Fuß war für uns das Schönste auf der Welt. So hatten wir immer viel zu lachen."

Als der Arzt ihm mitteilte, dass er Krebs habe, heulte Green, als er sagt, tagelang, bekam Todesangst und Depressionen. Er wollte aufgeben. Seiner Freundin Drew Barrymore und seinem alten Kumpel Glenn Humpnik hat er es zu verdanken, dass er aus der größten Krise seinen größten Erfolg machte. Humpnik erinnerte ihn an die Skateboard-Zeit, als sie Katastrophen in Späße verwandelten. „Das machen wir jetzt auch!", forderte Humpnik. Und da der Plan aufging, hat der Mann mit einem Ei nun die freie Auswahl: Filme, Shows oder Plattenverträge. Er hat sich entschieden, nicht zu viel zu arbeiten: „Ich will mehr Zeit mit Drew verbringen." Dennoch wird wohl noch in diesem Jahr eine Platte von ihm erscheinen. Und Greens Kino-Komödie „Road Trip", für die er auch das Buch schrieb, kommt Ende August in Deutschland in die Kinos. Ein Teil des Eintrittsgeldes geht an die „Tom-Green-Eierkrebs-Stiftung". **Lars Jensen**

Nur für Jungs:

KRANK.

Obwohl wir uns an keinen einzigen grippelosen Winter in unserem Leben erinnern können, werden wir jedes Jahr von Neuem überrascht. Wie kann es nur etwas so Heimtückisches, absolut Fieses wie Grippe geben? Gegen solche Gemeinheiten der Natur sind wir wehrlos. Daher jammern wir erst mal rum, sofern gerade ein Ansprechpartner im Hause ist. Das ist unsere Art der Grippebekämpfung. Eltern oder die Freundin kochen uns dann Hühnersuppe und versorgen uns. Das ist gut so. Falls wir alleine zu Hause sind, vergessen wir nämlich meistens, dass man gegen Grippe ja auch mehr tun kann als daheim bleiben, rumrotzen und schlechte Laune haben. Krankheit ist Schicksal, denken wir. Und dagegen kann man eben nichts machen. Vitamine oder andere zweifelhafte Mittelchen? Wir sind doch keine Pharma-Schweine aus deutschen Agrarfabriken.

Ein wunderbares Entgegenkommen der Natur ist es allerdings, dass eine richtige Erkältung meistens drei Tage dauert. Am zweiten und dritten Tag ohne Schule und Arbeit geht es uns nämlich eigentlich schon wieder ganz gut. Wir sind zwar noch viel zu entkräftet, um zu lernen oder etwas Vernünftiges zu tun – ein anspruchsvolles Buch zu lesen sind wir auch nicht imstande –, aber wir können den riesigen Stapel alter Comichefte neben unserem Bett endlich mal wieder von oben bis unten abarbeiten. Und auch stundenlanges stumpfes Daddeln an der Konsole (endlich mal alle Levels durchspielen!) muss uns heute kein schlechtes Gewissen einjagen. Das Tolle an Grippe: Wer sie hat, hat nie etwas Besseres zu tun. *Marc Deckert*

Es gibt Wahrheiten, die sind so unumstößlich wie Naturgesetze, und trotzdem scheinen nur Mädchen sie zu verstehen. Zum Beispiel, dass Gelassenheit Mädchen sexy macht, nicht aber unbedingt ein kurzer Rock und makellose Beine. Oder dass Jungs mit rattenkurzen Haaren rattenscharf aussehen. Eine der bedeutendsten Wahrheiten aber ist, dass es gegen alle Widrigkeiten des Lebens ein Mittel gibt und damit auch gegen die größte Widrigkeit dieser Tage: die Wintergrippe. Wir lassen uns nämlich ungern hineinreden in die Momente des Lebens, die Glück verheißen, wie Wochenenden oder Freitagnachmittage – schon gar nicht von einer schnöden Erkältung, die uns ins Bett zwingen will, mit Fieber und Husten und Rotz in der Nase. Darum haben wir die Krankheitsbekämpfung professionalisiert. Wir kennen unseren Körper. Wir wissen um das Geheimnis der zwei Schritte, eine Grippe zu bekämpfen. Und diese Schritte gehen so: Fängt unser Hals zu schmerzen an oder unser Kopf oder einfach alles, nehmen wir sofort naturheilkundliche Tropfen und Aspirin Plus C, trinken Kamillen- oder Salbeitee und legen uns ins Bett. Dann schlafen wir mindestens zehn Stunden. Werden wir trotzdem ernsthaft krank, empfehlen wir Chemie. Mit Chemie sollte man nicht zimperlich sein. Grippetabletten sind erfunden worden, damit man sie schluckt. Entgegen aller Gerüchte stehen Mädchen nämlich gar nicht so auf esoterische Heilkräfte. Schließlich trinken wir auch Whisky, wenn wir mal ernsthaft blau werden wollen, und nicht irgendeinen verdünnten Mist. Aber das ist wieder eine andere Wahrheit. *Christine Rosachwitz*

22 January 2001

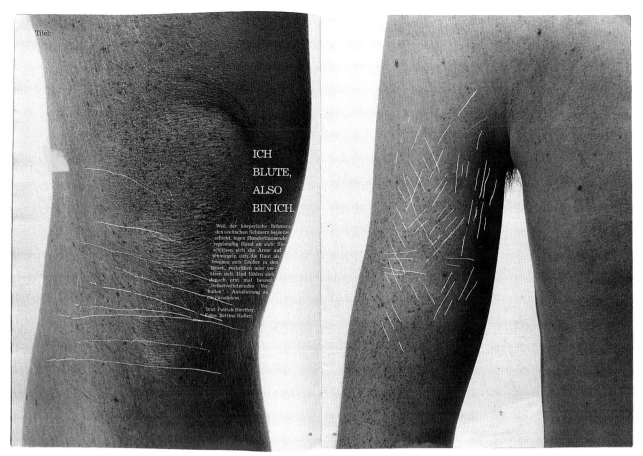

ICH
BLUTE,
ALSO
BIN ICH.

Weil der körperliche Schmerz
den seelischen Schmerz beiseite
schiebt, legen Hunderttausende
regelmäßig Hand an sich: Sie
schlitzen sich die Arme auf,
schmirgeln sich die Haut ab,
brennen sich Löcher in den
Bauch, verbrühen oder ver-
ätzen sich. Und fühlen sich
danach erst mal besser.
'Selbstverletzendes Ver-
halten' – Annäherung an
ein Paradoxon.

Text: Patrick Bierther;
Fotos: Bettina Koller.

4 September 2000, 214 x 282mm/8 ½ x 11 ⅛ inches

Who published *Jetzt*?
Jetzt, which means 'Now', was published every Monday with the newspaper, *Süddeutsche Zeitung*. It was an attempt to attract younger readers to buy the newspaper – teenagers and people in their twenties. *Süddeutsche Zeitung* is a very traditional-looking newspaper, one of the biggest in Germany. I art directed the magazine for three years, from 1999 until its closure in July 2002.

How did the design of *Jetzt* relate to the rest of the newspaper?
We used the same type of newsprint paper and the same column sizes and typeface, called Excelsior. But we had our own grid and were able to play around a lot more with the design.

How big was the design team?
There were just two of us, myself and Sandra Eichler.

What was the content about?
The content was just about normal young people; their problems, music, apartments, love and politics ... all the things that concern them. We covered serious subjects, like when we ran a story about a Jewish girl and a Palestinian girl, both of whom grew up in Germany. They were friends but returned to their homeland and were unable to mix. We also had lighter stories, for example a story we set up where we gave DM50 to people and asked them to use the money to get all the way to London through exchanges. We followed these people as they bought a football, swapped it with someone else for a lamp, and more, until they arrived in London. And we ran an issue about how movies can influence your sex life!

How did your designs respond to that content?
The design was inspired by the content without trying to show what is mentioned in the text. The design had the aim of inspiring the imagination of the reader and helping the text to express what can't be written.

We tried to awaken the creativity of the reader, for example, by using text to make illustrations so that the reader was able to make his own picture. We also ran a story about 15-year olds who injure themselves with knives and needles. To illustrate this we photographed close-up shots of skin and then wounded the pictures with knives. By doing this the reader didn't see actual wounds but saw the pain.

You must have worked very closely with the editor and the writers.
We did. The editor, Timm Klotzeck, was a good friend and professional partner.

We would be involved right from the beginning, planning the stories, thinking about how to make the ideas look good. We had a say in what went into the magazine – photographers would come to us with ideas and we would match them with writers to go out and work on those ideas.

***Jetzt* was very design-led and you seemed to have a lot of freedom to design what you**

Interview
Mirko Borsche
Art director
Jetzt magazine

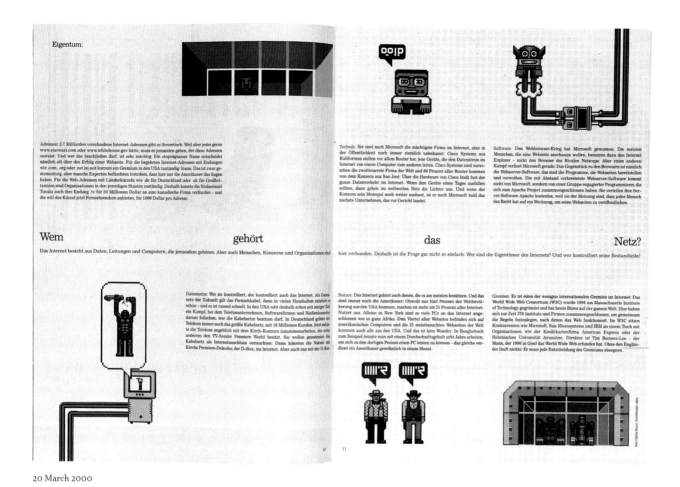

20 March 2000

wanted. What was your philosophy about the design? I didn't have a lot of freedom as it was a newspaper magazine and not a design magazine. The whole look developed because we had very little money for commissioning. Sandra and I are both from painting rather than design-led backgrounds so we would do the illustrations and save what budget we had left for commissioning photography.

I developed a typographic style of illustration that used the look of the main newspaper in a different way. My philosophy was to use that to give the magazine a special look. The words are very important to me but I try to make them more interesting for the reader. I think no-one needs to see a blond girl walking down the street if the text says so but you can show the atmosphere of what the author wants to say.

For example, we put together a special issue about drugs in which we looked at the subject from many people's viewpoints – the users, the parents, the police – and the designs for each article were just about expressing feelings such as happiness, envy or feeling unconscious. Every article had a different word and picture to start it. In this way, we were able to create the atmosphere of the subject.

How did that philosophy and the design develop during your time on the magazine?
It developed weekly. It's very hard to be creative every week, but once you start working your design starts to grow every day.

Were there designs you did that were turned down by the editor?
Of course. I did a lot of typographic designs I couldn't use. I want to make a book with them. There were also a lot of free interpretations that the editor didn't want to use.

Do you regard the project as successful?
It was successful when we closed the magazine! Young intellectual Germans loved it. The newspaper had built a base of young readers – there were about 60,000 more young readers than the other German newspapers had. There was a small riot to get their *Jetzt* back! Hundreds of people blocked the main entrance to the office. They wrote thousands of letters – national newspapers, magazines and television stations covered the story. So it was successful in that sense. The problem was the drop in advertising that all newspapers suffered during 2002. It meant the newspaper had to cut back on all 'extra' projects, so *Jetzt* was cancelled.

What projects are you working on now?
I'm doing illustrations for other magazines, including the main 'grown-up' *Süddeutsche Zeitung* magazine, but also for web magazines Tiger (www.tigermagazine.org) and thisisamagazine.com, and for record labels.

20 March 2000

9 October 2000

9 October 2000

Issue 1, Winter 2000/01

Interview: Sandra von Mayer-Myrtenhain, Jörg Koch **Photography:** Elisha Smith-Leverock

BERLIN DESTRO YERS

WE POSED FIVE QUESTIONS TO BERLINERS WHO
ARE BUSY DESTROYING THE IMAGE OF NEW BERLIN
TRUE DESTROYERS. THEY PROVIDE A KALEIDOS-
COPIC VIEW ON BERLIN BEYOND THE HYPE BY
TALKING ABOUT THEIR JOBS.

Issue 2, Summer 2001

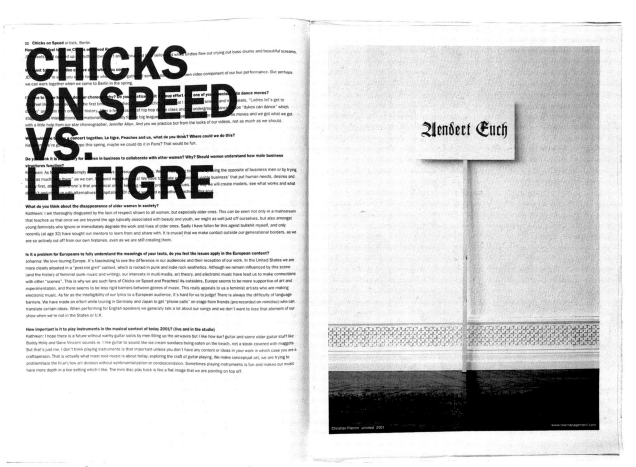

Issue 3, Winter 2001/02

032c *(Germany) 230 x 315mm / 9 x 12 ½ inches*
Strong, direct typography in red and black on newsprint gives this independent magazine a very bold, direct identity, described by its editor as a 'punk fanzine designed by Dieter Rams'.
Art director *Vladimir Llovet Casademont*

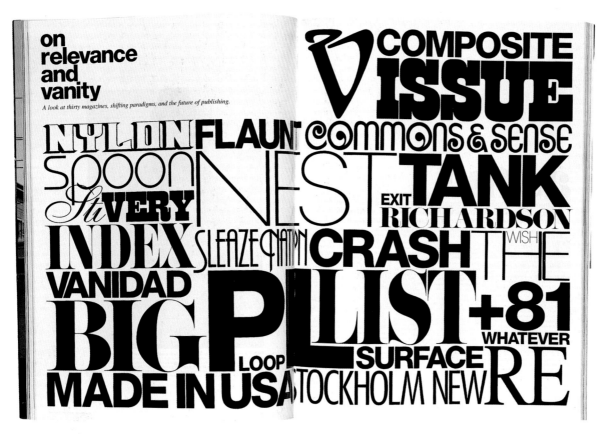

on relevance and vanity

A look at thirty magazines, shifting paradigms, and the future of publishing.

NYLON FLAUNT

V COMPOSITE ISSUE

COMMONS & SENSE

SPOON NEST TANK

STU VERY EXIT RICHARDSON WISH

INDEX SLEAZE NATION CRASH THE

VANIDAD LIST +81

BIG P WHATEVER

LOOP SURFACE RE

MADE IN USA STOCKHOLM NEW

Issue 14, Spring/Summer 2001

HIGH SOCIETY SHOULD BE CODDLED AND CARED FOR CONSIDERING THERE IS SO LITTLE OF IT LEFT PHOTOGRAPHY BY ROBERT WYATT STYLING BY LUCY EWING MAKEUP BY LIZ DAXAUER AT CAN FOR STILA HAIR BY ADAM BRYANT FOR TONY&GUY MODEL: MINI ANDON AT MODELSONE PHOTOGRAPHIC ASSISTANCE BY RICHIE HOPSON STYLING ASSISTANCE BY SUSIE RUSHTON POLONECK SWEATER, JIGSAW. DRESS, SEQUINED COLLAR, BOTH, MARTIN MARGIELA. SHOES, EMMA COOK. TIGHTS, FOGAL. RING, CHRISTIAN LACROIX.

Issue 14, Spring/Summer 2001

TOSS ON A SKIMPY CITRUS SWIMSUIT ADD WATER CREATE STIR PHOTOGRAPHY BY CORINNE DAY STYLING BY JANE HOW

HAIR BY NEIL MOODIE@PREMIER USING AVEDA
MAKEUP BY INGE GROGNARD@AUSTIN
PHOTOGRAPHIC ASSISTANCE BY DANNY GLASSER AND MARC
STYLING ASSISTANCE BY ANNA FOSTER AND EMILY JERMAN
MODELS: ROSEMARY FERGUSON@SELECT AND DELPHINE@FORD SHOT AT STUDIO P1, LONDON

Issue 14, Spring/Summer 2001

DOUBT PATTERNS
by Carsten Höller

Is doubt acceptable, picture-friendly? Can it be transmitted? Is it a vector of sensations, dizziness, relationships? How can we look at an image, a landscape that stays secret, synchronized with indeterminable and delirious movements? How can we consider life, thought—but also lines, surfaces, planes of light—neither as image nor language, but as an "in-between" construction, seeking nothing but itself? I do not think that for Carsten Höller the Laboratory of Doubt is another conceptual strategy aiming to prove that art can exist outside of the object, form or history. I see it as a machine for multiplying reading angles and vantage points, like an oblique space that gives each spectator the possibility of considering art across cycles, autonomous moments or sensitive rhythms. If the Laboratory of Doubt is a space of resistance against the productivity syndrome, I doubt that it produces nothing. It's an architecture which has been constructed in layers for many years, and which always takes the centrifugal shape of a helix, a stairway, a slide, a wheel, an hypnoid pattern, an illusion. This might finally be the experience of doubt: a long corridor where every hypothesis is disoriented and hallucinated, a path towards suspicion and perplexity. - Stéphanie Moisdon-Trembley

For more than ten years, Carsten Höller has been fascinated by "vehicles"—all those moving things that speak of the future, happiness, love, childhood, cruelty, free time, appearances, connections, telepathy, drugs, intervals, reflexes. In other words, all those physical and intellectual movements built outside of the determinism and conventions of contemporary culture. The Laboratory of Doubt, an offspring of the radical project, Laboratorium, in Anvers (conceived in 1999 by Barbara Vanderlinden and Hans-Ulrich Obrist) is one of these evolutive machines that throws us into a world of interference and uncertainty.

Self Service *(France) 220 x 297mm/8 ¾ x 11 ¾ inches*
Stark black-and-white typography has long been a trademark of this magazine, one of the earliest of the new breed of microzines. These spreads show recent moves toward use of decorative typefaces associated with 1970s rubdown lettering.
Art direction *Work in Progress*

Issue 15, Autumn/Winter 2001

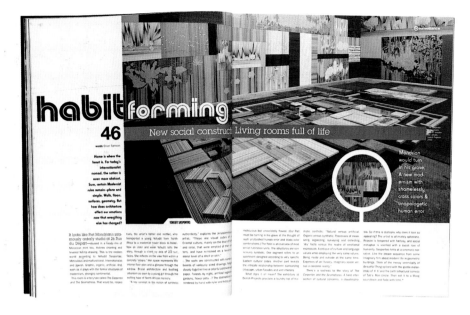

THIS PAGE **Surface** *(USA, Issue 29,) 230 x 275mm/9 x 10 ⁷/8 inches*
Exuberant use of colour, decorative typefaces and text overlaid on photographs gives this independent glossy interiors magazine an identity far removed from its cooler competitors.
Design Exquisite Corporation

OPPOSITE **Details** *(USA, Issue 1, October 2000) 230 x 275mm/9 x 10 ⁷/8 inches*
The design of this opening page of the latest relaunch of this men's title has become a defining statement for the look of the magazine. The use of a gridded set of brief number-based stories is now a much-copied device.
Art director Rockwell Harwood

KNOW + TELL

A random roundup of necessary numbers, nomenclature and newsbreaks

THE CORPULENT **Marlon Brando**, on location in Canada shooting Frank Oz's *The Score*, reportedly arrived on the set every day undressed from the waist down. Sources say that Brando is trying to motivate the former Muppets puppeteer to film him from the shoulders up to hide his considerable waistline.

[SLANG]

"pack of Newports"—*adj.* hard, difficult. Origin: Skateboarders on the X-Games circuit. Usage: "That kickout was a pack of Newports, my man." (Ant.: "cooking fish sticks")

 WWW.

www.airdisaster.com This obsessive catalog of air disaster lore, crash investigation updates and graphic photos is highlighted by a selection of actual cockpit voice recorders, or CVRs, which capture the final minutes of conversation between the pilots and the control tower. One disturbing example: The pilot of a Chicago-bound 737 is flirting with a female flight attendant, discussing her "mating habits." He says to his copilot, "If we crashed right now, this conversation is what our wives would have to remember us by." Just then, the stall alarm sounds; ten seconds later, the crews' screams are cut short by the plane's impact with the ground.

IN 1984, A HARD UP SEATTLE RECORDING STUDIO PAID THEIR PAST-DUE SODA BILL TO A PEPSI DELIVERYMAN. INSTEAD OF CASH, THE STUDIO MANAGER GAVE HIM THE ONLY EXISTING RECORDING OF A JIMI HENDRIX PERFORMANCE. THE PEPSI MAN RETURNED IT IN JULY.

THE LOS GATOS, California, Ferrari franchise now outsells any other in the world. Silicon Valley's IPO set gobble up about 225 cars a year, or about $40,000,000 worth. The most popular model is this year's $175,000 360 Modena (red, of course), by far the most expensive Ferrari on the market.

74%

of people experience "hugging, kissing and intimacy" after using an aftershave containing the designer pheromone Athena 10X. According to its advertisement Athena 10X was invented by the same University of Pennsylvania endocrinologist who codiscovered the human pheromone in 1986.

[THE CHEMICAL COMPOUND OF COCAINE] This drug has never really gone away, but it'll have a higher profile this fall, with the side-by-side release of *Blow* and *Traffic*, two coke-heavy action flicks.

It's

BEEN WIDELY REPORTED THAT CARY GRANT TOOK OVER 100 THERAPEUTIC ACID TRIPS IN THE '50s. BUT WORD RECENTLY CIRCULATED THAT THE *NORTH BY NORTHWEST* STAR, LIKE TIM LEARY, SOUGHT TOTAL CLARITY IN THE AFTER-LIFE: GRANT REPORTEDLY DROPPED A HIT OF HIGH-POWERED BLOTTER ON HIS DEATHBED.

Psychologists at the Money, Meaning & Choices Institute in Silicon Valley have diagnosed a malady peculiar to the nouveau riche: Sudden Wealth Syndrome. Tech millionaires and heirs to large fortunes are among its victims. Some symptoms of SWS: confusion, guilt, denial, paranoia, panic attacks and "ticker shock," which links the patient's mood to stock market fluctuations.

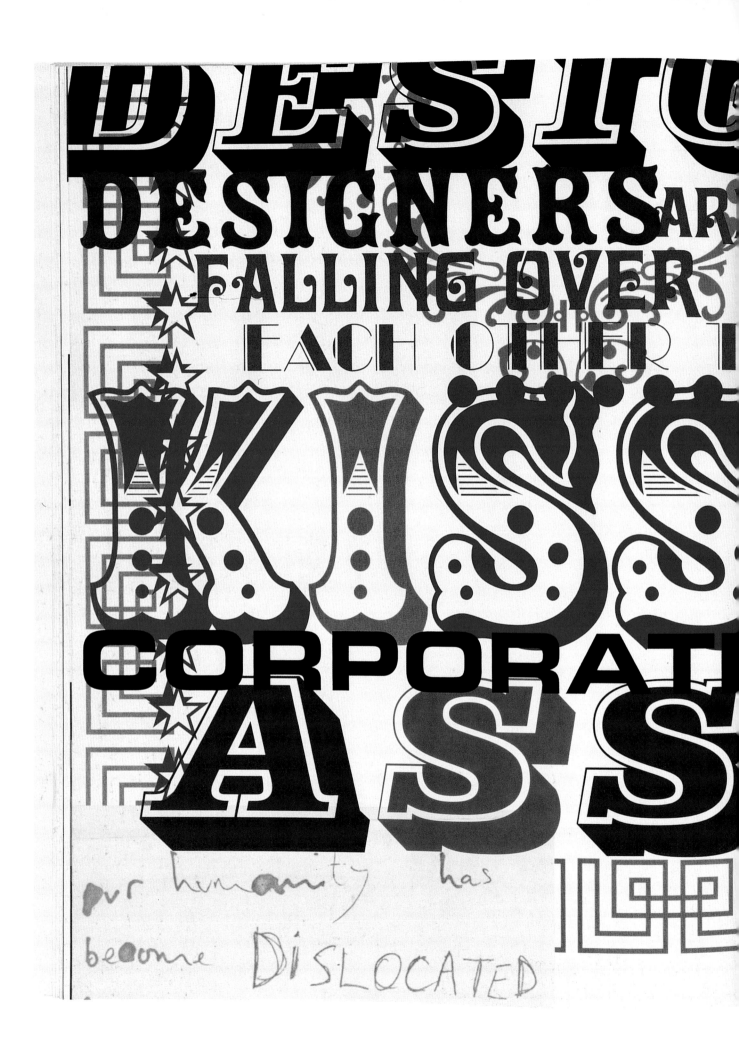

DESIG
DESIGNERS AR
FALLING OVER
EACH OTHER T
KISS
CORPORATE
ASS

our humanity has
become DISLOCATED

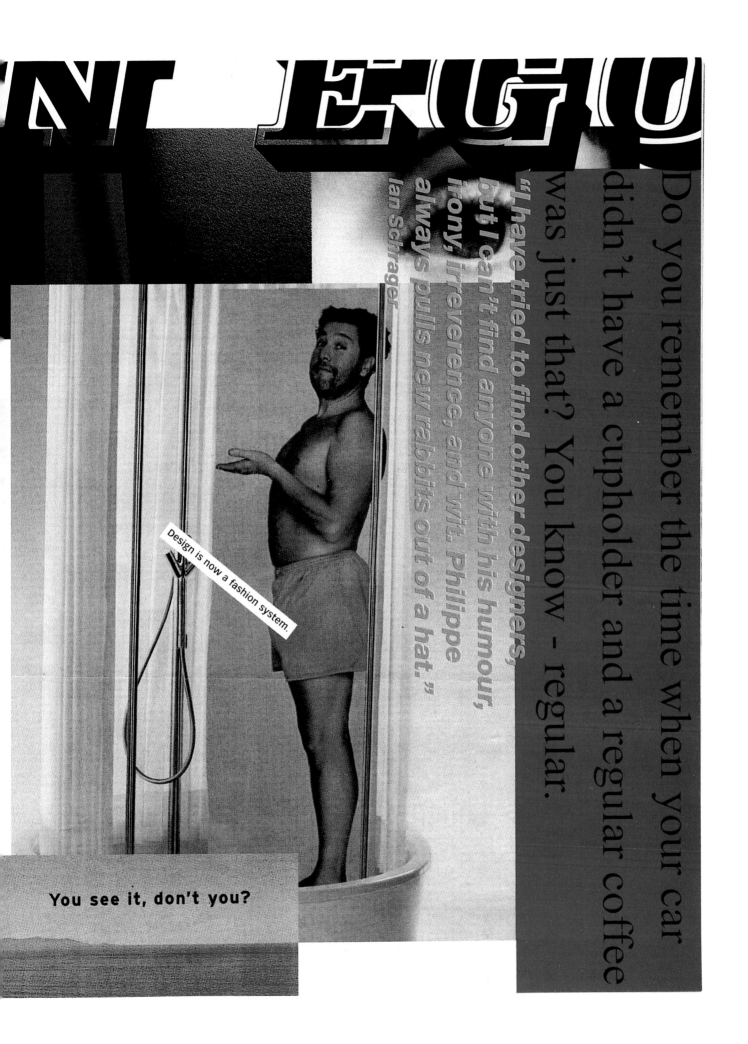

Do you remember the time when your car didn't have a cupholder and a regular coffee was just that? You know - regular.

"I have tried to find other designers, but I can't find anyone with his humour, irony, irreverence, and wit. Philippe always pulls new rabbits out of a hat."

Ian Schrager

Design is now a fashion system.

You see it, don't you?

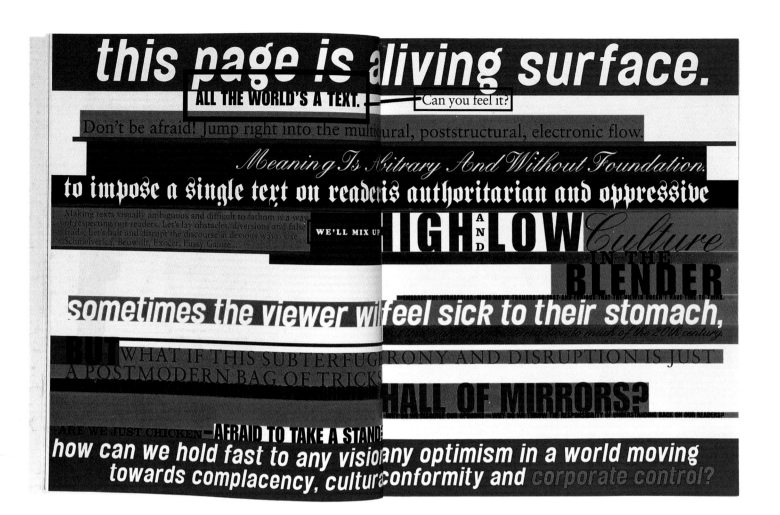

this page is a living surface.

ALL THE WORLD'S A TEXT. Can you feel it?

Don't be afraid! Jump right into the multicultural, poststructural, electronic flow.

Meaning Is Abitrary And Without Foundation.

to impose a single text on readers authoritarian and oppressive

Making texts visually ambiguous and difficult to fathom is a way of respecting our readers. Let's lay obstacles, diversions and false trails. Let's halt and disrupt the discourse in devious ways. Use Schmelvetica, Beowolf, Exocet, Pussy Galore...

WE'LL MIX UP HIGH AND LOW *Culture* IN THE BLENDER

EMBRACE THE VERNACULAR. MAKE MOVIE TRAILERS SO FAST AND FURIOUS THAT THE VIEWER DOESN'T HAVE TIME TO THINK.

sometimes the viewer will feel sick to their stomach,

but this is the price we have readers to much of the 20th century.

BUT WHAT IF THIS SUBTERFUGE IRONY AND DISRUPTION IS JUST A POSTMODERN BAG OF TRICKS

HALL OF MIRRORS?

ARE WE JUST CHICKEN — AFRAID TO TAKE A STAND?

how can we hold fast to any visionary optimism in a world moving towards complacency, cultural conformity and *corporate control?*

PREVIOUS PAGES, **Adbusters** (*Canada, Issue 37, September/October 2001*)
THIS PAGE & *230 x 274mm/9 x 10 7/8 inches*
OPPOSITE This issue offers a tour-de-force visual rant against the way design has become the servant of global capitalism. The colour pages reproduced here are self-explanatory in their tone. The first black-and-white spread criticizes the concept of the grid, describing it as a reductionist tool to replace spontaneity. Behind this description is an egg; the visual antithesis of the grid/square. The next spread features circles of typefaces spinning out from the centre, starting with Gutenberg's first printed words from 1455 and swirling out chronologically to reach the typefaces of the 20th century. Guest art director *Jonathan Barnbrook*.

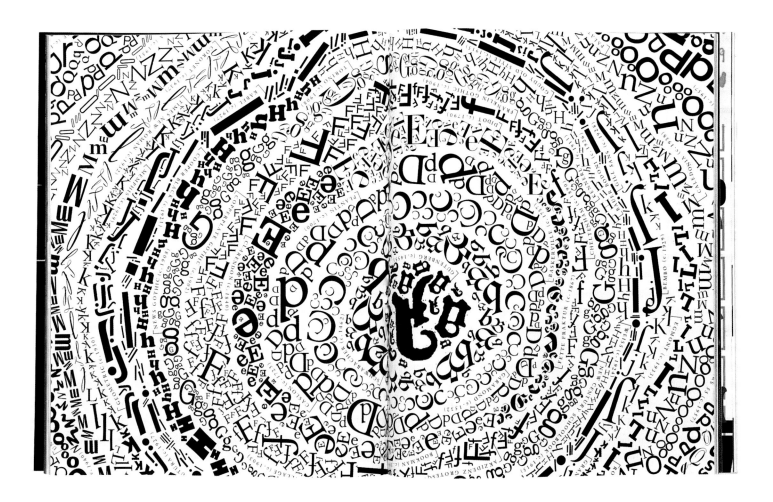

THE GRID: A FILTER THROUGH WHICH TO GLIMPSE AN IDEAL, RATIONALIZED WORLD. GAINS IN PREDICTABILITY AND ACCURACY ARE MADE AT THE EXPENSE OF AMBIGUITY AND INTUITION. WHEN YOU GAZE AT THE WORLD THROUGH A GRID, YOUR BRAIN CLICKS INTO A REDUCTIVE MODE AND DECISIONS BECOME ROTE AND MECHANICAL. IT'S A KIND OF DEVIL'S BARGAIN FOR LOGIC FREAKS, A TOOL TO REPLACE INSIGHT AND SPONTANEITY WITH ENDLESS POINTS ON AN AXIS. THE TRICK IS TO SLIP OUT OF THIS MINDFIX. GET RID OF YOUR FILTERS. SEE THE WORLD ANEW.

THE GRID: a filter through which to glimpse an ideal, rationalized world. Gains in predictability and accuracy are made at the expense of ambiguity and intuition. When you gaze at the world through a grid, your brain clicks into a reductive mode and decisions become rote and mechanical. It's a kind of devil's bargain for logic freaks, a tool to replace insight and spontaneity with endless points on an axis. The trick is to slip out of this mindfix. Get rid of your filters. See the world anew.

THE GRID: a filter through which to glimpse an ideal, rationalized world. Gains in predictability and accuracy are made at the expense of ambiguity and intuition. When you gaze at the world through a grid, your brain clicks into a reductive mode and decisions become rote and mechanical. It's a kind of devil's bargain for logic freaks, a tool to replace insight and spontaneity with endless points on an axis. The trick is to slip out of this mindfix. Get rid of your filters. See the world anew.

THE GRID: a filter through which to glimpse an ideal, rationalized world. Gains in predictability and accuracy are made at the expense of ambiguity and intuition. When you gaze at the world through a grid, your brain clicks into a reductive mode and decisions become rote and mechanical. It's a kind of devil's bargain for logic freaks, a tool to replace insight and spontaneity with endless points on an axis. The trick is to slip out of this mindfix. Get rid of your filters. See the world anew.

THE GRID: a filter through which to glimpse an ideal, rationalized world. Gains in predictability and accuracy are made at the expense of ambiguity and intuition. When you gaze at the world through a grid, your brain clicks into a reductive mode and decisions become rote and mechanical. It's a kind of devil's bargain for logic freaks, a tool to replace insight and spontaneity with endless points on an axis. The trick is to slip out of this mindfix. Get rid of your filters. See the world anew.

THE GRID: a filter through which to glimpse an ideal, rationalized world. Gains in predictability and accuracy are made at the expense of ambiguity and intuition. When you gaze at the world through a grid, your brain clicks into a reductive mode and decisions become rote and mechanical. It's a kind of devil's bargain for logic freaks, a tool to replace insight and spontaneity with endless points on an axis. The trick is to slip out of this mindfix. Get rid of your filters. See the world anew.

THE GRID: a filter through which to glimpse an ideal, rationalized world. Gains in predictability and accuracy are made at the expense of ambiguity and intuition. When you gaze at the world through a grid, your brain clicks into a reductive mode and decisions become rote and mechanical. It's a kind of devil's bargain for logic freaks, a tool to replace insight and spontaneity with endless points on an axis. The trick is to slip out of this mindfix. Get rid of your filters. See the world anew.

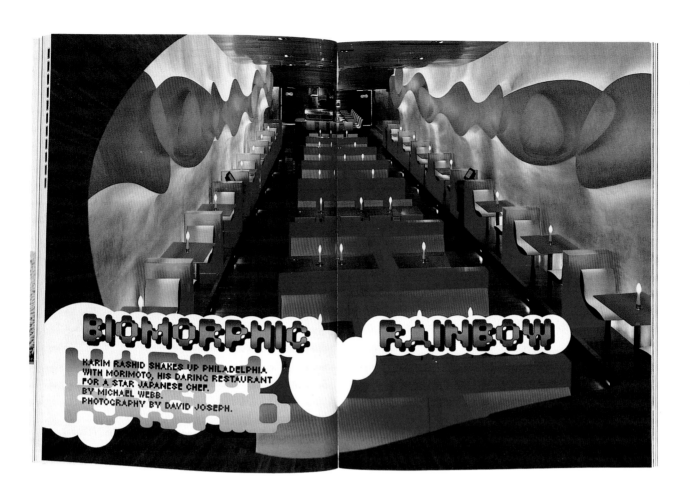

BIOMORPHIC RAINBOW

KARIM RASHID SHAKES UP PHILADELPHIA
WITH MORIMOTO, HIS DARING RESTAURANT
FOR A STAR JAPANESE CHEF.
BY MICHAEL WEBB.
PHOTOGRAPHY BY DAVID JOSEPH.

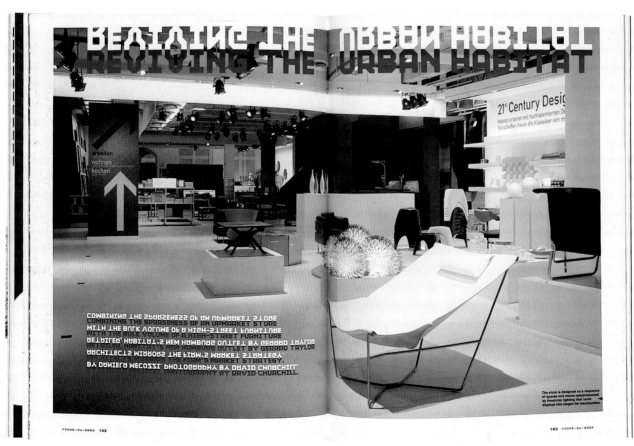

REVIVING THE URBAN HABITAT

21st Century Design
Habitat arbeitet mit hochtalentierten De
Sie schaffen heute die Klassiker von m

arbeiten
wohnen
kochen

COMBINING THE SPARSENESS OF AN UPMARKET STORE
WITH THE BULK VOLUME OF A HIGH-STREET FURNITURE
RETAILER, NEW HAMBURG OUTLET BY GERARD TAYLOR
ARCHITECTS MIRRORS THE FIRM'S MARKET STRATEGY.
BY DANIELA MECOZZI. PHOTOGRAPHY BY DAVID CHURCHILL.

The store is designed as a sequence
of spaces and zones complemented
by theatrical lighting that turns
displays into stages for merchandise.

— We got together November 16 1978 at a disco at the house of the Left Liberal Party in Møllergata in Oslo. Ingrid's very adult and feminine style, with skirts and high-heeled shoes, was what captured me initially.

STRANGER THAN PARADISE

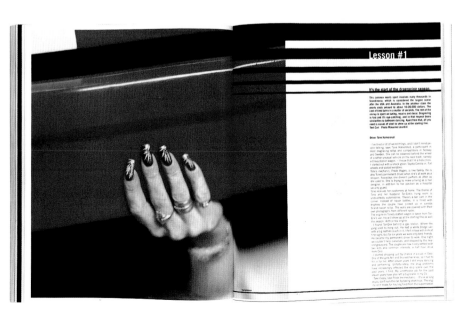

OPPOSITE **Frame** (The Netherlands, Issue 26, May/June 2002) 230 x 297mm/9 x 11 3/4 inches
This interior design magazine takes its design cues from its content on a page-by-page basis, so that every feature uses different fonts and styles. The result is the opposite of the clean, modernist design ideal and means the magazine can quickly adapt to and reflect on trends in interior and graphic design.
Art director Roelof Mulder

THIS PAGE **Carl's Cars** (Sweden, Issue 2, 2002) 230 x 280mm/9 x 11 inches
This independent magazine about car culture has a visual identity based primarily on its photography. Where graphics do feature, they take their cue from cars – the go-faster stripes and the vernacular of car logos.
Creative director Stéphanie Dumont

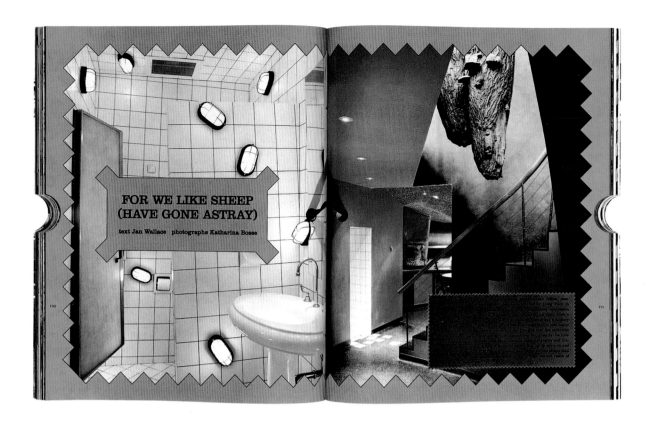

FOR WE LIKE SHEEP
(HAVE GONE ASTRAY)

text Jan Wallace photographs Katharina Bosse

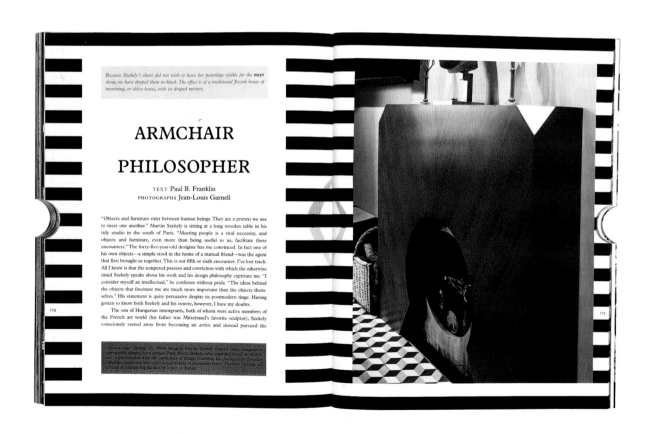

Because Szekely's client did not wish to have her paintings visible for the **nest** *shoot, we have draped them in black. The effect is of a traditional Jewish house of mourning, or shiva house, with its draped mirrors.*

ARMCHAIR

PHILOSOPHER

TEXT Paul B. Franklin
PHOTOGRAPHS Jean-Louis Garnell

"Objects and furniture exist between human beings. They are a pretext we use to meet one another." Martin Szekely is sitting at a long wooden table in his tidy studio in the south of Paris. "Meeting people is a vital necessity, and objects and furniture, even more than being useful to us, facilitate these encounters." The forty-five-year-old designer has me convinced. In fact one of his own objects—a simple stool in the home of a mutual friend—was the agent that first brought us together. This is our fifth or sixth encounter. I've lost track. All I know is that the tempered passion and conviction with which the otherwise timid Szekely speaks about his work and his design philosophy captivate me. "I consider myself an intellectual," he confesses without pride. "The ideas behind the objects that fascinate me are much more important than the objects themselves." His statement is quite persuasive despite its postmodern tinge. Having gotten to know both Szekely and his oeuvre, however, I have my doubts.

The son of Hungarian immigrants, both of whom were active members of the French art world (his father was Mitterrand's favorite sculptor), Szekely consciously veered away from becoming an *artiste* and instead pursued the

Nest *(USA, Issue 19, Summer 2001) 230 x 280mm/9 x 11 inches*
This interiors magazine has developed a brash, almost naïve, exuberance based on the nature of much of its content: the unreconstructed busy-ness of rich US interiors. Traditional wallpaper and tile patterns are a key influence.
Graphics director *Tom Beckham*

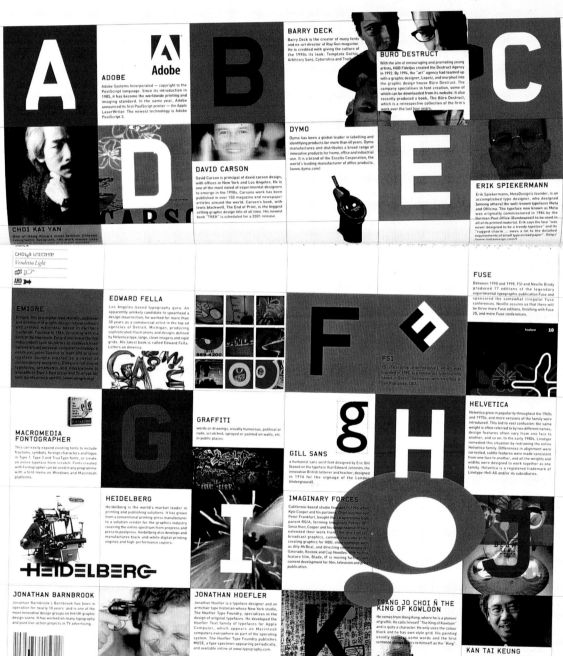

IdN (Hong Kong, Volume 8, Number 2, 2002) 235 x 297mm/9 ¹/₄ x 11 ³/₄ inches
This 'A–Z of Type' is typical of the way this digital design magazine turns its page designs at odd angles and overlays text and image, reflecting the area of design it covers.
Creative director *Victor Cheung*

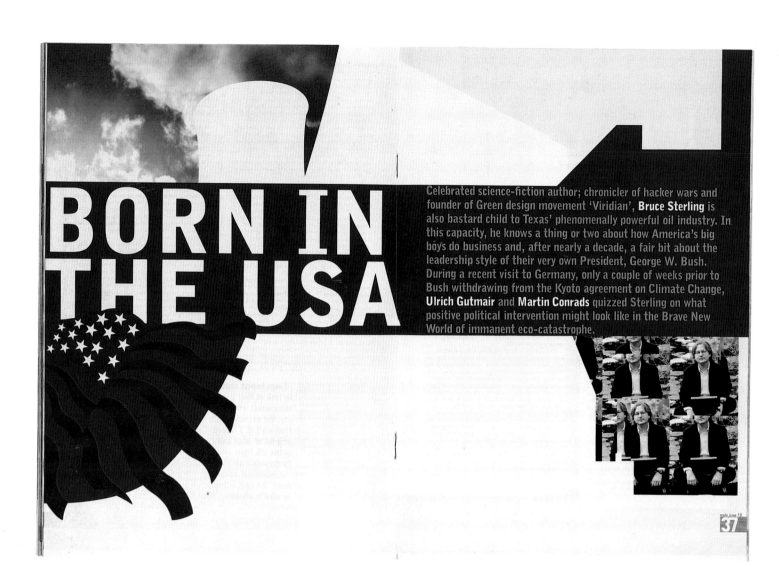

BORN IN THE USA

Celebrated science-fiction author; chronicler of hacker wars and founder of Green design movement 'Viridian', **Bruce Sterling** is also bastard child to Texas' phenomenally powerful oil industry. In this capacity, he knows a thing or two about how America's big boys do business and, after nearly a decade, a fair bit about the leadership style of their very own President, George W. Bush. During a recent visit to Germany, only a couple of weeks prior to Bush withdrawing from the Kyoto agreement on Climate Change, **Ulrich Gutmair** and **Martin Conrads** quizzed Sterling on what positive political intervention might look like in the Brave New World of immanent eco-catastrophe.

made_issue 19
37

THE TOMORROW PEOPLE

For a good few years before the NASDAQ began to crash, a certain synchronicity existed between where California's tech companies said they were going and where their share price went. Did they know something the rest of us didn't? Or did they have better kit? One popular tool they might have used is 'futurecasting', a cybernetically enhanced mode of storytelling. Last summer Hari Kunzru went to California to meet the Global Business Network, an eclectic cabal of futurecasters, and its founder Peter Schwartz. One year on, how bright does the futurecasters' future look?

In this view Schwartz and his organisation are not 'objective' futurists, but proponents of a particular free-market libertarian political position which has the not-coincidental effect of reinforcing America's global hegemony.

The crash was neither predicted nor planned for. This has an irony to it, since prediction and control of the future were the cornerstones of the ideology driving the dotcom bubble.

Mute (*UK, Issue 19, 2001*) *200 x 275mm/7 ⅞ x 10 ⅞ inches*
Critical of the way technology is harnessed against people rather than to help them, this magazine has developed a graphic style that is bright and colourful yet has a distinctly unsettling quality to it that reflects the editorial content. Images are savagely cropped or run repeatedly; ghostly shapes are cut into pictures and areas of colour.
Designer *Damian Jacques*

Bigger than life itself

43

History		Superman
Designing heroes		Graphic façades
		Myth
		Recruitment

Stereotypes	**Every era creates heroic imagery**
The imperial scam	**that conforms to its specific needs**
Bravery and fear	

By Steven Heller

Heroic imagery has long adorned canvas and poster for reasons as varied as patriotism and paternalism, valour and ego. To be called a hero – or to be shown as such – is the highest of human distinctions, and heroism is a status to which everyone aspires, if only subconsciously. The true hero is born with, or acquires, real virtues, while the synthetic one is a composite of ideal attributes. In either case, the heroic image has considerable sway over public perception. Nevertheless, a hero is not always actually 'heroic' in appearance or stature, so designing heroes that conform to accepted models necessitates the creation of symbolic beings that are bigger and bolder than life.

In heroic art the diminutive Napoleon was depicted as taller; Hitler was shown as being physically stronger than nature had originally intended. The exaggerating, flattering lens is routinely used to elevate rulers and warriors as well as sports and media stars. Michael Deaver, Ronald Reagan's chief of staff and principal 'image maker', once explained that placing the then president in a heroic light relied, quite literally, on effective lighting to smooth out the gnarled parts and give an aura to his countenance.

Film-makers routinely create larger-than-life live-action characters whose heroic personae the public unquestioningly embrace simply because of a few special effects. But the grandest fictional heroes are not made of flesh

1. Klimaschin's poster for USSR Agricultural Exhibition, 1939, uses classical poses to represent the common farm labourer as a hero of the state. Lithograph.

36 EYE

46 EYE 43/02

‘It's not a problem of being a woman in a man's world. It's being a type designer in a world that gives little recognition to this art form’

Zuzana Licko

Interview by Rhonda Rubinstein

Issue 43, Spring 2002, 237 x 297mm/9 3/8 x 11 7/8 inches

Eye **is a magazine about design. How difficult is it designing in that context?**
When designing a magazine about design the layout must not try to compete with the content it is presenting. Having said that, the magazine itself as an object is part of its subject so should therefore be worthy as an example of what it preaches – if it is not, perhaps the magazine loses some credibility. It's a fine balance.

We show works of graphic design and we provide text that tells our readers all about it. You might say that's enough, but talking to our readers it seems that they enjoy it more when visual examples and text are both intertwined in a pleasing or often dramatic way.

Of course, the reading of the original work changes, that's unavoidable as it is removed from its context after all. So whilst respect is paid to the nature of the original (scale for instance), this can only be done up to a point, since it might be more important to deliver opinion on how that work participates in a narrative of ideas instead. This may require comparison of several works on a page that, if presented according to exact relative scale, may produce a layout that is messy and which then disrupts the visual narrative flow.

The most important thing is showing the work as close to the real thing as possible and in a no-nonsense way. If there's a lot of material all the same size, I run it the same size.

Eye was a nice thing to be asked to do, a privilege, but very humbling – it's about other people's work.

What was the philosophy behind the recent redesign?
I wanted to increase the presence of *Eye*'s voice in proceedings and lessen the degree to which each layout responded specifically to its content, to lessen the degree to which I was interpreting ideas and styles in each article.

When I first started on *Eye,* I was interpreting everything, responding to each piece of content and it was getting too much – I began to feel my visual interpretation was making the experience of *Eye* dense and overwrought. I wanted a systematic, drier and low-key format which could be distinctive without being too cool. The design has to be straightforward to show the work well.

For a while the editor and I had been using themes (both

explicit and secret ones) to focus ideas for each issue. The redesign had to suit the nature of these themes and I thought a design where a set format dominates over visual responses to specific articles would work well with them.

I also wanted to reduce the feeling of starting from zero as each issue loomed. Both the editor and myself wanted the magazine to be less all-consuming to allow us time for our other work, and the systematic nature of the redesign helps limit our options, stopping us spending two days designing an opening spread, for example.

Describe the redesign.
It's simpler, and doesn't attempt to draw attention to itself. We have a 12-column grid on which both text and

images can be hung in a rich variety of ways. It's a very flexible structure. The design of *Eye* can't be full of rules, it has to be open to anything happening. The images we run are all different shapes and sizes and can often make for a messy layout.

I wanted the magazine to become more like a book, to reduce the amount of 'clever' headline writing and use the headlines just as information. At one stage a further idea was to completely lose the headlines, using the keywords and standfirsts alone to start the features. But the editor felt headlines were necessary from a journalistic standpoint.

You have relegated the visual importance of headlines?
In the main feature well, the opening spreads of each article

Interview
Nick Bell
Art director
Eye **magazine**

Issue 43, Spring 2002

are now designed as a set to make each individual issue distinct from others. We change the headline font every issue and this was prompted by the same aim.

The standfirst and byline are now contained in colour boxes along with the addition of a keyword list that was to influence how the *Eye* website was to look – it was being redesigned at the same time as the magazine. Although more systematic, the colour of these boxes changes every issue and there is a selection of box layout variables to choose from. Every opening is very distinctive, and these colour boxes add more distinctiveness.

So the redesign means that the look of each issue is now a result of an overarching idea to represent the issue as a whole rather than a collection of interpretations specfic to each of the main articles.

What fonts have you used for the headlines so far?

For the relaunch issue we used Radio FM, designed by Magnus Rakeng who designed *Eye*'s new logo. Mrs Eaves was used in second issue because we had an interview with its designer, Susanna Licko.

Tabloid Compressed in issue three was used partly in response to the amount of content that issue contained about newspaper design, and partly to counter the criticism that we were over-academic .

How did the new logo come about?

We had already decided to use the Radio FM font for the redesign issue because it connected with ideas I had about the logo harking back to the early naïve days of corporate identity with logos like Ford, AEG and Pepsi. These seemed like precious,

cherished badges that companies wore in a different way. I wanted a logo that looked unfashionably hand-drawn and crafted, one that showed the movements of the hand and the pride of the person that created it – all very much NOT now, it seemed to me. So with his Radio FM as a model, Magnus gave us just what we wanted and when we decided that it should appear in chocolate brown on the cover of the launch issue of the redesign it

reminded me of the Cadbury's logo. It was warm, friendly and cosy and part of our attempt to stop designers thinking (incorrectly) that *Eye* is somehow an academic magazine. *Eye* is primarily visual; it features graphic design and we want the design of the magazine itself to communicate an enjoyment in the activity of graphic design itself.

What has the response been to the redesign?

On the whole the response has been very positive and encouraging. We tend not to hear from those that don't like it. But I did read on the 'Lines and Splines' website that they think there are too many typefaces being used. (We take pleasure in breaking this 'rule'). Some people hate it –

one regular contributor thought the design seemed arbitrary and assumed that the use of colour was for some kind of complex colour-coding. He felt provoked to say that he didn't want to write for *Eye* anymore. He doesn't see it as the right environment for his writing which was a surprise since so many aspects of the layout have been simplified and made more flexible. But the most flattering comment was from another designer, who told us we were now doing things with *Eye* that you don't see tried out in other magazines.

The good thing is we elicited a response rather than silence. I would like to hear much more criticism from readers. Designers are much less passionate about what they like and don't like these days, it seems to me.

Issue 42, Winter 2001

Issue 42, Winter 2001

Issue 42, Winter 2001

Call for entries... A feature article without content

By Daniel Eatock of Foundation 33 / December 2000 / Say YES to fun & function & NO to seductive imagery & colour!

Title clever reference to designer/s' work or name

Designer/'s/company name set in very large bold type

White space

Subtitle one sentence that leads the reader into the feature, includes authors name

Image moody / soft focus / black & white portrait of designer/s in studio

Introduction background information on designer including education, location, nationality

Image full colour photographic reproduction presenting a project on a white background. Freeze-frame from motion or interactive work; music packaging; book cover; poster; wine label etc.

Quotation repeated from the main text, type set in a display font in a colour that links with a prominent colour from the reproduction selected above

Main text including unusual witty facts and comments

Image an example of some early work before the designer/s made it big!

Text image captions, very small text linked with a numbered/alphabetised system, providing specific information about the content of each image

Folio

Folio

TOP **Dot Dot Dot** *(UK, Issue 2, 2001) 164 x 234mm/6 ¹⁄₂ x 9 ¹⁄₄ inches*
This independent design magazine uses a format typical of a design award entry form to take a dig at 'normal' design magazines. The form, titled 'Calls for entries... A feature article without content' has blank fields for the reader to fill in, including: 'Title – clever reference to designer/s' work or name' and 'Image – moody – soft focus / black & white portrait of designer/s in studio.'
Design Jurgen Albrecht, Stuart Bailey, Peter Bilak and Tom Unverzagt

BOTTOM **List** *(USA, Issue 1, 2000) 220 x 275mm/ 8 ¹⁄₄ x 10 ⁷⁄₈ inches*
Taking the recent editorial obsession with listmaking to its extreme, this unique magazine consists solely of written and pictorial lists. Information includes the full guest list for the launch party of *Talk* magazine, details of the most expensive photographer's day rates, and reproduction of the polaroids taken during a casting session for a Macy Gray video.
Designers Steven Baillie and Danae Grandison

Issue 2, 2001

Issue 4, 2001

Issue 4, 2001

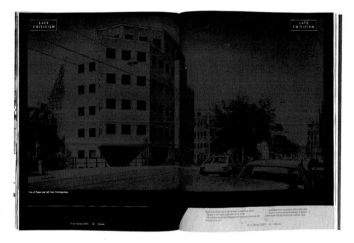

Issue 5, 2001

Issue 1, 2002

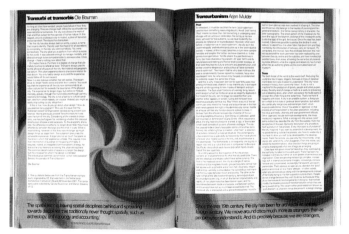

Issue 1, 2002

Archis *(The Netherlands)*
220 x 275mm / 8 3/4 x 10 7/8 inches

This architecture magazine has become
an experiment in editorial design. It is
designed to be interactive – all the pages
are perforated so they can be removed
and re-ordered. The design itself
involves complex layering, starting with
the covers (SEE PAGE 62), taking advantage
of the ease with which pages created on
the computer can be copied and
reproduced. Much of the content is
presented as if taken from other
publications, the layouts mimicking the
designs of various newspapers, typed
reports and trade magazines.
*Designers Maureen Mooren
and Daniel van der Velden*

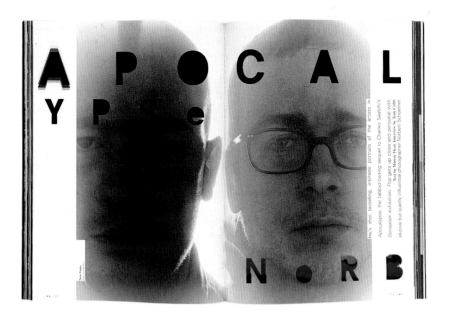

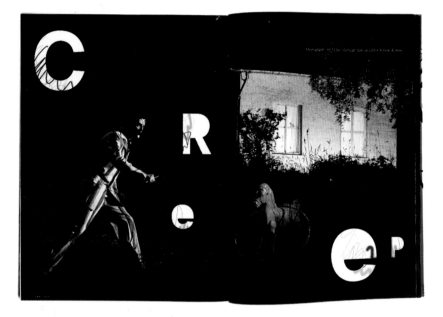

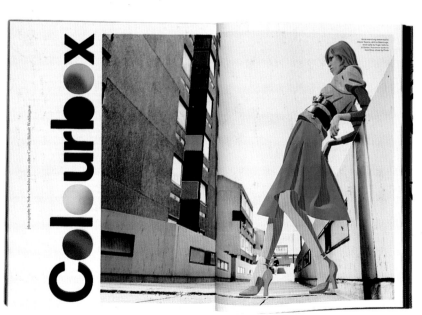

Pop (*UK, Issue 1, Autumn/Winter 2000/01*) *230 x 300mm/9 x 11 7/8 inches*
Making use of the way type and image are reduced to a single set of digital information in the production process, the type has been retouched as much as the images; the irony being that the technology has been used to distress the type and image rather than clean it up.
Art directors *Lee Swillingham and Stuart Spalding*

TOP AND SKIRT BY COMME DES GARÇONS.

NYLON

THE HOME FRONT
GOOD FASHION IS SIMPLE, ACCORDING TO LONDON'S DARLING DESIGNER LUELLA BARTLEY. GOOD FASHION IS "CLOTHES THAT MAKE YOU FEEL ATTRACTIVE AND HAPPY." EASY ENOUGH THIS SPRING, THANKS TO THE COMFORTABLE, RELAXED STYLES AND BRIGHT, BLISSFUL SHADES FROM SUPERSTAR DESIGNERS SUCH AS CHANEL, YOHJI YAMAMOTO, AND JEAN PAUL GAULTIER. THE BEST PIECES WORK A DOUBLE SHIFT: A.M. AND P.M., WORK AND PLAY. THIS MONTH, PHOTOGRAPHER DIRK "SEIDEN" SCHWAN EXPLORES THE NEXT GENERATION OF PALE SHADES, SOFT COLORS (FROM PINK TO BEIGE) THAT PACK THE VISUAL PUNCH OF WHITE. SHANNAN ROUSS INVESTIGATES THE CULT OF COLLECTING. IN "BEST OF SHOW," PHOTOGRAPHER DUC LIAO MAKES A CLOSE LOOK AT THE HIGH-IMPACT DETAILS OF HAUTE COUTURE. AND FOR THIS MONTH'S "21 QUESTIONS," BARTLEY TELLS *NYLON* THAT HOME IS WHERE HER ART IS.

nylon month __may__ year __2002__ page __099__

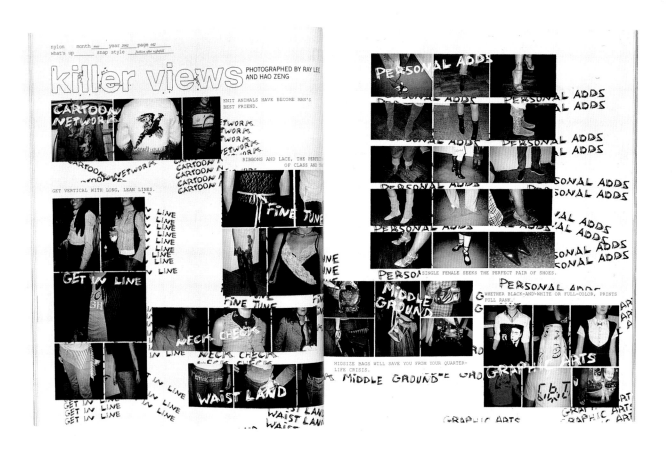

nylon month _may_ year _2002_ page _042_
what's up _____ snap style _fashion after nightfall_

killer views PHOTOGRAPHED BY RAY LEE AND HAO ZENG

CARTOON NETWORK

KNIT ANIMALS HAVE BECOME MAN'S BEST FRIEND.

RIBBONS AND LACE, THE PERFECT OF CLASS AND

GET VERTICAL WITH LONG, LEAN LINES.

LINE

FINE TUNE

GET IN LINE

NECK CHECKS

WAIST LAND

PERSONAL ADDS

SINGLE FEMALE SEEKS THE PERFECT PAIR OF SHOES.

MIDDLE GROUND

WHETHER BLACK-AND-WHITE OR FULL-COLOR, PRINTS PULL RANK.

MIDSIZE BAGS WILL SAVE YOU FROM YOUR QUARTER-LIFE CRISIS.

GRAPHIC ARTS

Nylon *(USA, May 2002) 230 x 274mm/9 x 10 ⅞ inches*
The type elements here have been both handwritten and printed, rescanned and auto-traced to achieve this loose, distressed effect.
Art director Lina Kutsovskaya

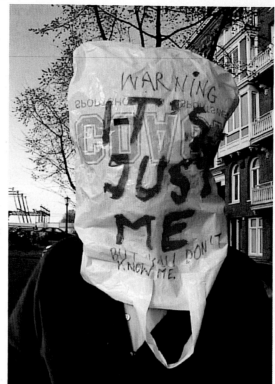

Hide! Join the Network. Information and communication technology devices and services permanently connect you to virtual networks of your choice but alienate you from your direct physical surroundings. Simultaneously, public space is transformed into an unclaimed territory, a wasteland where social exchange partners have given up responsibilities, engrossed in incomprehensible dialogues on mobile phones, exchanging data that never receives public significance. Join the Network. Hide!

By Daniel van der Velden

'Hide!'

Freestylin': an analysis by Wilfried Nijhof and Jop van Bennekom.
Photography by Maurice Scheltens.

FreeStylin' Looking at forms of boredom. Creating clouds of text.

Re – *(The Netherlands, Issue 4, Summer 2000) 220 x 297mm/8 3/4 x 11 3/4 inches*
'The Boring Issue' featured handwritten notes and marks written across the pages, as if doodled on by a bored reader. These two spreads show two different ways the doodles were used to emphasize content. The first uses a heavy circular pattern all but obliterating the headline, echoing the headline 'Creating clouds of text'. The second features a feeble crossing out of the headline, 'Hide!', implying that hiding is all but impossible.
Design *Jap van Bennekom*

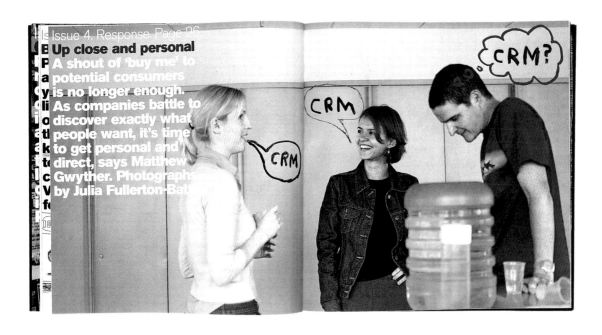

Up close and personal
A shout of 'buy me' to potential consumers is no longer enough. As companies battle to discover exactly what people want, it's time to get personal and direct, says Matthew Gwyther. Photographs by Julia Fullerton-Batten

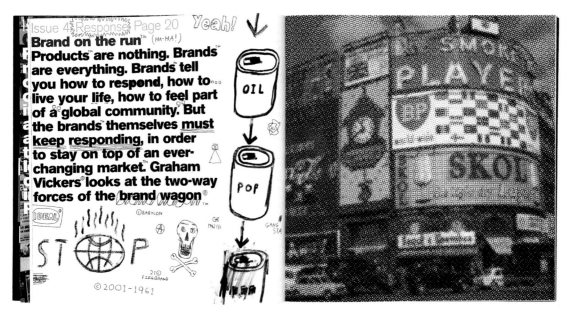

Brand on the run (HA-HA!)
Products are nothing. Brands are everything. Brands tell you how to respond, how to live your life, how to feel part of a global community. But the brands themselves must keep responding, in order to stay on top of an ever-changing market. Graham Vickers looks at the two-way forces of the brand wagon

Head to head
Why do some artists and writers provoke a strong response from their audience? Because they want to? Because they have to? Are they responding to some impulse deep within themselves, or are they just trying to sell a product? A leading editor and artist debate the problems and opportunities of going too far.

M-real (*International, Issue 4, Winter 2001*) *280 x 280mm/11 x 11 inches*
Themed 'Response', this magazine was designed to a simple grid with all images in place. The pages were then passed to the illustrator who 'responded' to the content, drawing and doodling over each page on tracing paper. The two elements were then combined at repro stage to make it look like a reader had been through the whole magazine defacing it.
Creative director *Jeremy Leslie* Illustration *Austin@New*

Weybridge, Surrey, England
September 2001
Valerie Phillips

In Weybridge with a very cool twelve
year old junior tennis champ who
sings Karaoke in her bedroom to
Britney Spears.
 wish u were here
 X Valerie

p124

THIS PAGE **Wish You Were Here** (USA, Issue 4, Spring/Summer 2002)
210 x 268mm/8 ¼ x 10 ½ inches
This fashion magazine features shoots from photographers from
around the world. These shoots are presented with little text other
than an introductory handwritten 'postcard' from the photographer.
Designer Amanda Brown

OPPOSITE, TOP **Viewpoint** (UK, Issue 10)
215 x 285mm/8 ½ x 11 ¼ inches
The end section of this trend prediction magazine consists of a series
of small reports. In each issue, the section is illustrated in this loose
style, as if someone has doodled across the pages.
Art director Gerard Saint

OPPOSITE, BOTTOM **Label** (Italy, Issue 5, Spring 2002)
230 x 297mm/9 x 11 ¾ inches
Handwriting is used to emphasize the meaning of the headline, itself
reacting to the damaged negative of the lead photograph.
Art director Roberto Maria Clemente

6

NOUVEAU GRISE

Age is the new youth and retirement a second adolescence, according to 'Fit and Fifty', a report by the UK's Economic and Social Research Council.

Across Europe, fiftysomethings are adopting a more self-focused hedonistic attitude to living as baby boomers come into their own, but none are more hedonistic and pleasure-orientated than the Brits, who are forsaking zimmer frames and M&S skirts for clubbing, hiking, walking and pleasure seeking experiences that are surprising advertisers and brand owners alike. UK clothing retailer M&S has been the biggest casualty of this revolt into middle youth, but also companies targeting this market with laboured images of grey haired folk taking hip baths, using stairlifts or growing old gracefully in matching his and her sweaters.

Indeed product purchase generally is less a concern to this group, which says it is more keen on collecting 'experiences' - via travel, trekking and long term lets abroad. It also sees its 'assets' as a way of bringing pleasure to itself rather than passing them on to family or children whom they believe will only squander it anyway.

Although fiftysomething in terms of age, they carry an inner idea that they are still in their forties (see Leon Kreitzman's essay page 129) and want to be sold to accordingly. Adverts then encouraging risk, travel, pleasure, splurging, or 'having a go' are more likely to succeed at this end of the market than any other, and since this generation is more liberal than the one ahead of it, and the one behind, food, wine, sun, sand and sex all appeal in a way that 'its does to the average eighteen year old', say researchers.

'Fit and Fifty' details from: www.esrc.ac.uk

7 **8**

LA DOLCE VITA

Unsurprisingly, London and Paris rank highest for recreational facilities among top EU cities, while Vienna follows closely behind, according to Geneva based Mercer Global Information Services' recently published Quality of Life survey.

Copenhagen, Helsinki and Stockholm score highest for public transport and traffic management within Europe, while internationally Oslo, Singapore and Vancouver take the prize.

Recreational scores are based on the number and variety of restaurants a city has and also the frequency and range of music and theatrical performances, numbers of cinemas and availability of health clubs and sports and leisure facilities. Cities were ranked against New York as the base city which scores 100.

Globally the top cities for recreation are New York, Los Angeles, Washington DC and Sydney - each scoring 100. The high score can however be attributed to sports and health facilities rather than cultural or food related ones.

The world's lowest ranking cities for recreation were Brazzaville, capital of Congo. Switzerland has three of the highest scoring cities on the survey, Zurich (106.5), Geneva (105.5) and Bern at 104.5. Likewise German cities rank high on the list, for their transport and health facilities, Frankfurt at 104.5, Munich at 104.5 and Dusseldorf at 103. According to the survey, Paris and London slipped slightly from last year's position because of increased crime rates in the French capital and worsening traffic and transport problems in London. Full report from the Mercer website on: www.iemmercer.com

EURO-COSMETICS

Sales of colour cosmetics and skincare products are booming across Europe, according to Retail Intelligence's report Consumer Goods Europe. Increases have been driven by new product launches, innovations in the skin and products market itself, but also a growing confidence among consumers that personal skincare regimes improve their overall wellbeing.

In France, Germany, Italy, and Spain sales of luxury products are up generally, in many cases stimulated by fashion's return to luxe fabrics, bright colours and body products that embrace colour, glitter and novelty.

The skincare market saw similar growths due to the arrival of advanced moisurising formulas, anti-ageing creams, nourishing treatments and the launch of 'next generation' cleansing wipes, strips and balms that promised multi-performance possibilities e.g. a cleanser with soothing properties, wipes with fragrance-like smells rather than antiseptic ones.

Growth was also stimulated across all territories by bringing to mass market products the same technological or luxe beauty advances in packaging and formula creation found at the top end of the market.

Fragrances & Cosmetics 2001, from: Retail Intelligence, £395, T:+44 02078143715

NO MISS TAKE.

EVERYTHING HAPPENS FOR A REASON

Photography by Claudio Cassano

March 13
Foot and mouth disease was first identified at an Essex abattoir in mid-February. The epidemic spread to farms across the country. Thousands of slaughtered animals were incinerated in immense pyres. It was a Ministry of Agriculture official admitted, a 'medieval' method of controlling the disease

September 11
On a beautiful, clear New York morning, first one hijacked passenger plane and then another flew into each of the twin towers of the World Trade Centre in lower Manhattan. Some office workers were able to run down staircases to safety before the towers collapsed. Others, in despair, leapt from windows

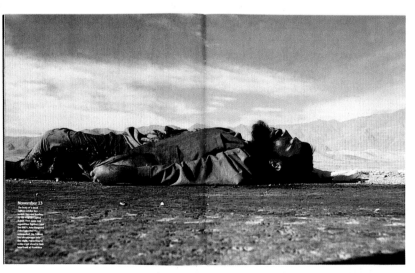

November 13
The body of a dead Taliban soldier lies beside the road leading to the Afghan capital, Kabul. That same day opposition fighters (and the BBC's John Simpson) rolled into the city, unopposed. The Taliban had disappeared into the night, regrouping to make a last stand in their heartland of Kandahar

The Guardian Weekend *(UK, 29 December 2001) 254 x 300mm / 10 x 11 7/8 inches*
The Guardian *(UK, 12 September 2001) 305 x 380mm / 12 x 15 inches*

Potent photography featured similarly in two parts of the same publication at different times and for different purposes. A series of three photographs (THIS PAGE) – run full-bleed with no interruption – sum up a bleak year in the colour supplement *Weekend*: the slaughter of cattle in the UK, the attack on the World Trade Centre, and the subsequent war in Afganistan. This is classic photographic journalism, the images working together to link three news stories and convey a united message of despair. The attack on the World Trade Centre is conveyed in explicit horror as a news story on the front page (OPPOSITE) of the main newspaper. For the first time the whole front page of this broadsheet newspaper is cleared for a single image. *Design director Mark Porter*

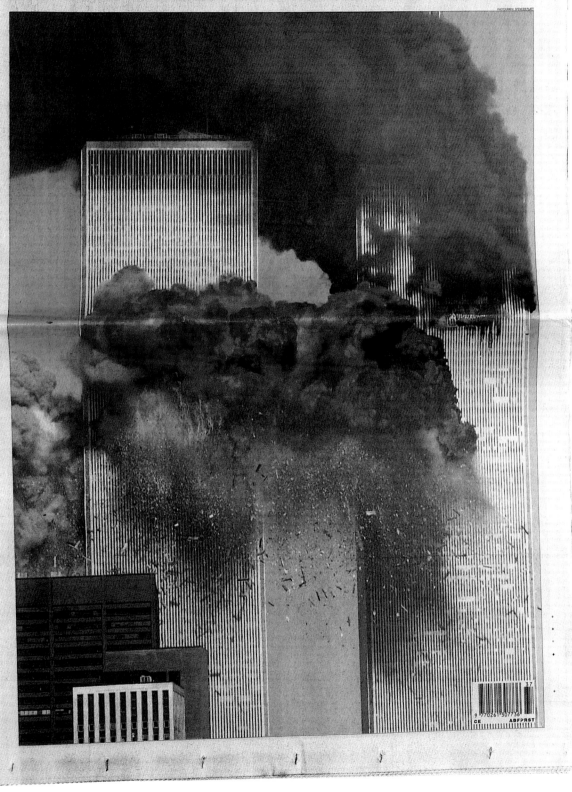

50p
Wednesday
September 12 2001
Published in London
and Manchester
guardian.co.uk

The Guardian
A declaration of war

A&F Quarterly (USA, Back to School Issue, 2001) 230 x 275mm/9 x 10 ⅞ inches
Fashion company Abercrombie & Fitch added an editorial element to their catalogue
and relaunched it in a magazine format. This particular issue caused panic among
America's religious right with its sexually provocative images of college life.
Photographer *Bruce Weber*

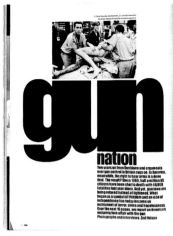

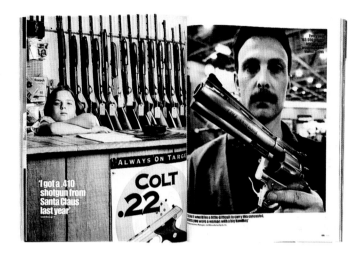

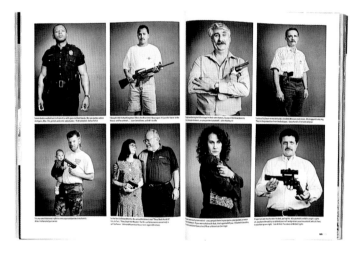
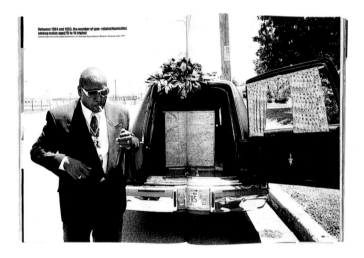

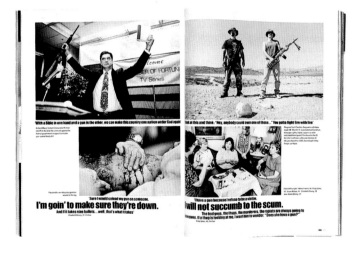
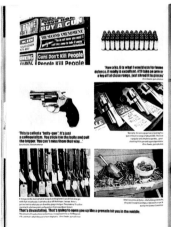
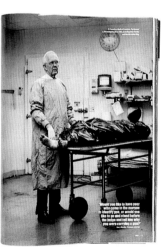

GQ *(UK, April 1998)*
220 x 285mm/8 3/4 x 11 1/4 inches

Such stories were once the mainstay
of news magazines and newspaper
supplements, but have become
increasingly rare as they are squeezed
out by celebrity interviews and
fashion. In a curious turnabout, a
magazine best known for its celebrity
and fashion content, published this
extraordinary 16-page photo essay
about US gun culture.
Art director *Tony Chambers*
Photographer *Zed Nelson*

It is the medium that shapes and controls the
scale and form of human association and action.
— *Marshall McLuhan*

OVER

sex4790.jpg

75%

ALICIA-05.jpg

OF ALL

usa1847.jpg

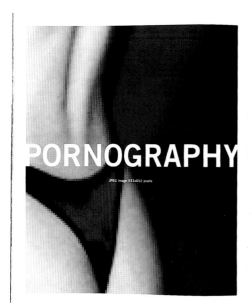

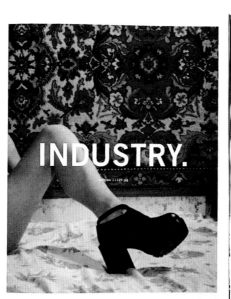

Coupe (*Canada, Issue 1, 1999*) *245 x 293mm/9 ¾ x 11 ½ inches*
A ten-page 'installation' uses a statement about internet usage
and runs it across a selection of massively enlarged pieces of
downloaded porn site JPEGs, to illustrate a quotation from
Marshall McLuhan.
Art direction The Bang

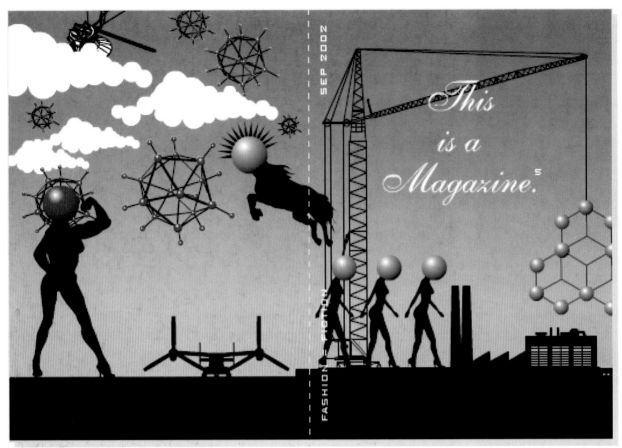

Issue 5, September 2002. Illustration *Andy Simionato*

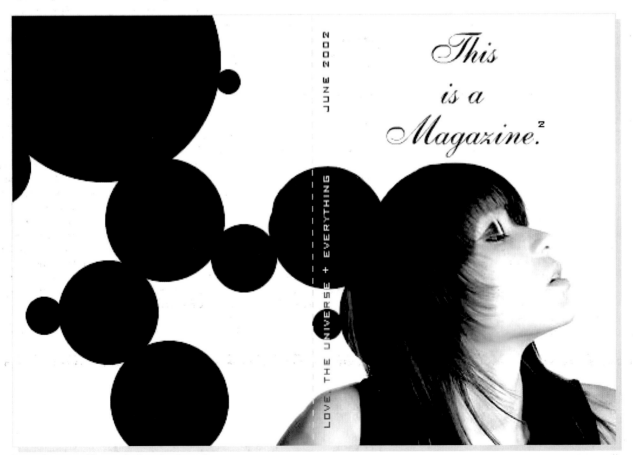

Issue 2, June 2002. Photography *Karen Ann Donnachie*

Issue 4, August 2002. Photography *Boogie*

Issue 4, August 2002. Illustration *Wonder Wagon*

PREVIOUS PAGE:
USE A CONDOM POSTERS.
DDD GALLERY, JAPAN.
OPPOSITE PAGE:
JUST SAY NO,
POSTER TIMES SQUARE, NYC.

Issue 4, August 2002. Illustration *James Victore*

Issue 4, August 2002. Illustration *Our Machine*

Why does thisisamagazine (TIAM) use a print magazine format to display its pages?

Initially I was not really concerned with making a magazine-like interface; it simply suited our needs. I wanted a design that removed much of the conscious choice of mouse-clicking, that allowed the reader to return to absorbing the artwork. Moving left or right is already such a universal 'language' of magazines that it is no longer a conscious act.

Compared to most websites, magazines are so simple in structure, a product of cut pages stitched or bound together into a form that is both volume of work and a collection of articles, images and text. It minimizes the reader's decisions, in order to better perceive the artworks and articles. I believe it frees the artists to communicate with the greatest liberty, each one contributing to an overall effect.

In the same way, with our website you can start to read from the cover, or flip to the back and read from there. (Use the keys 'a' and 'z' respectively.) We are also developing a random key, where the reader can 'flick open' the online magazine at a random page.

Why do you also produce a printed edition?

Because you can't touch a pixel for quality. We sell the printed magazine online and through art galleries and bookstores. The profits (if any) will contribute to part of the expenses of the project. We are not interested in carrying advertising or commercializing the project in other ways.

How similar is the printed edition to the web edition?

The web edition is published once a month, and the print edition is published every three months as a compendium that contains almost all the original artists, but not every page is reproduced as it is in the online magazine. Instead, we reinterpret the articles with print considerations, such as through using fluorescent and metallic inks, forced mis-registration, and sometimes taking a completely new approach to the original story.

What are the differences between creating a magazine for print and for web?

Technically, the two processes are almost identical, even more so now that print design heavily uses CTP (computer to plate) and therefore remains digital practically to the printing press. What is different? The web magazine involves combining pixels and sound, the print magazine combines paper and ink. These physical differences involve different and important considerations: the screen involves projected light and moving pixels, which are transitory but infinitely reproducible. Print uses reflected light, and fixed ink, and its physical permanence has a finite life. Web / Print. A kind of Yin / Yang.

The web page pulses away forever, the print magazine is slowly consumed, and ages through use. Therefore, in our case we like to contrast or highlight these differences, allowing animation to contaminate the still images, to create a web magazine with 'inks' that dissolve and disappear, and a print magazine that has 'pixels' that jump (for example by using fluorescent inks or mis-registration).

In creating a magazine for print we must consider the element of consuming, owning. A pixel is infinitely reproducible without loss in quality, a printed page will have unique elements and be limited in distribution. It also immediately forms part of a consumer system. Whereas the web version is freely available (given the neccessary equipment and technology required to view it). We encourage the copying and distribution of the web version; it's only around 2MB so can be readily emailed.

The web version is owned by a single person, kept on a hard-drive, and 'read' only by that person, generally all in one sitting. Whereas there's a public

Interview
Andy Simionato
Art director
www.thisisamagazine.com

Issue 5, September 2002. Illustration *Reilly P Brennan*

Issue 5, September 2002. Illustration *Reilly P Brennan*

Issue 5, September 2002. Illustration *Andy Simionato*

Issue 5, September 2002. Photography *Karen Ann Donnachie*

element to print to consider – the print version will be read in multiple sittings, in different places and by more than one person. People like to keep art-magazines on display, so visitors can browse them.

These considerations are what make the difference in creating the two objects. So I need to consider design elements, and editing choices respectively. In particular, difference in rhythm, density of information/detail, negative space and legibility issues, size and proximity of text to image. That's apart from more basic editorial choices in content. There are some analogies between the two however. For example, I 'read' animation online as special inks or punch-cuts on the printed page.

Ultimately I would like the two media to simultaneously inform and deconstruct each other, to connect and form new visual languages.

Who are your contributors?

Many of our contributors have been published elsewhere; for others this is the first time. Some are (in)famous: James Victore has produced some of the most polemic poster art in north America, such as the Disney Go Home series in Times Square, NYC. Others include Yanick Dusso, designer for Lord of the Rings, Anthony Burrill, Wonder Wagon and Takeshi Hamada who is already well known for producing his own independent magazines.

For me, what is important is the combination of artists. Each acts as a kind of lightning rod, and through placing them near to each other connections start to form. Artists are invited to contribute. Sometimes we provide a brief, other times I go from a suggestion by the artist him/herself. We collect and filter the artwork. Many articles are developed as collaborations, using our Milan studio as a base. We do a layout then test the results – posting the work online for a private contributor's viewing – and finally make the issue public. We announce the new issue to subscribers via email, along with secret sections and keys.

Who are your competitors?

There are many noteworthy online magazines (and I mean projects that are using magazine-style formats or languages of multiple page layouts) but my favourite is Tiger magazine (www.tigermagazine.org), which deals more with the art gallery world. When I saw it I immediately invited its creator Takeshi Hamada to contribute to TIAM. His beautiful drawings will also be featured in the printed version.

TIAM can only be unique through its content. There is a homogenization happening in mainstream magazines, brought about mainly by the competition for increasingly restricted markets and publicity motivated editing. The large number of similiar magazines on the market does not neccessarily indicate that the market is satisfied with what they offer. We continue to produce magazines because, ultimately, despite all the perfume/cell phone/leathergoods advertising financed material we want to have a means for one group of people to communicate something to another group of people. While we have stories to tell, there will always be magazines. They are store-houses (in italian the word for a warehouse is 'magazzino') for our culture.

What kind of response have you had to TIAM?

Issue 1 received more than 55,000 unique visitors, which knocked us out since we didn't even register the magazine in the search engines. We are currently on about 30,000. I start an hour earlier each day so I can respond to all the emails.

Emails and messages have been extremely supportive, as if we are doing something strange or unique but I think this is an exaggeration. We just made a toy, and others enjoy playing with it too. Perhaps there is simply a need to play more.

Issue 2, June 2002. Photography *Karen Ann Donnachie*

touched up

photography
RANKIN
styling
MIRANDA ROBSON
retouching
THE SHOEMAKERS ELVES

Dazed & Confused (*UK, Issue 85, January 2002*)
230 x 300mm/9 x 11⅞ inches
This fashion story was demonstrating the extent of retouching now routinely
carried out on fashion pictures. The images have been heavily retouched but
the areas behind the large crosses have been reproduced un-retouched.
Art director Suzy Wood Photographer Rankin

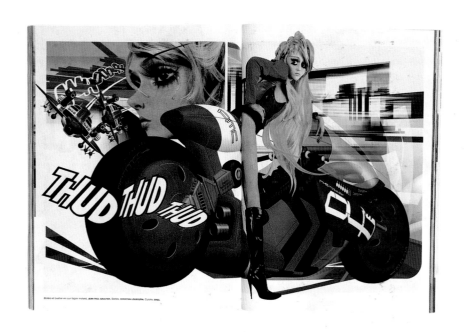

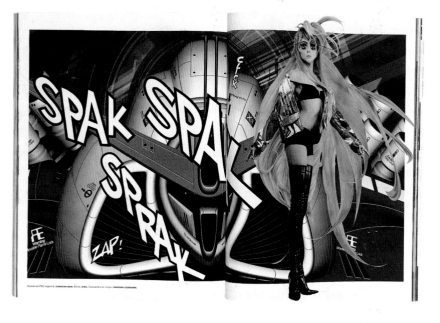

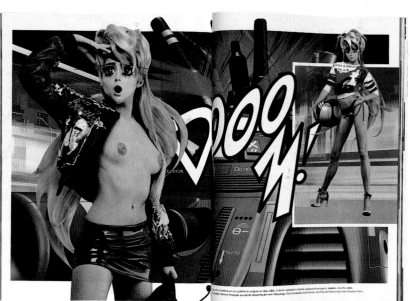

THIS PAGE **Details** (*USA, Issue 2, November 2000*)
230 x 275mm/9 x 10 ⅞ inches
Photography and illustration combine in lo-tech style: a fashion story drawn by a young artist, based on photographs by his father. Art director *Rockwell Harwood* Drawings *Riccardo Sorrenti, based on photographs by Mario Sorrenti*

OPPOSITE **Numero** (*France, Issue 26, September 2001*)
230 x 300mm/9 x 11 ⅞ inches
Photography and illustration combine with digital technology in this manga-style fashion story created by Me Company. Art director *Emma Wizman*

Cotton shirt by **Giorgio Armani**

Vintage American denim jeans by **Helmut Lang**. Belt by **Prada**, at Prada boutiques nationwide.

Cotton shirt by **Burberry**. White jeans by **Levi's**. Shoes by **Nike**. Khaki pants, T-shirt, and button-down shirt by **Emporio Armani**. Shoes by **Hermès**, at Hermès stores nationwide.

Khaki pants by **Perry Ellis**. Belt by **Prada**, at Prada boutiques nationwide.

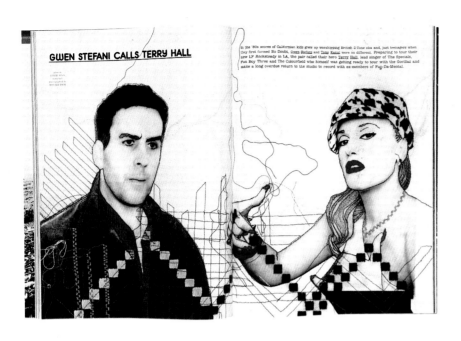

GWEN STEFANI CALLS TERRY HALL

In the '80s scores of Californian kids grew up worshipping British 2-Tone ska, just teenagers when they first formed No Doubt, Gwen Stefani and Tony Kanal were no different. Preparing to tour their new LP *Rocksteady* in LA, the pair called their hero Terry Hall, lead singer of The Specials, Fun Boy Three and The Colourfield who himself was getting ready to tour with the Gorillaz and make a long overdue return to the studio to record with ex-members of Fun-Da-Mental.

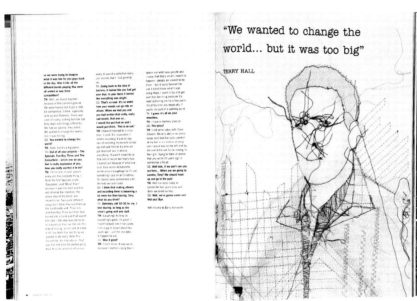

"We wanted to change the
world... but it was too big"

TERRY HALL

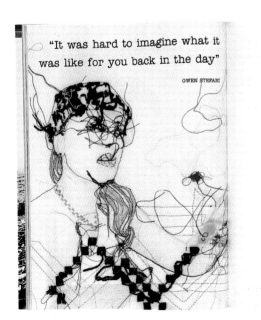

"It was hard to imagine what it
was like for you back in the day"

GWEN STEFANI

OPPOSITE **Viewpoint** (*UK, Issue 10*) *215 x 297mm/8 ¹/₂ x 11 ³/₄ inches*
A piece on UK men's magazines opens with this image of a magazine cover featuring handsewn outlines of the magazine logos, overlaid in different colours at the top of the page with the inevitable female figure outlined in beads.
Art director *Gerard Saint* Image *Jo Taylor*

THIS PAGE **Dazed & Confused** (*UK, Issue 89, May 2002*) *230 x 300mm/9 x 11 ⅞ inches*
Photographs printed onto fabric are embroidered with coloured thread. The following two spreads reproduced the backs of the artwork showing the loose ends of thread.
Art director *Suzy Wood* Images *Lizzie Finn*

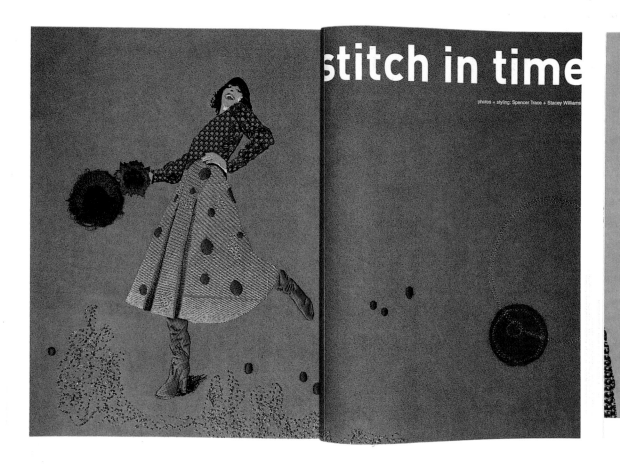

stitch in time

photos + styling: Spencer Trace + Stacey Williams

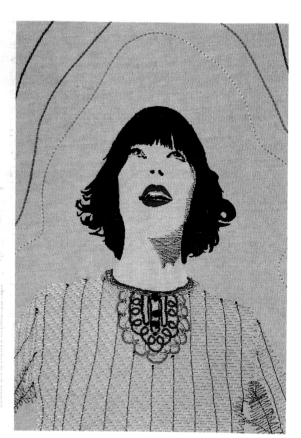

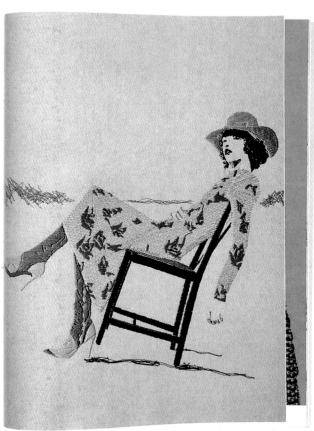

Tank (UK, Volume 2, Issue 6, 2001) 280 x 350mm/11 x 13 7/8 inches
This embroidered fashion story, based on photographs, mixes realistic light and shadow with simple needlework pattern and tones.
Art director Andreas Laeufer Embroidery Debbie Stack and Jennifer Carr, based on photographs by Spencer Trace and Stacey Williams

It's 2pm on a brisk Belgrade afternoon as I meet Madonna at the Serbo-Croat Virtual Mothering Institute where she is taking a break from undergoing a simulated birth to meet me. She is smaller than she seems in her ads for her spray-on lingerie collection. Her hair is scraped back into a long grey ponytail and she wears a turquoise bio-sensory boiler suit, which I immediately recognise as one of only a handful made by Gligoroy Ljubco, enfant terrible of the Macedonian fashion world.

Nova: 'Hello.' M: 'Hi. Have a pod. Drink? Wait. Don't get up. Let the help do it. Britney, Christina...'. N: 'So, your move to Belgrade – nobody anticipated that.' M: 'Yeah, I know. But there's something about this town. It's not just the fashion, the fractured sense of history, the turn-of-the-century architecture... It's the artistic vibe. It's like London was 20 years ago... urban, gritty and real and, you know what, less clone-infested than other parts of the world. I mean the last time I was in the States, I had, like, double vision.' N: 'Yes, I heard San Francisco just broke the record for the highest number of Madonna clones inhabiting a city.' M: 'Yeah – they're all still in their teens, but, yeah, there are 37 of the things slumping around over there.' N: 'So you regret having promoted your last-but-one album, Genealogy, by cloning yourself 20 times over?' M: 'Well, it was a groundbreaking thing. Besides, all 20 of those clones were allocated good homes in stable gay families before we went ahead.' N: 'Madonna, you're about to make your own contribution to world under-population.' M: 'Yeah – I had these eggs frozen 16 years ago and just kind of held on to them. But now that most people don't have time to have kids any more and since Guy went off to direct Minge – I thought, 'I'm going to have one of these things fertilised.'' N: 'Who's the lucky sperm donor?' M: 'Well, I was looking to give birth to a brainy, good-looking sort of a kid. Lysander [Kate Moss's son by her marriage to Noam Chomski] just seemed the obvious choice. His parents gave him permission. It's not like he doesn't produce the stuff by the gallon-load. Fifteen-year-old boys will be fifteen-year-old boys.' N: 'What about your other children? There's talk of a rift between you and Lourdes...' M: 'It's not really the nun thing [Lourdes enrolled in a convent at 16]. It's just that I was so hurt when she refused to duet with me on a cover of Mistletoe and Wine.' N: 'And your son?' M: 'He can't sing.' N: 'But your relationship...' M: 'It's good. In fact, he was the one who persuaded me to buy up London Underground and turn it into a tourist attraction.' N: 'And it's been a success, along with the Floppy-Go-Slippy™ solar-powered flip-flop and your reinterpretation of the Mrs Robinson role after Jerry Hall's 18-year run. Any other projects up your sleeve? M: 'A photographic study: Sixty Nudes at Sixty, and I'm playing Gertrude in the CD-Rom adaptation of Hamlet.' MELANIE HOWARD, TREND PREDICTOR FOR THE FUTURE FOUNDATION

We're two journalists aged 10 and 12 and today Nova has asked us to interview Madonna at a beauty parlour for the magazine. We are living in 2020. Madonna is 62 and looks young for her age but not so pretty. She is wearing glasses disguised as sunglasses because of her poor eyesight. Her body is slim and she has no flab because she goes to the gym every day. She is wearing a lot of mascara on her face and a lady is plucking her eyebrows quite thin. She is having her hair dyed light ginger and put into ringlets. She is having her nose and eyebrows pierced. She is wearing the latest clothes, a lot of leather, a tight top and a big floppy parka jacket. She has a mobile phone with a colourful cover. Men still like her, especially those in their 40s they think she's sexy. Men in their 30s think she looks good for her age. She takes getting old well and was happy to retire because it meant people stopped mobbing her when she went out. She lives alone in the country because she is old and needs more fresh air. She is seen driving round in different cars and has one that is able to turn into a boat and an aeroplane just like James Bond. She also likes to ride around on motorbikes. Madonna asks the woman plucking her eyebrows to put on some music. She is still involved in the world of music. She makes guest appearances with Robbie Williams and Craig David, but her main job is managing young pop bands. She shows up at big awards parties but isn't in the charts anymore. Madonna is on television and in newspapers because she still goes to posh dancing clubs. Her children are famous singers, dancers and in films. Older people remember her songs but there are a whole new generation of kids and bands that don't know her. She doesn't care though because she's really cool. LOUISE-MARIE EBANKS, 12, AND CINDY CROME, 10.

Louise-Marie and Cindy's contribution courtesy of Children's Express, a programme of learning through journalism for children aged 8-18

There is something unsettling about meeting Madonna in her new house. Maybe it's because her new house is the Kremlin, which she picked up when Russia became part of The United States of the World. But what is really unnerving is the lady herself, who has gone through so many reincarnations it is impossible to predict who she will be next. Last month it was Pepe le Pew, before that Mahatma Ghandi.

Madonna sits upright on the edge of a Regency chair. Her hair is light brown and coiled into a solid mass – it resembles a helmet. She wears flesh-coloured tights, a woollen navy blue skirt and a matching jacket. Her hands are folded onto what appears to be a brick nestling in her lap – it turns out to be a handbag. 'Do sit down,' she says. Her accent is unmistakable: an American take on British upper class. Of course! It's so obvious. This month Madonna is Margaret Thatcher.

As she is now the world's richest woman, few people risk critiquing Madonna's metamorphoses. Indeed, nobody batted an eye when she turned up at Patsy Kensit and Leo Blair's engagement party, a pair of giant black ears pasted to her head (Mini Mouse). Nor did anyone comment when, having spent an alleged £1 million on the outfit, she presented the Oscars from inside an aluminium case (the Tin Man).

Each new 'style' has generated a financial whirlwind. It was Madonna who extended the concept of a fashion accessory to include everything from aeroplanes to real estate. 'You can't get the look without the detail' has been her mantra ever since her Abraham Lincoln phase, during which she bought Mount Rushmore and popularised the use of testosterone among women in a bid to grow a beard. Her stovepipe hat sits on the sideboard as a reminder.

But who is the real Madonna? 'Good question,' she says wavering between today's English accent and the Urdu twang she likes to adopt with close friends. 'To be honest, I lost my identity a while back and I can't seem to find it. I mean, one minute I'm working on a cover version of the Waltons theme tune and the next... I look in the mirror only to find Pope Jean-Paul I staring back at me. At first it scared the shit out of me but after a while I thought, "Hey, white really is your colour."'

Madonna looks the picture of relaxed, right-wing elegance. At 60 her body has reached its physical peak. And half the world knows it intimately – thanks to the range of 'nude' salt and pepper shakers she had made in her likeness last year.

So what next for this makeover junkie? 'Well it's either Jean-Paul Belmondo or I set up my own fashion line as myself circa 1982. Now that fashion has become so stuffy, I think this could be the right time. I mean, look at Alexander McQueen's – Siamese twins on the runway? How terribly modern.' Any clues as to what she might be including in her first collection? 'Think fingerless lace gloves,' she twinkles mysteriously. DAVID WOLFE, FASHION EXPERT

Guru, poet, publishing magnate Madonna, the world's most influential businesswoman-cum-spiritual leader, sits atop her rattan chair and picks up her pan pipes. Just over a million people have made the pilgrimage to see her here today, live in Hyde Park, and although for most of them she is but a tiny speck on the womb-shaped stage, it was worth the journey. 'She changed my life,' whispers Lourdes, a 50-something female fan from New Mexico who changed her name by deed poll 24 years ago when Madonna gave birth to her first daughter. A hush descends upon the crowd. 'She's going to read from Touched for the Very First Time,' squeals 55-year-old Bart from Oslo.

As Madonna begins to read, members of the crowd assume The Noose, the heads-wrapped-around-their-neck yoga position that she first championed in the belatedly acknowledged classic film, The Next Best Thing. 'Open your heart to me,' she says in the voice that has graced a thousand audio-tapes. 'Beautiful strangers – if I ran away I'd never have the strength to go very far.' Her mane of white hair tumbles down her back, her pale billowing garments swirl about her vast frame, her pale limbs are adorned by countless rings and bangles, and her unmade-up face is partly framed by the chiffon drape that erupts from the medieval cone she wears on her head. All of this is set off by Madonna's trademark Roux-ivory cane, that has become such a must-have since she first modelled it at the launch of Stephen Hawkins' 22nd tome, A Brief History of Pop.

It's been a tricky ride to the top for the queen of karma, whose role models include Clannad, Mother Teresa and, more commercially, God. 'Well, she's a woman isn't she?' Madonna famously quipped in an interview with The Catholic Herald five years ago. Having taken a public vow of celibacy in her late 50s, Madonna had to work hard to convince her public this was not just another publicity stunt and enlisted the help of Rabbi Macaulay Culkin. It was Culkin who convinced her to donate her entire £1 billion high-heeled shoe collection to charitable projects in Asia and invest the next few years helping to raise funds for disadvantaged children and the politically oppressed – earning her the title 'The High Priestess of Hearts'. No wonder, then, that when, last year, she experienced what she describes as a 'vision', there was speculation that Madonna and The Madonna had finally met.

The change in image has meant a change in her circle of friends. Gone are the Gwyneth Paltrows and the William Orbits – instead Martin Amis, Camille Paglia and the actor-turned-UN Secretary BA Baracus take turns to meditate and read each other's auras in the VIP box. As Madonna launches into her Celtic interpretation of The Iliad, they pause, perhaps awed by her command of the harp. Madonna in her sixties is a breathtaking sight – a teacher, a leader but, most important, a friend. KIM FARNELL, ASTROLOGER

Nova (UK, Issue 5, October 2000) 230 x 290mm/9 x 11½ inches
Another example of the combined methods of working with analogue and digital: these images of Madonna were hand-drawn, scanned and coloured on the computer and supplied to the magazine as a digital file.
Art director *Gerard Saint* Drawings *Paul Davis*

Credits, Index

Thank you...

All the art directors, designers, editors and publishers whose co-operation and advice made this book possible

Richard Dean for photographing the magazines

Zoe, Jo, Laura and Felicity at Laurence King Publishing

Steve Martin for help from Japan, Lewis Blackwell for help with the title, Marc Vialli and Montse for opening Magma, a store capable of sating my magazine addiction

Lesley, Cameron and Ewan for putting up with me working evenings and weekends

And Jean Baisier, Lucas Badtke-Berkow, Jop van Bennekom, Peter Bilak, Marion Bouchard, Josefin Brink, Anthony Burrill, Simon Esterson, Fernando Gutierrez, Jessica Gysel, Andreas Hoyer, Warren Jackson, Mayumi & Daisuke Kawasaki, Nigel Kendall, Andreas Lange, Martin Lilja, Jarno Luotonen, Anja Lutz, Sandra von Mayer-Myrtenhain, Lionel Moinier, Dave Niddrie, Andrew Pothecary, Christopher Sanderson, Brian Saffer, Astrid Stavro, Gijs Stork, Winnie Terra, Daniel van der Velden, Jan Walaker, John L Walters and Clare Watters

www.magculture.com
Like the pictures? The real things are even better. Visit *www.magCulture.com* for magazine stockists and links to web magazines